Story Money Impact

Story Money Impact: Funding Media for Social Change by Tracey Friesen is a practical guide for media-makers, funders, and activists who share the common goal of creating an impact with their work. Today, social-issues storytellers are sharpening their craft, while funders with finite resources focus on reach, and strategic innovators bring more robust evaluation tools. Friesen illuminates the spark at the core of these three pursuits. Structured around stories from the front lines, *Story Money Impact* reveals best practices in the areas of documentary, digital content, and independent journalism.

Here you will find:

- Twenty-one stories from people behind such powerful works as *CITIZENFOUR, The Corporation, Virunga, Being Caribou, Age of Stupid,* and *Food Inc.*
- Six key story ingredients for creating compelling content.
- Six possible money sources for financing your work.
- Six impact outcome goals to further your reach.
- Seven practical worksheets for your own projects.
- A companion website located at www.routledge.com/cw/friesen containing up-to-date information for those seeking the tools and inspiration to use media for social change.

Tracey Friesen is a media strategist, committed to supporting storytellers and social innovators in the creation of impactful content. Formerly an Executive Producer at the National Film Board of Canada, Friesen is now Director of Programming for Roundhouse Radio 98.3 Vancouver, a hyper local commercial station with a community focus.

"This is a remarkable book. Tracey Friesen deftly guides a meditation on the transformative influence that film can play in steering and affirming positive change in the world, and on the financial support and narrative grounding requisite to this shift."

—Ross McMillan, President & CEO Tides Canada

"Fresh, authentic, and experiential, this book is an asset to every filmmaker who wants to make media that matters."

—Patricia Aufderheide, Professor, American University
and founder of the Center for Media & Social Impact

"Not all docs can or should ignite social impact, but a good many do. Friesen provides the essential research, roadmap and tools for this transformative and exciting new space. A compelling read."

—Chris McDonald, President, Hot Docs

"A new metaphor for looking at the relationship between Story, Money (funding), and Impact. This book is a valuable resource with many concrete stories of real projects."

—Gordon Quinn, Kartemquin Films (*Hoop Dreams, Life Itself, Stevie*)

"Tracey Friesen is perfectly positioned to offer this most useful little tool *Story Money Impact*. Her work with story during her time with the NFB and inspirational contribution to the media community have resulted in both insight and a unique approach for filmmakers at all stages of their career, from the spark of an idea to the thrill of a hard won premiere screening. Her own credentials, being without question, are complemented by a stellar cast of contributors from storytellers to funders, to programmers to philanthropists, worthy of the who's who list of media creators and leaders for social change."

—Valerie Creighton, President and CEO, Canada Media Fund

"This book offers a great mix of both practical advice and inspiration. *Story Money Impact* goes way beyond just the idea of creating an 'impact campaign,' which is where many manuals on the subject seem to both begin and end. Covering everything from finding and structuring your story to demystifying the fundraising landscape to making sense of the march towards metrics, Friesen has written an invaluable companion for filmmakers looking to make films that spark change."

—Amy Halpin, International Documentary Association

Story
Money
Impact

Funding Media for Social Change

Tracey Friesen

Routledge
Taylor & Francis Group

NEW YORK AND LONDON

First published 2016
by Routledge
711 Third Avenue, New York, NY 10017

and by Routledge
2 Park Square, Milton Park, Abingdon, Oxon, OX14 4RN

Routledge is an imprint of the Taylor & Francis Group, an informa business

© 2016 Taylor & Francis

Library of Congress Cataloging-in-Publication Data
Friesen, Tracey.
 Story Money Impact : Funding Media for Social Change / Tracey Friesen.
 pages cm
 1. Documentary films—Finance. 2. Documentary films—Social aspects. I. Title.
 PN1995.9.D6F7375 2016
 384'.83—dc23
 2015029165

ISBN: 978-1-138-18463-3 (hbk)
ISBN: 978-1-138-85997-5 (pbk)
ISBN: 978-1-315-71685-5 (ebk)

Typeset in Myriad Pro and Giovanni
by Apex CoVantage, LLC

Printed and bound by
CPI Group (UK) Ltd, Croydon, CR0 4YY

Contents

Contents

Contents

Foreword

Get ready to ignite your spark! *Story Money Impact* is the book media change-makers have been waiting for. It offers a fresh perspective at a time when social media-making is in trouble, a "lifeboat" that can radically change the prospects we have of getting our projects off the ground, into the world and creating tangible change. Contained within these pages is an integral, whole system exploration of the process of creating, funding and releasing high impact, transformative media. Get ready for insights and "aha" moments galore.

For the last three decades I have been what I call a "cinematic activist," creating feature-length, social issue documentaries, including the Genie award winning *Bones of the Forest* (co-directed with Heather Frise) and the acclaimed *Fierce Love Trilogy—Scared Sacred, Fierce Light and Occupy Love*. My home base oscillates between Vancouver, San Francisco, Toronto, and New York City. In these major centers, and indeed around the world, similar patterns are emerging: we are falling into a crisis of documentary funding, as traditional avenues of support dry up, due to tough economic times, and other factors, such as the rapid rise of reality TV sucking up network slots and funding previously allocated to documentaries.

While new technologies like low-cost DSLRs and editing systems have made it easier than ever for first-time filmmakers to create a project, in the long run it's also easier than ever to get into debt, increasingly difficult to maintain a sustainable career as a social issue documentary maker. This book offers key insights, as we struggle to find a new path to impact and financial stability, while helping to avoid media-maker burnout. It is clearly in sync with the zeitgeist of our time, as the social impact media-making reinvents itself. The case studies contained within this book are invaluable, giving us the opportunity to explore what works, as well as what doesn't.

Back in the early 2000s—a hundred years ago in internet time—I was blessed to work with the author, Tracey Friesen, when she was my producer at the National Film Board of Canada, collaborating on my feature documentary *Scared Sacred*. Tools like Facebook and Twitter weren't around then, but nonetheless *Scared Sacred* managed to have a massive social release, driven by the power of community, the power of crowd sourcing. At the time we were creating the path by walking it, and much of what we were doing was breaking new ground. We relied on email lists, snail mail, and good old word of mouth, to connect with our audience. Tracey and I both shared a passion for changing the world through documentary, and

were excited to experiment with house party screenings, collaborating with niche groups related to our subject matter, and searching for every possible way to get the work out into the world, creating opportunities for real-world change to happen. And it did!

Over the years the tools have evolved, allowing media-makers to greatly increase our reach. Today, word of mouse is where it's at, and the ability to use the latest tools of communication offers unprecedented opportunity. On a good week, during its release, the Facebook page of my latest film, *Occupy Love*, reached millions of people around the world. At the same time, oversaturation, information overload, is also a serious issue. How do you go beyond mere likes into tangible results, not just in the digital world, but on the ground? This book offers a path, along with exercises to personalize your approach. The possibilities today are enormous, and now we have a guidebook to help us find the most effective pathway for each project.

In recent years I have been delighted by the way in which Tracey has been devoting her considerable talents, passion, heart and energy to unlocking the puzzle of story, money, and impact. Be prepared to up your game, to step up to the plate, to discover and seize the opportunities to find the funding you need. You will learn to hone your story, and bring the social impact of your films to the next level. Before you begin your next project, read this book to inspire your creation and development process, and set the course for maximum impact. Go for it—the world needs you!

Velcrow Ripper
www.velcrowripper.com

About the Author

Tracey Friesen is an active and ongoing contributor to the Canadian social issues media sector. Contracts include research, writing, and strategic consulting for businesses and organizations. Links to published reports and films can be found at www.storymoneyimpact.com.

In 2014–2015 Friesen authored a book for Focal Press/Routledge called *Story Money Impact: Funding Media for Social Change*, plus joined Roundhouse Radio 98.3 FM Vancouver as director of programming. Roundhouse is an independently owned commercial station with a hyper-local community focus. In the same period, she earned a writing credit on the feature documentary *Amplify HER*.

Early in 2013 Friesen left her position as executive producer at the National Film Board (NFB). She had been with the Vancouver studio for 11 years and has credits on over 30 projects, including the award-winning films *Being Caribou*, *Scared Sacred*, *Carts of Darkness*, and *Force of Nature: The David Suzuki Movie*.

Before the NFB, Friesen was with Rainmaker Digital Pictures for five years, working up from visual effects producer to the position of director of sales and industry relations. Prior to this she was employed for 10 years in post-production with such companies as Finale and the Post Office.

Friesen spent three years on the board of Women in Film & Television Vancouver—serving one term as president—and was honored with their 2013 Woman of the Year Award. She was a mentor for the Minerva Foundation and a protégée in Women in View's Creative Leaders' program.

She taught post-production at UBC, ethics and social responsibility at VFS, co-facilitated annual Media that Matters conferences at Hollyhock Leadership Institute, and routinely accepts invitations to lead workshops, panels, and industry juries. Passionate about education, Friesen has a BA from Ryerson (Radio & Television), a BA from UBC, and both an MA and MBA from SFU.

Acknowledgments

Story Money Impact was first sparked by Women in View's Creative Leaders Program, the brainchild of Rina Fraticelli. This initiative permitted me to invite friend and social innovator Al Etmanski to be my formal mentor during 2012–2013. I was employed at the National Film Board at the time and I appreciate that Cindy Witten and Michelle van Beusekom gave me the space to explore this, as well as attend my first (and rather life-altering) Good Pitch event.

Ideas coalesced through subsequent contracts with Mindset Social Innovation Foundation (thanks Alison Lawton and Graham Dover), Inspirit Foundation (thanks Andrea Nemtin), the Documentary Organization of Canada (thanks Liza Fitzgibbon), and Creative BC (thanks Richard Brownsey). It was Sharon McGowan who challenged me to collect all this research into a book.

The interviewees for *Story Money Impact* were almost disarmingly generous with their time, knowledge, and front-line expertise. My heartfelt thanks to all of you dynamic firestarters!

I appreciate the insights offered by the proposal readers, including Mandy Leith, Bonnie Sherr Klein, and Velcrow Ripper, and the careful attention of the peer reviewers, Jessica Clark, Brian Newman, and Hilary Mandel. An extra hat tip to Hilary who was integral during the formation stage. And kudos to Lucia Dekleer, the talented teen who came through with eye-catching illustrations.

Thank you to Maggie Landrick and LifeTree Media for accelerating my thinking about an author's platform, and to Melanie Jane Parker and Alanna MacLennan for their transcriptions. Throughout it all, Focal Press's Emily McCloskey and Elliana Arons have been a delight to work with. And I so appreciate that Velcrow Ripper agreed to write the foreword.

For letting me road-test the flow during the *Story Money Impact: Media that Matters* conference at Hollyhock Leadership Institute in May 2015, I offer gratitude to Bill Weaver, Sue Biely, and Joel Solomon. There on Cortes Island, in the presence of 45 attendees—and the soaring eagles—I witnessed firsthand the power of connecting mission-aligned artists, funders, and activists for social change.

And on a personal level, for his support at the beginning of this journey, I thank Joel Calvo (and his sister Barbara for her home—and campfire pit—on Vashon Island, where the proposal was written and the "fire" metaphor

ignited). For their unwavering encouragement through its completion, I thank Roundhouse Radio's Don Shafer and Yvonne Evans. And for their anchoring presence through it all, I thank the two incomparable Glorias: my mother Gloria Friesen and my daughter Gloria Burke. The latter contributed to the research and manuscript preparation process and is herself an aspiring media creator. Here's the torch, Gloria!

Preface—
My Spark

I'm not even sure of his name. But he is tall and rugged and somehow perfectly fits the bill. Apparently he's spent hours combing the Cortes Island beach for just the right goodies—some rope, a small flat piece of driftwood, dried seaweed (or some such fragile clump). The only item he brought to the enterprise was his single-blade army knife.

After 20 minutes of crouching over the precious bundle, whittling and notching and spinning and gently blowing—oh, so gently—he straightens his back to stretch and takes a nourishing breath. Trying to coax fire out of nature takes not only patience, but stamina. If it were me, I'd be flummoxed by the dozen pairs of eyes around the circle, watching intently, silent. He seems quietly self-assured and leans forward again to resume.

I gaze up at these onlookers. Of course any number of them may have a lighter in their pocket. But that's not the point. Although this isn't billed as a summer camp for adults, it can sure feel like it. We're at the Hollyhock Leadership Institute for a conference called Media that Matters. It's a rather analog affair in a digital world. Facilitated sessions in circular wooden buildings, deep conversations during forest walks, shared vegetarian meals, and time spent in the solar-powered ocean-view hot tubs.

1

There are about 40 of us in total from across the US and Canada, and over the four days we talk for hours. Top of mind are new business models and the current challenges of media financing. Most are documentary filmmakers wanting to make a difference in the world, and they're having a harder time than ever finding money for their work. Hollyhock is meant to be a no-pitch zone, so broadcasters and funders can come as peer participants, but it generally evolves into a "slow-pitch" zone. Attendees tend to be generous with their knowledge and networks.

As part of my producer job with the National Film Board (NFB) of Canada, I've been coming to this annual gathering for years. It's a chance to meet new filmmakers, absorb fresh trends, and personally slow down some—take time to reflect on what we produce and what it all means, to the artists and to the public. I wonder though if this might be my last Media that Matters in this capacity. I've spent over 10 years at the NFB and I'm growing restless.

Making social issues content with independent directors and government money has been a real privilege. I mean, really—I said "pinch me" for about two years after I got the job at NFB. But 10 years *anywhere* is a long time, and especially so in a publicly funded bureaucracy. I've had the chance to produce powerful films with talented filmmakers, and on some beautiful occasions, I've even seen glimmers of how they've made an impact on lives. But they could do so much more. Documentary film can spark real societal change. I know it.

So does this group. We're not simply naïve do-gooders, waiting for this guy to make magic in the campfire ring. We're international producers, and creators, and entrepreneurs, and we believe in the power of media. We know that a compelling story, expertly told and financially supported, can have impact.

His deft hand movements continue and then there's a small puff of smoke at the center of the bundle. Again he blows, slow and steady. I'm surprised to find I'm holding my breath and have one hand across my mouth. In my mind I'm chanting "c'mon, c'mon, c'mon," like my actual survival might depend on this flame. It catches. There's a spark! But we're not out of the woods yet ... he fans it, adds a small stick, and then another in teepee formation, and gives it more air. Finally a more substantial piece of driftwood is gently placed on top and the small flames lick its sides and grow. We have a fire! People burst into applause and hug each other. It's like the climax of a powerful film. I'm actually fighting back tears.

Though I've enjoyed a number of bonfires on Cortes Island, something about the one that night tasted different. The songs were sweeter, the storytelling more meaningful. Was that the night we saw the massive

shooting star while splashing in the phosphorescence at the shore—or am I just getting carried away now? But honestly, witnessing the birth of a fire from scavenged objects had a real impact on me. It's so elemental.

Like fire, stories are deeply transformative. They have the power to change that which they touch. Turn one thing into another. And like fire, media needs the right combination of ingredients to create the spark. Story. Money. Impact. Beginning that weekend, fusing these three elements together has grown into my mission. This book is a part of fanning those flames …

Introduction

Story Money Impact: Funding Media for Social Change is a tale of opportunity. The world contains highly talented storytellers, highly principled financiers, and highly motivated activists. The goal here is to bring them together, to better understand each other, to spark alliances. What are the practical needs, professional stakes, and personal motivations of each?

We can all benefit from this exploration: filmmakers, funders, and social innovators, working so hard to solve seemingly intractable societal and environmental problems. Plus, of course, we welcome people who defy definition by straddling multiple pursuits, those modern hybrid practitioners. The bottom line is that our need for each other is mutual and our collective work will be that much stronger if done in collaboration.

- **Story** is fuel for the fire. The substance of story is like the physicality of firewood. Both are beautiful and unique and contain a hidden history. The more fuel we add, the greater it grows. Stories generate emotion; like fires, no two are alike—and they can be devastating, as well as illuminating.
- **Money** is the wind, air that stimulates combustion. Ephemeral yet necessary and even life-giving from the perspective of the fire-maker.

Directing intentional breath toward embers allows them to spark into actual flames, with the potential for an inferno. Without it, the embers fizzle.

- **Impact** is the fire itself, fusing the other two elements to generate intense heat. Dynamic and powerful, it alters whatever it comes into contact with. By bringing together the fuel of story and the winds of financial resources, the potential is heightened for the flames of impact to burn brighter.

When the lights came on after *Spoil* (director: Trip Jennings), a short documentary about the threat of oil tankers to the Great Bear Rainforest's waterways, I'd have signed any petition put in front of me. I'd have whipped out my wallet to donate to the cause. But instead I was wiping tears from my cheeks, stealing glances at the four other jurors in the private screening room at the 2012 Banff Mountain Film and Book Festival. There was a determined expression growing across my face that said, "We'll give this film an award this week if it's the last thing I do!" (We did.)

Not all documentary films seek to change the world. I truly appreciate that and have enjoyed working with artists on other genres too, like experimental, educational, musical, and animated films. But *Spoil* was unapologetic in its explicit goals to provoke change. Right before the production credit roll, viewers are told to take out their cell phones. The next screen gives the phone number of the Canadian Prime Minister, which stays up for the duration of the credits. We see by the logos that the film is financed by a consortium of alternative players—like a corporate brand and a couple of non-profits. But the story is compelling (the pursuit of an elusive white Spirit Bear by a *National Geographic* photographer); it grabs people's hearts on an emotional level.

This was a big week for me because while there, screening 72 adventure and nature films of various lengths over a five-day period, I had an epiphany. Something about watching back-to-back documentaries of people really "givin-er," living their lives full-out in pursuit of what they believe in, can't help but be a bit of a life-changer. It's a true occupational hazard. There, in the mountains of Banff, I knew with fresh-air clarity that it was the social issues media ecosystem I would commit myself to. I reasoned that I could achieve more on its behalf as an independent, working to ignite the flames of impact by bridging gaps between creators, financiers, and activists.

Once I made the nail-biting decision in 2013 to resign my executive producer position at the NFB, I started concentrating more heavily on this three-legged stool: Story, Money, Impact. (Or some days it was: Media, Means, Mission, or Art, Cash, Activism …) And then, like when you buy

a Volkswagen and suddenly start seeing them on every road, as soon as this triad was given an official name I began to notice the needs and the opportunities everywhere. Skilled filmmakers lacking access to resources, mission-driven foundations lacking relationships with strong storytellers, and those working for social change searching for compelling tools to amplify impact. In *Story Money Impact: Funding Media for Social Change* such gaps will be addressed.

Book Structure

The book comprises the elements below, delivered in three main parts—
Part I: Story, Part II: Money, and Part III: Impact, together with an Allies
section (Part IV).

- **Introductions:** There are informational sections that will cover topics
 that are creative, business-oriented and strategic in nature. We'll look
 at narrative structures (story), funding opportunities (money), and
 campaign design, with evaluation in mind (impact).
- **Motivation:** Near the beginning of each section, we will consider
 psychological drivers. What are the personal passions and institutional
 mandates that bring each of us to the arena of social change? How
 might media-makers describe their artistic goals? How does mission
 define the scope of activities of a funder? What inspires social activists?
 And importantly, what moves audiences to *action*? Awareness of
 motivation stimulates better project design from both an artistic and
 partnership-building perspective.
- **Elements:** Tales from the front lines are at the core of *Story Money
 Impact*. Interviews with leading professionals feed into the book's
 framework; namely, five essential ingredients for successful storytelling,
 five sources of funding, and five outcomes related to change-making.

The people, organizations, and projects were selected to draw out a diversity of topics and approaches in the social issues media sector. The majority of the examples unfold in the US, with a smaller sampling from Canada and the UK. Some subjects discussed are timeless (i.e. the importance of narrative arc) and others are evolving daily (i.e. data measurement tools).

Linear full-length documentary films are the primary focus. A few titles have just launched and others that have been on the market for many years are included to allow a view of the long tail, the impact over time. The funding section balances some established financing sources with more emerging models. The bias is toward values-based funders who have embraced or are awakening to the power of media to support their own objectives.

- **Producer's Journals and Memos:** Further elements of story, money and impact, along with all section summaries, come out in reconstructed Producer Journals and Memos that I've written from memory and lived experience during my time at the National Film Board of Canada. These pieces of creative non-fiction are each "based on a true story"!
- **Worksheets:** Within each part are two worksheets, and there's a capstone worksheet near the end of the book. Each starts with general questions to get you warmed up and then provides project-specific questions for anyone involved in media creation (whether filmmaker, funder, or activist). A single project can flow through these components of the text, leaving you, the reader, with a preliminary story, money, and impact map. Used in combination, you'll tackle your motivation, your story, your needs, your funding, your goals, your call to action, and finally, your vision.
- **Allies:** We wrap up with a peek into a dynamic profession birthed out of this evolving media landscape, that of the Impact Producer, and meet leaders in the multiplatform and independent journalism worlds. These experts illustrate that in looking across the genres, we have as much in common as not. This is useful information, because media practitioners are increasingly nimble in their selection of form.

The last section dishes up full biographies on all interviewees, two financing scenarios and a valuable list of resources: top films, progressive funders, innovative organizations, and brilliant evaluators. Because these fields are changing rapidly, stable aggregators are important for readers to source up-to-the-minute information. The *Story Money Impact* websites also contain active links: www.storymoneyimpact.com; www.routledge.com/cw/friesen.

Story

Story is Fuel
Generates Feeling!

Story. What it's all about. We know that. But what does "story" mean exactly? How do stories fuel emotion, inspire us, scare us, teach us how to live? In this first section of *Story Money Impact: Funding Media for Social Change*, we'll meet some "firestarters," people who let us in on how stories ignite action.

Putting together the elements of good storytelling is like laying the base of a campfire. The dry kindling and the firewood (and the scrunched up balls of paper, if you're me) are the ingredients, innocuous on their own, but containing potent energy. Similarly, the ingredients for sparking hot stories are both simple and powerful: *narrative arc, originality, emotion, immediacy, simplicity, and access.*

I love fires. And stories. *And* books … I have three books on the shelf near my desk right now, always within view. All blue (coincidence), easily digestible, and well worn. I've never been overly careful with my books, lots of highlighters and red pens and warped pages from reading in the tub. Where I do get precious is in not letting them out of my house. I'm a greedy hoarder, not one to lend from my library. You just never know when you might need to leaf through this one, or reread a quote from

Whatever stage you are in with your media making, you'll benefit from highlighting the bright spots, amplifying the emotion, and inspiring a desire in your audience to become a part of something greater than themselves.

that one. Even standing three feet back from the shelves and taking in the colorful pattern created by all those spines. Ahhh … both calming and inspiring.

Books, like films, like all art that's story driven, touch us in essential ways. For this story, money, and impact journey, my office is laden with reports and white papers and other publications that tell parts of the tale. My hope with this project is to tie them together. Make some sense of the sweet spot at the center, the spark that ignites media for social change.

As for my three key books, regarding story, I have in my hands *Switch: How to Change Things When Change is Hard*.[1] On the topic of money, I'm inspired not by your average book but rather a catalogue, that for *Good Pitch New York 2014*. And for impact, I keep coming back to *The Dragonfly Effect: Quick, Effective and Powerful Ways to Use Social Media to Drive Social Change*.[2] I'll return to the final two in later chapters, but here we'll peek into work of the Heath brothers in their *New York Times* bestseller, *Switch*.

There are of course dozens (thousands?) of excellent books on story structure. Most well known perhaps are Robert McKee's *Story* for screenwriters, and Joseph Campbell's *The Hero With a Thousand Faces*.

Campbell's articulation of the archetypical hero's journey goes something like this: Our hero, in her ordinary world, is called to a mission. She is reluctant but goes, in part emboldened by a mentor. After crossing the threshold, she encounters enemies, trials, and tribulations. She reaches the depths where she endures a supreme ordeal. Victorious, she seizes the treasure. After one last sacrifice, our hero returns home, transformed by the experience and with a gift to benefit her world.

We seem wired to respond to the hero's journey, yet there are myriad ways to deconstruct the narrative framework. Two others books I quite love are John Truby's *The Anatomy of Story* and Jonah Sachs' *Winning the Story Wars*. We visit Sachs' company, Free Ranges Studios, in the chapter on "Simplicity" to learn about the creation of *The Story of Stuff*. In his book he reminds us that to be winning storytellers, we need to tell the truth, be interesting and live with authenticity. A decent way to approach daily life, in fact.

Switch is nowhere billed as a storytelling bible. It doesn't explicitly cover narrative arc, BME (beginning, middle, end), or dramatic set-up/payoff. I use *Switch* rather as a blueprint for stimulating human behavioral changes. The central metaphor, about an elephant and its rider, is an analogy out of Jonathan Haidt's book *The Happiness Hypothesis*. Chip and Dan Heath take the concept and, well, run with it, like a massive, mounted mammal.

Documentary films can be tricky to fit into the hero's journey. They are often made of composite characters rather than a single protagonist, and

often you just don't know the ending when you begin. But this classic structure is satisfying, recognizable to all of us, if at a subconscious level, and as a writer it's smart to overlay this timeless approach whenever possible. We need more tools, though, in our storytelling toolkit.

The elephant and rider from *Switch* provide another model. With audiences in mind, think of the rider as "reason" and the elephant as "passion." The animal is motivated by instinct and emotion, but is skittish and short-term in its thinking. It's also huge, so cannot be moved, at least for long, by brute force. As a human, the rider is driven by logic and purpose, but can be immobilized by overthinking. To get the two advancing in unison toward the same goal, you need to appeal to both sides. *Switch* gives examples galore and practical advice on doing just that, guidance perfectly adaptable to social issue media-making.

To "direct the rider," show the bright spots and point to the destination. Our rational selves, our internal jockeys, love seeing solutions in action. If there's a recurring criticism of the documentary form, it's that films are too negative: earnest at the light end of the spectrum, and downright depressing at the other. "Why would I want to spend my scant leisure time in a doomsday mindset? Enough already with the 'world is coming to an end' story. Give me some hope!" Our films can do that.

I don't mean to suggest skirting issues or glossing over challenges. It's a question of weighting. Do you spend 80 percent of your screen time outlining the problem and then throw in a couple of solutions near the end, or do you reverse? Set up the problem and devote the bulk of your storytelling to a positive vision of change taking place. Bright spots are demonstrable instances of things working. When you point to a rosier future, and even script some of the critical steps en route, you direct our inner rider. There's a reduced risk of "analysis paralysis" when we see where we're headed and grasp how we might get there.

To "motivate the elephant," play to feelings, plus break things down into bite-sized pieces. Our intuitive selves are easily agitated by an issue that is too enormous. *What can I possibly do about that? I'm just one person.* When overwhelmed, we'd rather simply graze on the grass in our own backyards and live in the moment. But show us something a little smaller to do and we just might take action. Change a light bulb, sign a petition, help a stranger, give a can of soup to the food bank. That first step leads to the next and before you know it, we're galloping across the savannah. (Do elephants even gallop?)

In the chapters ahead, we talk about simplicity and emotion as two key story ingredients. Our inner elephant needs to *feel* before it'll move. It's not enough to simply know on an intellectual level that change is required,

that we have to alter our course and begin forging a new track. That's hard work. A taut pulling of the reins or a kick to our side might stimulate some movement short term, but to affect lasting behavioral changes, our heartstrings need tugging. In media-making, this means identification with key characters who have the courage to share their personal stories with vulnerability.

Switch also highlights the importance of shaping the path, for both the rider and the elephant. How can you make change easy, make doing the right thing the obvious choice? Sometimes what's needed is just a subtle tweak in the environment. The colorful boxes and bags we use for recycling, the "Best Choice" labels on sustainable seafood, the donation bins at the supermarket checkout, these are all no-brainer initiatives. The path has been paved. Our rider has clear directions and our elephant is not spooked. It's simple. Consider the calls-to-action in your own work. Do they shape the path, while inviting the masses to ride together?

The power of groups is the last great nugget in the Heaths' book. "When you are leading an Elephant on an unfamiliar path, chances are it's going to follow the herd."[3] If you can rally a herd, behavior change will spread through its members. It's contagious! People can be both shamed and inspired by the crowd around us. We want to belong. We feel our strength in numbers. Think about the goose bumps when a full theater rises to its feet for a standing ovation, or the warm fuzzies when a neighborhood gets together for a community clean-up, or the fierce pride when a group of activists takes a stand for its beliefs. This is the herd, charging together to bring about positive social change.

Whatever stage you are in with your media-making, you'll benefit from highlighting the bright spots, amplifying the emotion, and inspiring a desire in your audience to become a part of something greater than themselves. Whether you are rehearsing an elevator pitch, writing a treatment, structuring an edit, recording a narration or strategizing a campaign, these techniques will strengthen your storytelling. Though this book is documentary-centric, such an approach is applicable to all genres.

Grab your hero and send them on a journey: a determined rider jockeying a motivated elephant.

Motivation
Why Use Art to Make Change?

Which came first, the artist or the activist? The media-maker or the movement builder? The creator or the change agent? Some of us will say we're "all of the above." Or a blend. Or that it might depend on the day of the week. I have pals who are all about impact and see media as a means to an end. Others have cultural expression in their blood and feel it's a bonus when a project also makes a difference. Some float between these categories. Or refuse to be labeled at all. This book is for all of us—anyone who wants to spark media for social change.

When I was producing at the NFB I called myself a "serial activist." Full-length documentaries take a long time to produce. We might greenlight a project for development and four years later be in the darkened theater for the festival premiere. In the meantime, I'd learn so much about the issue at the heart of the film. From the research to the characters to the filmmakers and organizations attached to the related subject matter. It's like doing a mini-masters degree on a specific topic. Juggling a slate of concurrent projects means life as a documentary producer is akin to being a perpetual student. Perfect.

For me, it was media first and social impact second. I did forays into visual effects, corporate video, advertising, non-fiction TV, music videos,

In *Making Waves: A Guide to Cultural Strategy*, The Culture Group asserts that it's often our artists who are brave enough to challenge the status quo. They are essential to the fabric of our society because their voices are unique and their work inspirational.

and animation. But the satisfaction of editing my first documentary when I was in my early 20s stayed with me. A canvas bag of videotapes (Hi-8!) was dropped off and I just knew that inside was a story, one that had to be teased out before making a difference in this world. That film was about the ecological aftereffects of the Gulf War and I felt its significance. I set to work on *Eco War* (director: Will Thomas). Although it was years before making impact media was to be my full-time profession, I'd been bitten.

Social change happens through rallies, marches, lobbying, policy reform, strikes, and the brave personal conviction of someone willing to put their life on the line for what they believe in. It also happens through culture. Why use art to make social change? Because it works.

In their report *Making Waves: A Guide to Cultural Strategy*, The Culture Group asserts that it's often our artists who are brave enough to challenge the status quo. They are essential to the fabric of our society because their voices are unique and their work inspirational. Cultural change precedes social change and so it should be supported.

> Culture reaches everybody in one way or another. In today's world, culture encompasses a huge range of activities and values—and thus brings huge opportunities for winning hearts and minds. Culture is too potent a force to go unorganized and be allowed to slip through the cracks between arts funding and social justice funding.[4]

The report's excellent examples range from civil rights to smoking, to marriage equality, to the Vietnam War, and in each they chart a timeline of political events set against cultural milestones. Think "I Have a Dream," "Black is Beautiful," "Yes We Can," and #OccupyWallStreet.

Here's an abridged version of The Culture Group's summary of what *art is*:

- **Emotional:** Art connects with people's emotions and opens them up to new possibilities.
- **Visionary:** Art can help make goals once regarded as impossible suddenly appear concrete, achievable, even inevitable.
- **Systemic:** Art doesn't just ask for incremental reforms or seek to change what is "politically feasible," it often challenges systems of power at the most fundamental level.
- **Popular:** Art can make complex policy ideas or reams of incomprehensible data suddenly accessible and easy to understand.
- **Bold:** Art isn't about caution. It tends toward the bold, the courageous, and the outrageous.[5]

The best documentary films incorporate these principles. They touch, inform, and surprise audiences. In fact, there is overlap galore in the criteria describing art above and our collection of key story ingredients to follow.

In this book we'll review **narrative arc, originality, emotion, immediacy, simplicity, and access.** These are all tools in the quest for compelling storytelling: media that's memorable and impactful, created by artists who are **motivated** *to* generate positive change with their work.

Worksheet 1—Your Motivation

Warming you up:
Where are you on the spectrum from artist (1) to activist (10)?

What do you most appreciate about the power of cultural products? (place in order)
Art is:
_____ emotional—touches people
_____ educational—helps people understand
_____ provocative—makes people think differently
_____ inspirational—makes people want to act
_____ visionary—gives people a glimpse of the future
_____ other? _____

What are your primary motivators as a media-maker? (place in order)
_____ creative innovation
_____ artistic recognition
_____ personally cathartic
_____ earn a living
_____ career stepping stone
_____ working in a team
_____ awareness-raising
_____ social change
_____ other? _____

How have your motivations changed over the years?

Name a project you admire for its creative excellence.

Name a project you admire for its social impact.

Name a project of *yours* that's mostly driven by its creative form.

Name a project of *yours* that's mostly driven content.

Your project:

Title:

Genre:

Stage:

Consider the following regarding the social issue(s) at the core of your project:

- **Bright spots:** How are you giving a picture of solutions in action?

- **The destination:** How are you pointing the way toward a better future?

- **Emotional storylines:** How are you engaging through feelings?

- **Manageable actions:** How are you making new behaviors bite-sized?

- **The herd:** How are you appealing to the wish to belong to something greater?

Producer's Journal

(Please note that the following chapter as well as the "Producer's Journals" in the Money and Impact sections were recreated from my memory and notebooks. Some of the dates might not be spot on, but each of the stories indeed unfolded as mapped out.)

NARRATIVE ARC (STORY INGREDIENT 1)
Being Caribou (Karsten Heuer & Leanne Allison)

November 2002: Diana Wilson was in the office today. She pitched a project about this couple following a caribou herd on its annual migration. On foot. For months. She figures the National Film Board is exactly the right partner for this project. It's a pair of intrepid Albertan newlyweds, about to embark on a major adventure, in order to draw attention to an environmental threat. There's oil and gas drilling being proposed in the Arctic National Wildlife Refuge (ANWR). The area on the Canadian side of the border is well protected by law, but the Americans are considering reopening the territory. To see the possible effects on wildlife this couple plans to "be caribou." For months. Oh yeah, I already said that. Crazy idea, can't really see it flying.

January 2003: Just finished reading *Walking the Big Wild*. In fact, couldn't put it down. Its author, Karsten Heuer, is the guy Diana wants to feature in her film. In the book he shares the story of how he and his now wife, Leanne Allison, fell in love while expedition partners on a Y2Y hike. That means "Yosemite to Yukon," and yes, Karsten completed that journey on foot a couple of years ago. Took months. He wanted to see for himself how well connected the wildlife corridors are, those linkages that allow animals to pass between major tracts of protected land.

OK, so these two are serious. They know what they are doing in the outdoors, are clearly dedicated activists, plus he can spin a good yarn. But what about her? Diana has suggested Leanne co-direct, considering Diana herself won't be on the journey. But what's she done before? I scoured the proposal and documentation and bios and all I can see is a one-week course at the Gulf Island Film and Television School. Oh my.

March 2003: Our programming committee met today. I brought up the *Being Caribou* project to my colleagues. Should we consider this film? Unproven team with a super ambitious plan. Short development period too because they're leaving in just a few weeks. Right now, Leanne and Karsten are putting together food caches, pouring over maps, getting gear, and making connections in the remote northern community they'll leave from. In other words, this trip happens regardless. If we don't come on board as a producer on the film, they're following the migration anyway. As activists. And storytellers. No matter what, there'll be a

camera documenting their journey to the best of their ability. The question is, will they have enough support, creatively and financially? If the NFB greenlights the project, it'll open doors, plus give them some money they could really use right now.

I feel mixed. I haven't even *met* this couple yet and they're soon to leave. Diana is here though and she's got a good plan about how we'll stay in contact, look at material that'll be shipped out periodically, send creative notes and feedback, help with some ground logistics as they go. I don't know. To go straight into a full-on production agreement just feels risky. So many unknowns. I'll offer them a small development deal. That'll at least get us in a contractual relationship, and put a few bucks in their bank. Not such a gamble. And we'll get to help shape the story as it unfolds.

May 2003: Leanne and Karsten have been gone for seven weeks now. We got a dispatch from the field today, through Diana. Some notes, photos and a bit of tape. Leanne looking into the lens, running fingers through her matted blonde curls: "40 days, no wash." Diana's also communicated with them by satellite phone. So far, so good. They waited longer in Old Crow, Yukon, before setting out than they'd hoped. The caribou hadn't passed yet. That's one of the challenges of *being caribou*, you move on their timelines, at their pace, not according to a carefully prepared production schedule. Diana suggests Leanne shoot herself more, make the material as personal as possible.

July 2003: That crazy Canuck couple have made it to the calving grounds on the coastal plain of the Beaufort Sea. They're there! 123,000 caribou in this herd. Must be magical ...

Now ... months more foot travel facing them as they follow the *return* migration.

September 2003: So Leanne and Karsten are safely back. 1500 kilometers later. That's almost a thousand miles. This week they're getting ready to head to Washington DC. While it's still so fresh, they want to bring the story of the caribou migration to American politicians. In all its majesty—and misery—their first-hand account. People are deciding the fate of their precious calving grounds and it's urgent.

Today Diana brought in dubs of key sequences. Oh. My. Gawd. I had to lift my jaw from the floor. I grabbed a couple of co-workers and we crowded around the screen in the boardroom. I was grinning from the awesomeness. Such a range. From grand sweeping vistas, to the most intimate moments in the tent—it's all so beautiful. Diana directed them well from afar.

Believe it or not they spent 10 days captive in the tent with birthing happening all around them. Didn't want to spook the mamas, so they literally had to pee in a bottle and at night Karsten would shimmy out on his belly to dump that and get them fresh water. They spoke only in whispers. And captured it all on film. Riveting.

They brought a George Bush figurine and when hiking would hold it up in the frame every now and then, like a voodoo doll. "See, look George. Like, as if these animals don't already have enough challenges facing them without finding drilling rigs in their calving grounds." A bit of comic relief.

And the two-shots. You have to stop and remind yourself that for almost all of the journey, it was just the two of them. Leanne would take off her backpack, set up the tripod, hit record, pack back on, run ahead to join Karsten, and they'd slowly hike (or ski) across the frame. Then off with the pack, run back, and retrieve. And repeat. Again and again. For someone with so little training, this gal has an eye and an instinct that's extraordinary. As a producer, I'm giddy.

October 2003: I finally met the dynamic duo today. Karsten looks like the outdoorsman you see on screen, but Leanne is somehow smaller than I expected. Wiry and strong though, with clear, confident eyes. Diana was in too, and we're negotiating our deal. Considering they basically shot the entire film while on a small research and development budget, they effectively own the rights to the material. But now I want to bring this into the NFB as a full in-house production.

Wish I could say I knew from the get-go how successful this expedition would be, that they'd actually make it, and get enough material to cut an outstanding film. Truth is I was skeptical. Now that I've seen footage, I can totally

picture the finished project and I'm hungry to be a part of it. No doubt they've demonstrated the visual and narrative potential.

It was a good meeting today. Looks promising that we'll be able to back-pay the directors, license the footage and put together the resources for a solid post-production team. I'm keen to see this film reach its full potential.

March 2004: Janice Brown is an editor extraordinaire. Just screened a first assembly of *Being Caribou*. Much to be learned here about **narrative arc**. This is a journey film, with a clear beginning, middle and end. An activist couple on a most unusual honeymoon. The motivations are clearly articulated, the obstacles constant (grizzlies, river crossings, fatigue, hunger, black flies the size of small birds), and the villain well represented.

We've structured it with very short sections at the top and tail that give some exposition on the issue. A few minutes in the intro to set up the stakes: this is what we're up against. And then a few minutes at the end when they go to DC and basically (tragically) their story gets little attention. The rest is all journey. A wildlife adventure film, but packing a political punch just under the surface. It was a pleasure to direct Leanne in the narration. Her gentle voice comes off like a confidante letting you in on her private diary. You lean in.

June 2004: *Being Caribou* is done. Color corrected, titles designed, music composed, sound mixed. Can't wait to introduce it to the world.

August 2004: I'm in DC for a major public screening of *Being Caribou*. The Alaska Wilderness League has adopted the film like it's a gift from above. Just the tool they've been waiting for. The message is so strong and on target with their efforts, but delivered in a way that makes it accessible to mainstream audiences. People, beyond the choir, want to watch it for the pure story: this crazy and beautiful and political and spiritual adventure. They are preparing to send one copy to each US Senator along with a coffee table book about ANWR. They're also making plans for a Day of Action, including a "living room screening series," with letter writing and advocacy kits for hosts.

September 2004: CBC's *The Nature of Things* has just licensed *Being Caribou*. Instead of cutting the feature-length film down to fit their TV slot, they'll break it into two parts, and do some additional shooting. Iconic host Dr. David Suzuki will interview Leanne and Karsten, going deeper into some of the biology and ecology behind the story. This is great news. It'll bring thousands of eyeballs to the project.

October 2004: Tonight I was on stage at the Vancouver International Film Festival accepting the Audience Choice award for Best Canadian Film. *Being Caribou* won! Not just best "documentary," but most popular Canadian film, even among all the features. Such a bummer that Leanne and Karsten were not there tonight with me and Diana. But good enough excuse. This very night Leanne was in labor herself, about to give birth to their first child! Their very own little calf …

Story Ingredient 2— Originality

Each main section of this book, story, money, and impact, contains conversations with five industry leaders. Their full biographies can be found in **Appendix 3**. These are our firestarters, our sages, and our mentors. Imagine them sitting on a log, bright stars above, flickers and shadows from the flames dancing across their faces. They lean forward and in calm, confident voices share their wisdom.

Some words of introduction are first offered about each, plus a brief description of a film they mention during our campfire chat. After they depart, I reflect on their words and further draw out one of their central ideas. Enjoy …

> So many advocacy pieces only see their own somewhat self-righteous point of view, and I think that can make for very dull and unconvincing films.
> MARK ACHBAR

The Firestarter—Mark Achbar, Big Picture Media Corporation

Mark is president of Vancouver-based Big Picture Media Corporation and Invisible Hand Productions Inc. that develop, produce, and co-produce feature documentaries for theatrical release, TV broadcast, and home and institutional distribution media.

THE FLAME—*THE CORPORATION*

Directed by Mark Achbar and Jennifer Abbott, 2003, Canada

"Provoking, witty, stylish and sweepingly informative, *The Corporation* explores the nature and spectacular rise of the dominant institution of our time. Part film and part movement, *The Corporation* is transforming audiences and dazzling critics with its insightful and compelling analysis. Taking its status as a legal "person" to the logical conclusion, the film puts the corporation on the psychiatrist's couch to ask "What kind of person is it?" *The Corporation* includes interviews with 40 corporate insiders and critics— including Noam Chomsky, Naomi Klein, Milton Friedman, Howard Zinn, Vandana Shiva and Michael Moore—plus true confessions, case studies and strategies for change …"[6]

The Campfire Convo

Tracey: *Both as a filmmaker and then film financier you have thought a lot about the elements of story. What to you are essential story ingredients for documentaries?*

Mark: I ask questions. Is it novel? Are you telling me something I don't already know? I'm always grateful for that. Are you going to tell it in a *way* that's novel? Are you going to advance the form? Is it well-written? A surprising number of proposals are dull, and you wonder how are they going to make it. Why did they think I'm going to find this interesting?

Do they show me something in a way that I hadn't thought of it before? And are they considerate of the audience? By that I mean, if they're introducing something new, or a new set of ideas or a new analysis, are they presenting it in a way that somebody else hasn't? That they're not speaking to the converted as it were, but that they can put themselves in the shoes of somebody who is intelligent, but possibly ignorant of the story or the set of facts that they want to convey. That they're not speaking in jargon, for insiders.

I also really appreciate, especially when something is an advocacy piece, that it's not completely one-sided. That the filmmaker is able to step over the fence and actually talk to the people, or at least talk about the phenomenon from the point of view that they're opposing. That's where it gets interesting. So many advocacy pieces only see their own somewhat self-righteous point of view, and I think that can make for very dull and unconvincing films.

Tracey: *Do you have an example from your own work?*

Mark: In *The Corporation* we could have criticized big corporations and their CEOs from a distance, but we chose instead to try to talk to them, and talk to

figures who represent the point of views that we are being critical of, like Milton Friedman. Because Joel Bakan, who wrote the book on which the film is based, because he is an academic himself and a law professor, that gave us a certain credibility going in to talk to figures like Milton Friedman.

Once we had a couple of those interviews under our belt, it opened the doors to other CEOs. Our associate producer presented the film to these people and they didn't want to be left out by the time she was finished with them. That made for a so much more interesting and credible film because we also got very highly placed businesspeople to be critical of the corporate form themselves, and talk about their own frustrations with it. That's where it gets really interesting, when they can talk about the challenges of having your own personal values at odds, sometimes, with the imperatives of putting profit before everything else.

Tracey: *How did you manage the story structuring process in* **The Corporation?**

Mark: I was working with a very structured thinker, and that's Joel Bakan, who wrote the film and the companion book. He developed an outline, which I incorporated into a huge story choice spreadsheet. I called it a Story Evaluation Grid.

Let's see, it's 170 lines by about a 100 columns wide. And going down the side were various points and topics that we wanted to address, in a logical order. Across the top in the columns were various stories that we'd pulled from various newspapers and from other research. Where they intersected I would rate them. I had a criterion for each story in terms of what the potential was: Strong Insider Interviews, Strong Critic Interviews, Rich Audio, Revealing Engaging Archival Footage, Revealing News Footage, What a Corporation Says vs. What It Does, Easy-to-Tell Narrative. Would the story engender empathy with corporate victims or would it engender empathy with corporate insiders? Would it engender outrage at corporate injustice?

Tracey: *In some ways the approach is conventional—talking heads, archival footage, and some scenes—but with the device of the "sociopath" it becomes so much more than that. What other factors contributed to its success?*

Mark: Partly it was good timing, choosing the topic in the first place as something so utterly ubiquitous that hadn't really been talked about in this way before.

But a main aspect is Joel's brilliant analysis. The use of metaphor in trying to define the thing, setting up that idea and playing with it. There's a playfulness to the film in the way it handles interview subjects. It's a little bit irreverent, especially starting off with Ira Jackson (Director of the Kennedy School at Harvard's Center for Business and Government) waxing poetic about the nature of corporations and the good that they do in the world, and then he says, OK, guys, enough bullshit. And that really sets the tone, got people's attention.

We also had the luxury of time. I was terribly inefficient in the process of doing this. I did research interviews, went to conferences. It's like I was casting the film, and I'm sure there are ways that can be done more efficiently. But I actually shot

70 interviews and threw out 30. Those were full-on interviews, all the research and travel and everything. It was really only when people sit down in front of the camera, that you find out whether they're really great storytellers.

Tracey: *What do feel the impact has been on our society having* The Corporation *out there in the world for the last 10 years?*

Mark: Well, you can't take credit for too much. But having said that, I don't think there were very many people out there in the streets in the Occupy movement, who wouldn't have seen this film. It's a little hard to verify, but it likely informed them at some point.

There are a lot of municipal or regional groups that are trying to assert their authority over corporations. People are trying to strip them of the rights that they've accumulated as so-called "persons under the law." That little trick of legislation has given corporations this absurd roster of rights, and once people find out, they get really upset, because it has very dire consequences in the real world.

But I take greatest pride in seeing the film used in business schools, which I'm not sure I could've predicted at the beginning. I thought our critique was too harsh, too radical for that. It is being widely used to teach MBA students. In fact, Dr. Tima Bansal, an MBA professor at the Ivey Business School in Canada, created a curriculum specifically to teach students using the film. She did a shortened version of it and made 5 modules and discussion topics. When it becomes a part of a core institutional curriculum, that's amazing. That's such a feather in our cap, that it wasn't constructed in such a way that's so offensive to people with a business mindset. They can still hear the critique and try to deal with it in some way.

Tracey: *How has the film lived up to your goals around social change?*

Mark: I can't tell you the number of people who have told me the film changed their life. It's changed the course of their studies, it's changed the course of their careers, it's changed the way they see the world. And that is constant. It's an awesome responsibility that one feels. You feel like, well, shit, I sure hope I got it right, because you don't want to send people in the wrong direction!

The Spark—Originality

To stand out your film needs to be original. Unique. Novel. Innovative. You've heard all these words and understand this is your job, yet I appreciate that it's hard to do. Many filmmakers describe in their early proposals the intention to be original, without always being clear about how they'll pull it off. "This film will provide a unique view on a universal issue." "This story will unfold

in a surprising and dramatic manner." "This documentary will delight audiences with its innovative approach." These are excellent ambitions. Now, how to deliver?

Mark Achbar asks whether he is being told something he didn't know. Has the director unearthed a character or a concept that's fresh? Or have they reframed it in a way that provokes a new perspective or deeper understanding?

When tackling a topic as potentially dull as a corporation, the filmmakers came up with a clever device. They structured the film around a psychiatrist's checklist. Is the modern corporation a psychopath? This framework provides an organizing principle for viewers, something to anchor us through the journey—important for a film that's nearly two and a half hours long! It also gives us welcome comic relief, as does the generous use of often hilarious archival films.

When my own job involved reading treatments and receiving pitches by the dozens, I'd often observe my body language. Am I leaning forward? Am I asking questions? Do I want to know more? As Mark says, am I hearing something new? And then for me, the real moment of truth: do I tell my friends or family about this idea *after* work, on my own time?

If a story is indeed original, then those you are pitching (be they potential funders, partners or crew) will be excited to share your concept with others. We live in a world that thrives on forwarding tidbits of originality. My own cred increases when I can offer my network something unexpected. "Hey, I met this filmmaker today. She was telling me the most amazing story about this couple. I've never heard anything quite like it. So poignant. You see, it all started when …"

A topic ripped out of the headlines rarely induces a heart-race-increase type of reaction. Any of us can scan the news and offer up subject after subject that may make an informative enough documentary film. But to elicit lean-in enthusiasm, go further. Tell us something we've not heard before. Dig deep to ask the tough or sensitive questions. Or present a topic that's seemingly ordinary in a way that arouses an extraordinary response. Mark and the team did it with the diagnostic test in *The Corporation* and by approaching, and humanizing, subjects on all sides of the issue.

To achieve originality ask yourself:

- Is the *story new*?
- Is there a *juxtaposing viewpoint* that will surprise?

- Is there a *framing device* that will inspire a reevaluation of this topic?
- Is there a way *to mix genres* to serve the story even better?

You don't need to be tied to a traditional definition of documentary. As long as it helps convey your underlying message: incorporate drama; animation; interactivity; game play; spoken word; poetry; live musical accompaniment; comedy; or anything your imagination cooks up. Delight the senses. Stimulate the intellect. Find unexpected counterpoints. Smash stereotypes. It's a crowded media landscape, so to get noticed be **original**!

Story Ingredient 3—Emotion

The Firestarter—John Battsek, Passion Pictures

John runs Passion Pictures' film department and is one of the most successful and prolific feature documentary producers in the industry. In 1999, Battsek conceived and produced the Academy Award-winning *One Day in September* and he has since been responsible for over 30 high-profile feature documentaries, many of which have achieved international distribution.

It's about not being satisfied until you feel you've really really done everything you possibly can to make a story feel as powerful and as dramatic as possible.
JOHN BATTSEK

THE FLAME—*THE AGE OF STUPID*
Directed by Franny Armstrong, 2009, UK

"*The Age of Stupid* stars Oscar-nominated Pete Postlethwaite as a man living in the devastated future world of 2055, looking back at old footage from our time and asking: why didn't we stop climate change when we had the chance? …

Multi-award-winning documentary director Franny Armstrong and Oscar-winning producer John Battsek were early pioneers of the now ubiquitous "crowd-funding" model to finance the film. They then spent four years following seven real people's stories to be interweaved with Pete Postlethwaite's fictional character: an Indian entrepreneur struggling to start a new low-cost airline, a Shell employee in New Orleans who rescued more than 100 people during Hurricane Katrina, an 82-year-old French mountain guide watching his beloved glaciers melt, two Iraqi refugee children searching for their elder brother, a young woman living in desperate poverty in Nigeria's richest oil area and a windfarm developer in Britain battling the NIMBYs who don't want his turbines to spoil their view."[7]

The Campfire Convo

Tracey: *How do you decide on which projects to produce at Passion Pictures?*

John: We are always driven by story and character. It would be no different if it's a book, a film, a movie, a doc. Ultimately I need to feel like it is something that resonates on many levels with me, and thus has the potential to do so with as many people as possible in a deep, core profound way. Now on certain films, I may know from the get-go that they're not necessarily for a big audience, but it can still feel like a story that has enough going for it, enough power, enough universality. For instance, *Age of Stupid* was at that time particularly a huge subject, a huge topic. I knew that absolutely if we could get it right it was something that could play to a wide audience.

Tracey: *Can you tell me about the genesis of that film? Was the device fully developed or something that you worked on together?*

John: At that time I did glossy, expensive, high-end, cinematic docs. Franny, the director, did powerful, impactful, message ridden, low-fi, very, very good docs. I think she felt that the combination of the two styles might lend itself very well. Bring all her strengths to the importance of the story she wanted to tell and bring Passion's ability to make films feel like cinema. Now, the conceit was there from day one, it was her idea, that an archivist was going back in time to look at archives that showed that the environmental warning signs were there all along and that we ignored them. And actually even still on *Age of Stupid*, I know we struggled for a long time with the narrative to get it into a shape where it felt it could really grab an audience's attention and retain it.

Tracey: *What is that secret sauce that makes your films so suspenseful even though we might know how they're going to end?*

John: This is probably a frustrating answer, but I do think it's just storytelling. There is a way to shape these stories so that they become completely engaging, compelling, riveting … It takes a lot of commitment, passion, time, a lot of time. You need to be prepared to go the whole nine yards. And often people aren't. It's about not being satisfied until you feel you've really really

done everything you possibly can to make a story feel as powerful and as dramatic as possible.

Films are made in the editing room! You discover things you didn't know, you go down avenues you didn't realize existed. It's where you create the story, shape the story, develop the story.

In order to really engage and compel a person with a story it needs to work on multiple levels, have multiple layers. So, that's the other secret ingredient with a lot of these films. Yes, there is a core narrative going on the surface, but there's all sorts of other stuff at play that is touching the audience in different ways.

Tracey: *How would you talk to an emerging filmmaker about the importance of emotion and character development?*

John: If one is not able to engage an audience's emotions, then your film is failing and your audience will be leaving. I am sentimental. I like sentiment. I veer probably to the wrong side of wanting films to be as emotional as possible. It happens less and less with cinema that one sits in the theater and wants to cry or feels properly moved. I think more and more documentaries, telling real true stories, have a better shot at doing that for an audience. And so I am always very straight with filmmakers, directors, editors, about trying to maximize that impact in any film that is being made.

Tracey: *How do you approach funders?*

John: If you are making a film that does align itself naturally with philanthropists or someone who is particularly keen on financing that subject, well then that's an obvious way to go. The way we get people to invest in our films is that we convince them that this is an important story and an amazing story and we are going to do a great job of telling it. Ultimately, whether that is a philanthropist or a broadcaster, it boils down to the same thing. I still need to find the people for whom that story can really play in order to be able to raise the money and if you look around, those people are out there.

I don't have any rules. It's on a per-project basis. Like, if there are equity people who are interested in putting money into films, we will pitch as hard as we can with whatever we feel strongest about and hope that they might be interested in investing. Occasionally they are. We've had that kind of money in a few of our films and I think more and more that is a likely route. We like to be straight up and realistic with investors as to what the risks are. And we never overpromise, in terms of returns. I feel like that is a foolish thing to be doing.

Tracey: *Are you staying up to date on all the tools that have been developing around impact measurement?*

John: I honestly can't be too preoccupied about the impact of our films because we're so busy trying to make the next one. Ultimately, all we can do is make the very, very best possible film and hope that it finds the widest audience and hold

our heads up if we feel that we've done that. Which for the most part, I think that we do with our films. And then later track what the impact was.

I mean if it (a call to action) comes with the project and it feels appropriate and is something we're passionate about—then great. But it is not a prerequisite. We just want stuff that inspires us and that feels like a great story.

The Spark—Emotion

 I love that John Battsek of Passion Pictures describes himself as "sentimental." He admits it almost sheepishly, like it's unbefitting a man of his professional stature. "I want my films to be as emotional as possible ..." he confesses. Is this a personal preference or a business strategy? Or both? His track record of producing wildly successful feature documentaries, like *Searching for Sugar Man, Project Nim,* and *Sergio,* suggest his instincts are spot on. Even when impact goals are not front and center, intimate storytelling lingers in the heart. Bring on the emotion!

What do you describe to others when you recount a powerful piece of art? Fact or feeling? While those can be intertwined, cultural products that touch us at our core are more memorable. The very primal act of crying, or laughing, or gasping out loud is evidence that we've been moved. The scene that brought us that emotion will be remembered, even viscerally. While names, dates, and data fade from our brain, sentiment is integrated at a deeper level.

People are naturally empathetic, in differing degrees, toward different subjects of affection. We have compassion for fellow humans, often more so for those who are vulnerable, like children, or elderly or marginalized people. Storytelling allows us a more intimate understanding of each other. Authenticity itself is stirring. It's a privilege to simply bear witness to a character opening him or herself up with honesty, whether in triumph or despair.

Animals and nature, especially when under threat, can capture our hearts. Think of the lengths activists will go to protect wildlife and the environment. They may be reacting in part to facts or science, but likely their instincts are driven by an emotional attachment. A compelling story or image can rub us raw, and motivate action.

For inspiration, take a journey through films mentioned in this book. But please be warned: meeting these characters may cause you to experience deep and memorable emotions.

- the filmmaker's mother with early onset Alzheimer's in *The Genius of Marian*;
- the mountain gorillas of Congo, and the park rangers literally dying to protect them, in *Virunga*;
- the female soldiers brave enough to expose military sexual assault in *The Invisible War*;
- the world-renowned scientist coming to terms with his family's wartime internment in *Force of Nature: The David Suzuki Movie*;
- the 25-year-old girl dying of Cystic Fibrosis who uses art, the internet, and her public profile to increase organ donation in *65_RedRoses*;
- and the late Pete Postlethwaite asking from a dystopian world in the year 2055 "why didn't we stop climate change when we had the chance?" The fictionalized Archivist's tone in *The Age of Stupid* is somber. "I'm looking through binoculars, observing people on a far off beach, running around in circles, fixated on the small area of sand under their feet, as a tsunami races toward the shore" ... Why indeed? We watch with both compassion and horror as the earth, its species, and our very civilization face destruction before our eyes.

To build emotion into your media project, consider these four words, in the acronym **PACT**.

- **Personal**: is the storytelling intimate?
- **Authentic**: is it honest?
- **Courageous**: is it brave?
- **Transformative**: is it transcendent?

Make a PACT with your subjects to build a level of trust together, so they may reveal their true nature. We feel emotion when we witness emotion. As a filmmaker seeking impact with your work, take the time needed to go deep with the people generous enough to give you their stories. And make a PACT with your audience. Be sure those watching can feel with certainty that you're sharing these stories in a context of caring and respect for those who told them. **Emotion** is memorable, an essential ingredient to create impactful storytelling.

Story Ingredient 4— Immediacy

The Firestarter—Elise Pearlstein, Participant Media

Elise is Senior Vice President, Documentary Films, at Participant Media, where she manages the company's slate of feature documentaries from development to release. Prior to joining as a full-time employee, Pearlstein produced four feature documentaries for Participant, including *Food, Inc.*, *State 194*, *Last Call at the Oasis*, and *Misconception*.

> The most interesting characters tend to be in the moment of something happening to them, not past tense. ELISE PEARLSTEIN

THE FLAME—*FOOD, INC.*

Directed by Robert Kenner, 2008, US

"In *Food, Inc.*, filmmaker Robert Kenner lifts the veil on our nation's food industry, exposing the highly mechanized underbelly that has been hidden from the American consumer with the consent of our government's regulatory agencies, USDA and FDA …

Featuring interviews with such experts as Eric Schlosser (*Fast Food Nation*), Michael Pollan (*The Omnivore's Dilemma, In Defense of Food: An Eater's Manifesto*) along with forward thinking social entrepreneurs like Stonyfield's Gary Hirshberg and Polyface Farms' Joel Salatin, *Food, Inc.* reveals surprising—and often shocking truths—about what we eat, how it's produced, who we have become as a nation and where we are going from here."[8]

The Campfire Convo

Tracey: *Please tell us about your position at Participant Media.*

Elise: My title is Senior Vice President, Documentary. I work closely with producers and filmmakers and try to share some of my experience of being in their shoes as they work with us.

One of the things that I experienced as a filmmaker working with Participant, and am now experiencing being inside, is just the appetite this company has for taking on riskier subjects. That allows us to make some amazing films that take on the powers that be. There's support here for that, which is pretty rare. And even though we're doing nonfiction cinema with our feature documentaries, we use the same tenets of drama, story and character as filmmakers do on the narrative side.

Tracey: *Is there one story element that for you is the most important?*

Elise: When I'm evaluating material, I'm looking at who the characters are and what they're engaged in. The most interesting characters tend to be in the moment of something happening to them, not past tense. Sometimes it can be really fascinating to explore recollections and memory, but there's nothing better than being able to film somebody in the midst of action.

CITIZENFOUR is a great example. Laura Poitras captured Edward Snowden while a historic moment unfolded in real time. It's an amazing story, amazing access, but just that process of being present to witness a person crossing over the threshold of something is incredible.

Even in *Food, Inc.* when we were looking for how to embody some of the ideas we wanted to explore through stories and characters, we were most compelled by people in the midst of some life moment. For instance Carol Morrison, the woman under pressure from the company to upgrade her chicken facility, was wrestling with her personal opposition to what she was being asked to do. She made an incredible character because she was in that moment. Same with Moe Parr, the seed cleaner who was being sued and didn't know what would happen next—his fate was in the balance.

When you find people who are willing to let you into their lives while they're going through moments that they don't know they will resolve—it's an incredible act of trust to let a filmmaker in. In terms of storytelling, it's powerful to be able to watch that transformation unfold on screen.

Tracey: *How does the immediacy of watching a character facing a moral dilemma effect social change?*

Elise: I think if it's a first-person story it should transcend the specificity of the individual and speak to some larger idea or some larger issue. Some really compelling stories don't offer a window into something greater. They just exist on their own merits and there's nothing wrong with that. But for our lens, when we're trying to help shine a light on pressing issues in the world, we're looking for a personal, emotional, specific story that can operate on a couple of levels. It needs to be dramatic and compelling in its own right, but speak to something larger that emerges. It's not something that you can force; it should be organic to the story.

Tracey: *What advice do you have for filmmakers about how to approach either conventional or alternative funders?*

Elise: I think that given the accessibility of technology today it definitely makes it easier if a filmmaker is coming to a funder with even a short sample to show, but also having done the work to know what story they want to tell, and that they have the right sources and access to tell that story. Access is a part of the equation that not everybody always thinks of. You can't pitch a story that you aren't certain you have the access to tell.

It's the responsibility of the filmmakers to really do their homework before they go to the funder, and also to know that you might have to go multiple times and not be discouraged. You have to navigate that line between persistence and annoyance.

Tracey: *What examples can you share about the positive power of media?*

Elise: *Food, Inc.* is probably the best example. The impact it had at the time it came out and the impact it continues to have really just blows me away. Just anecdotally, when I'm out and I meet people and I tell them that I was involved in the film, so many people say, "Oh my god, that changed my life!" or "My husband became a vegetarian!", whatever the case may be.

I get asked the question a lot personally and on panels—how do you do that, how do you make a *Food, Inc.* or *An Inconvenient Truth*? I think if everybody knew then every film would have that impact, but it's this kind of rare combination of great storytelling but also zeitgeist—hitting at the right moment. When it happens it's amazing.

Tracey: *What about tips for crafting calls to action?*

Elise: At Participant, filmmakers work with the social action team at different junctures to share what they know, but then also the social action team surveys the landscape and really tries to figure out what's actionable in the timeframe of the release.

Again *Food, Inc.* is a good example: the Farm Bill was a big part of the film and as filmmakers we thought it was really important to the social action around the

film, but the Farm Bill only comes up for review every four years and it had just been passed when *Food, Inc.* came out. So we walked in thinking everything has to be about the Farm Bill, and they said, well, that timing is not going to work. But the Child Nutrition Act was just coming up, and that looked at school lunches, and there was a way to apply some of the same ideas about food health and safety to that. It was very successful, this combination of drawing upon the themes of the film but connecting them to an actionable moment.

But for filmmakers and for us focusing on the storytelling, we're looking more at where you want the audience to end up emotionally. You want people to end up in a place where they feel compelled to do something instead of feeling disheartened. And then what they actually do is something that we'll work on with our colleagues and with experienced organizations already working on the issues.

Tracey: *Tell us about the way you work with filmmakers to pull out the best possible film.*

Elise: We try to really protect the process of filmmaking. Towards the end when we're working on the distribution and outreach for the film, we expand beyond our core group and involve marketing and social action, but during the filmmaking process we protect the filmmakers' creative process. I know from having been a filmmaker. You just don't get a sense of the other factors or pressures; you're just focused on making your film, figuring out how to tell the story in the most compelling way. I think that's the best way to do it. If you're in the process of making the film, you shouldn't be worrying too much about what the call to action is going to be. You have to get the story right first and then everything else follows.

The Spark—Immediacy

Imagine being on a bus. The woman behind you is telling her friend about a similar ride last month. She was taking the same route, when a teen boy ran in front of the bus trying to catch his dog, which had gotten off its leash. You lean in to hear better. What will happen next? She says the bus slammed on its brakes, she nearly flew from her seat and there was an awful thud. Who was it, you wonder? The kid, the pet? The woman then tells her friend that a good Samaritan jumped up and hollered "I'm a doctor, let me through!" OK, so this is an interesting story. Yet it's all in past tense. It's already happened. It's being described through the filter of memory. How riveting the story is will depend on the strength of the storyteller.

Now imagine being on a bus. A teen boy bolts in front. There's barking, screeching tires, gasping passengers. You are almost tossed from your seat. A woman rushes past. Did she say she's a doctor? You strain to see the

street. What is happening? And what will happen next? You are *in* it. The story is now, unfolding in real time. There's a sense of immediacy. Because these moments are revelatory of our humanity, they are gripping and instructive. What are these people going to do? What should I do? (Just to set your mind at ease, both the boy and the dog are alright today.)

In documentary film, there are few approaches quite so satisfying as present tense storytelling. Being in the now. However, like the pledge of originality from an earlier chapter, many filmmakers express an intent to follow an unfolding narrative, but fewer pull it off. *Cinéma vérité* (French for "truth") is generally understood to be filmmaking without artifice. *Encyclopaedia Britannica* defines it as showing people in "everyday situations with authentic dialogue and naturalness of action."

Countless treatments I've read claim the proposed film will have few, if any, sit-down interviews, favoring instead a "fly-on-the-wall" aesthetic. The goal is to let the story unfold chronologically, each sequence intact, like a dramatic feature film. They've identified a character poised to go through a transformative experience which they'll capture in present tense. And yet often that's not what ends up being delivered. Rather it's conventional interviews, with cutaways, edited thematically. Why the disconnect?

The truth is that *cinema vérité* is *hard*. Pure and simple. It's a challenge to pull off the immediacy of being in the now, even with the best of intentions. Filmmakers need three cards up their sleeves: time, trust, and luck.

Time: Do not underestimate the shooting ratio of a film that "simply" appears to be following events as they happen, with well-rounded, satisfying scenes. By contrast, scripted films are, well, just that, scripted. If you need a shot of the middle- aged man crying, the actor delivers the performance. In documentary you need to be shooting constantly in order to get those unscripted, and yet essential, moments. If you want to *see* how someone feels, rather than having them explain it, you have to be there to shoot the emotion on their face, the minute it's felt. This is time-consuming stuff. Such time requires commitment (which documentary directors seem to have in abundance) and resources (which are decidedly more scarce).

Trust: You need time also to generate trust. It's only in the upfront relationship-building that you can uncover the strongest potential storylines. What transformative experience might your character go through that will give your film an emotional and dramatic arc? Then for someone to let their guard down with a camera present, they need to both forget that it's there, and trust what you, as director, will do with the footage. Over time, you and any crew should fade into the background

and the subject should have faith that their story, with its moments of vulnerability, is in safe hands.

Luck: OK, we all know that luck is preparation meeting with opportunity. But as Elise Pearlstein pointed out with *CITIZENFOUR*, sometimes, if you are open to it and ready, the most extraordinary story can materialize. Edward Snowden reached out directly to Laura Poitras when he was preparing to come forward as a whistleblower. But he's a smart man, and that was no accident. She had already established herself as a credible and courageous storyteller. The resulting filmmaking style is equally brave. With intimacy and measured pacing, we are witness to an unprecedented historical play-by-play. Time, trust, and good luck.

This is not to say that films with "talking heads" cannot be compelling. Deconstruct more of the exemplary work of studios Participant Media and Passion Pictures to learn how suspense can be built into even archival-dependent narratives. *One Day in September* takes place during the Munich Olympics in 1972 and most of us know how that story ends. Yet, it's constructed, through brilliant writing and editing, in such a way as to put us at the edge of our seats.

Food, Inc. is an excellent case of a hybrid approach. Strong expert interviews give us the necessary facts, but still the filmmaker sought additional characters in the midst of moral dilemmas and difficult personal decisions. They are not going on solely about activities in the past, but rather allowing us inside the high stakes events of their current lives. As Elise says, their "fate was in the balance." Another example of impact filmmaking at its best, unfolding in present tense, the **immediacy** of being in the now.

Story Ingredient 5— Simplicity

The Firestarter—Louis Fox, with Free Range Studios

Louis is an author, strategist, puppeteer, and trained filmmaker dedicated to looking at the world as it truly is, while also envisioning it as it could be. Since co-founding the values-based communication firm, Free Range Studios, in 1999, he's created some of the most successful online "cause-marketing" campaigns of all time.

Yeah, it can be hard to get out of the couch potato mode on things. There is something about sitting back and receiving a program or a story. LOUIS FOX

THE FLAME—*THE STORY OF STUFF*

Directed by Louis Fox, 2007, US

"We have a problem with Stuff. We use too much, too much of it is toxic and we don't share it very well. But that's not the way things have to be. Together,

we can build a society based on better not more, sharing not selfishness, community not division.

The Story of Stuff, originally released in December 2007, is a 20-minute, fast-paced, fact-filled look at the underside of our production and consumption patterns. *The Story of Stuff* exposes the connections between a huge number of environmental and social issues, and calls us together to create a more sustainable and just world. It'll teach you something, it'll make you laugh …"[9]

The Campfire Convo

Tracey: *Though a co-founder, I understand you are no longer with Free Range Studios full time, yet have stayed integral to the* The Story of Stuff. *For me it's such an excellent example of simplifying complex ideas.*

Louis: Which is always what stories do; they're really useful for that. But for us that was the apex of taking something complicated and making it simple. It was a project that I wanted to do for a long time. I had this vague notion of something really black and white, really simple, but something that diagrams out to the ten-thousand-foot view. We'd never done anything like that.

After doing a whole bunch of zoomed-in, single issue-based pieces, I started to say, well, we're only going to get so far with that solution. You really need to pull back and see the big picture and take a systems-level perspective, which is what makes *The Story of Stuff* special in my mind. It's what triggered and grabbed my interest immediately.

Tracey: *Please tell us how the project began.*

Louis: I remember when Annie Leonard came through our door. She had been asked to do this by people on the funding side. She had this talk which ranged from half an hour to three hours. She really knows her topic. People loved her. They're like, *you have to get this online.* And Tides Foundation said, *We'll pay for it. Find out what it's going to cost. Go talk to these guys at Free Range, they're probably your best bet.*

So she walked in and did the talk for us. The presentation was an hour and change. She put up a piece of white butcher paper, and drew stick figures, like true stick figures. She drew the five stations of the materialist economy and then she just crossed things out as she went through and showed their destruction. It was a very simple version of what ended up being the movie.

We came up with a menu of options—how do you want us to do this? Do you want us to make just a nice video of you giving the talk? Or do you want us to work with you and develop this? How short do you want it to be, how truncated and compressed can it be? Do you want animation, do you want an interactive website? So we came up with these tiers of options for her and Tides to respond to. Luckily they took the high-end vision, which was an interactive website with a marriage of video and animation.

The first version of *The Story of Stuff* was a website that you could pause and click "for more information" because it was this expanding, telescoping platform. We

knew that even though we got it down to 20 minutes, it was a real gloss on many issues. So it was designed as an interactive piece originally, and then it became more video-based.

Tracey: *Yet even at 20 minutes, the linear piece totally works. It's what took off, right?*

Louis: Yeah, it can be hard to get out of the couch potato mode on things. There is something about sitting back and receiving a program or a story. I don't consider *The Story of Stuff* particularly **is** a story; it's the least story-like story that we've done. Annie's the main character and she was curious about this overly simple diagram. And then she figures there has to be more to it, that we've got to understand. *So I looked into it and I found out that this is not the whole story.*

You know, the word "story" is just thrown around. It's got several meanings and everyone just goes *yeah, story, very important.* But there are several completely different meanings of "story," as far as I'm concerned. I actually don't use the term that much because it's a little too broad for me and a lot of things get shoe-horned into it.

Tracey: *Do you have one main definition then for "story"?*

Louis: Well, usually there's a main character. We fixate on this human scale, point of focus. That character goes through some process of discovery, and comes out changed at the other end. We seem to be hardwired to follow information when it's packaged in this way, for safety perhaps, to understand how the world works. So we're just playing to our minds, which have evolved in this world of autonomous creatures with supposed free will, and they go through these adventures and they change.

Tracey: *How does this relate back to* The Story of Stuff?

Louis: Well, it's loose. It stretches the definition because it doesn't really have a proper main character. More like a narrator. And honestly, we didn't think of it as a story as we did it. We came up with the name at the very end. We were wondering, what's it going to be called?

I have a list somewhere of potential names and *The Story of Stuff* had a good alliteration to it. And you know, everyone wants to hear a story because we have really nice associations with the word "story." That's what children ask to listen to when they go to bed; they just love stories. So when someone says, *Oh, I'm gonna tell you a story*, it's a lot better than: *Here's a cogent systems analysis of the materials economy*! And "stuff" is a non-technical word; very unthreatening for a really incisive piece.

Tracey: *As a partner, did Tides get involved in the creative process, and was there a specific call to action?*

Louis: If I remember, there was a person from Tides Foundation who came to the shoot as we fine-tuned the language. So yes, they were consulted, because the really hard part was taking and reducing this beautiful but very long talk that she would give. Annie's a great public speaker. She can really tailor her talk to

49

the audience. She reads them, she knows who she's talking to and she picks the right examples. The talk would change considerably depending on what kind of activists she was speaking to.

So what we needed to do was to squish it down to 20 minutes and turn it into something that could reach *any* audience. Say you're a group of people fighting incinerators, or you're a group of people working on fair trade … we had to come up with a way to make it universal from the beginning, and also have an ending that was positive. A "this is just the beginning" kind of ending. That was a big challenge.

Tracey: *Was it a lot of work for the team to create all the partnerships for* The Story of Stuff?

Louis: Writing it was a process of painful decisions all the way. Who's going to get named, which issues are going to get named? All the issues are in that completely broad map. So who will get a nod in the video? And it was strategic. The outreach is one of the reasons the project did so well, because it wanted to serve many groups. Annie reached out far, she knew a lot of the people, all these heads of groups. She was part of the ongoing funding. She was able to do outreach before the movie came out and had people sending it around. That was critical.

The Spark—Simplicity

As clever as we humans are, I don't know about you, but I can only hold so much information in my brain at one time. "Sorry, RAM is near full," I utter when bogged down in trying to retain in my memory too many names or numbers or dates. You know what they say about being able to actively remember only seven items simultaneously. Or was it four? Oh, I forget. Too many details competing for space in my head.

We are also highly visual creatures. Our tendency to think in pictures leads to all those corporate or creative whiteboard brainstorming sessions. Diagrams and shapes and stick figures and colors and images, these stimulate our imaginations and help our minds process complex ideas. Stats vary, but say roughly two-thirds of us are considered visual learners, and only a small percentage kinaesthetic learners, those who absorb meaning most effectively through touch and movement.

Then ponder how much media is designed for that final third, the auditory learners. Of course, we each use all three styles, but if I'm predisposed to acquire information visually (which I am), then a dense narration script leaves me cold. Verbally articulated facts and figures flow right through me, especially if I've no breathing room for my brain to catch up and

compute. Equally problematic are complicated ideas expressed in multiple compound sentences. What do I do when faced with that? If it's not crucial to safety and well-being, well, I stop listening. Your audience may be doing the same.

How can media-makers avoid this risk of information overload?

- **Make the complex simple:** visualize it.
- **Make the universal specific:** personalize it.

Louis Fox shares valuable insights from his time at Free Range Studio. What became the ubiquitous *The Story of Stuff Project* and viral 20-minute video started like so many projects do, as an unwieldy beast. Here was a super-complicated, perfectly boring topic, falling squarely into the "people should know this" category. If this isn't clear to you already, please take note: people, as in our very own coveted audiences, will rarely watch something because they "should." Time is precious and there's an expectation to be entertained, as well as informed.

Boiling down Annie Leonard's long PowerPoint presentation into a snappier personal journey, set over simple animation, was brilliant. The complicated concepts she had to get across were hand-drawn in their barest form, easily digestible as non-threatening, visual imagery. Then naming it *The Story of Stuff* was the icing on the cake. After all, as Louis reminds us, "we have really nice associations with the word." Five years later the collection of short films has generated over 40 million views.

When I worked at the NFB, I was visited by a man who had co-founded an organization that creates networks of support around adults with disabilities who may outlive their parents. Planned Lifetime Advocacy Network (PLAN) was doing excellent work and this topic would be important to thousands of families. But at this meeting it was just that, a topic.

I gave Al Etmanski a few filmmakers' names and sure enough, some weeks later I was pitched a story by Force Four Productions, that began something like this: "Chris is in his 20s and like anyone his age, he wants to move out. His parents wish for that, too. But they have serious concerns. Chris has multiple disabilities and the intellectual capacity of a child …" The concept had been personalized. They'd made a universally critical and potentially complicated subject very specific. *The Ties That Bind* (director: John Ritchie), along with PLAN, went on to create a lasting impact in the disability community, thanks in part to its emotional intimacy and its **simplicity.**

Story Ingredient 6— Access

The Firestarter—Michelle van Beusekom, National Film Board of Canada

Michelle is the Executive Director, Programming and Production for English Language Production at the National Film Board—Canada's public producer and distributor. She oversees creative direction, operations, and finances for six production studios from coast to coast.

> Making a documentary can sometimes be a delicate balance between trying to cram too much information into the film and trying to tell a good story.
> MICHELLE VAN BEUSEKOM

THE FLAME—*WE WERE CHILDREN*

Directed by Tim Wolochatiuk, 2012, Canada (a co-production of NFB and Eagle Vision)

"In this feature film, the profound impact of the Canadian government's residential school system is conveyed through the eyes of two children who were forced to face hardships beyond their years. As young children, Lyna and Glen were taken

from their homes and placed in church-run boarding schools, where they suffered years of physical, sexual and emotional abuse, the effects of which persist in their adult lives. *We Were Children* gives voice to a national tragedy and demonstrates the incredible resilience of the human spirit." [10]

The Campfire Convo

Tracey: *What is the climate out there for independent documentary filmmakers?*

Michelle: One of the big problems is that the financing model for creative one-off documentaries here in Canada and internationally has undergone a monumental shift because of convergence and fragmentation. Most financing for docs is still tied to a broadcast license, but many broadcasters, for all kinds of reasons, have stepped away from one-off documentaries. It's an artisanal form of production; it's relatively expensive; it doesn't deliver the audiences that some other forms of TV do, like reality TV and others. And as broadcaster margins have become smaller, they've moved away from forms of production that they would have supported before when they had bigger profit margins.

As a result, it's become a lot harder for people to finance documentaries. It also means that with the slots that still exist, there's a lot more pressures to conform to formulaic ways of telling stories—to use a narrator or to make sure you're repeating things as you go into a commercial break. It's become much more formatted so that the filmmakers don't have the kinds of liberties they used to have. There are still important exceptions and key players who remain committed to supporting the creative documentary form, but there's no denying that the landscape is a lot tougher. New models of financing are emerging but they're still pretty nascent.

Tracey: *Given those challenges what story ingredients do you think directors should try to hold sacred?*

Michelle: What resonates most strongly with me is emotion. The documentary, well, all film is an emotional medium, and you really have to connect with people at that level. That's what draws them in and carries them through the story, and it's what makes them care. Sometimes documentary filmmakers have a tendency to privilege the issue over the story.

When someone is making a story about an issue that's very near and dear to their heart, they want people to understand the issue better, so they often want to share lots of information. Making a documentary can sometimes be a delicate balance between trying to cram too much information into the film and trying to tell a good story. Sometimes people fall on the side of too much information and then it can become a bit of a lecture, and it can be a little bit cold. It might communicate things that are really interesting for people who already have a developed awareness of the topic, but it's not necessarily going to pull in a new audience.

That's the key—to connect with people at an emotional level. That's what draws them in, and then ideally they'll become really interested, passionate, outraged, or whatever the desired range of emotions is about what they've just seen, and that sparks their interest. Then right away afterwards they're on Google trying

to find out more about that topic or about what they can do, and they're really inspired. But if it's just information, the risk is that it's not going to touch people in their hearts, and it's just not going to hold their attention and have an impact.

Tracey: *As somebody who reads a lot of proposals, could you share advice for filmmakers on how to best express their story intentions?*

Michelle: Again, I think it's important to remember there's a big difference between topic and story. I'm not a point person for proposals anymore but I've read many in my day and something I've seen a lot of is people proposing a topic, like "this is a project about tar sands and environmental impact," or "it's a story about a particular type of cancer and its effects." And that's a topic. It's often harder for people to describe what the story is they want to tell. So who is the subject, what happens to them? Even if it's an essay documentary there's still a subject. What's the arc and what's the journey that you're taking people on?

Tracey: *What can you say about the importance of access and framing?*

Michelle: Even though we live in a time where we're saturated in media, so many of the images that come to us via mainstream channels are about the big centers and communities. And that's all about the logic of the marketplace. For the economics to line up, people need to produce stories that buyers believe will connect to audiences widely, nationally and internationally; buyers are looking for things that are going to sell across multiple markets.

So anytime someone wants to tell a story about a small community or about a group or a person that's not well-known, often what they hear is *it's too niche* and *it's not gonna sell*. So stories about smaller or non-mainstream communities often have a harder time getting made. And it's so important for people to see their stories told in a thoughtful, professional, and polished manner. It has tremendous impact.

Tracey: *Can you give an example?*

Michelle: *We Were Children* was a co-production between NFB, Eagle Vision, and E1. It's a film about the residential schools issue and all the abuse suffered by children and families. The team had a lot of internal conversations about who we were making that film for. We thought, OK, we're making this feature film for non-aboriginal persons, people who, for whatever reason, have a bit of a block around the whole issue of residential schools. They say they don't understand why it's still an issue because it happened in the past.

And so the goal of it was to create an empathy and an understanding in non-aboriginal audiences, because we figured, well, aboriginal people know very well what happened, this story isn't primarily for them because they understand it already. And then we ended up entering into a partnership with the Truth and Reconciliation Commission, and that film was shown at their events, different events that they organized around the country. They had a national event in Montreal about a year ago, and I attended that. There were three screenings at nine in the morning—not a great time—and the room was full each morning, with about 300–350 people.

It was mainly an aboriginal audience, and it was truly one of the most moving things that I've seen. A lot of the people in the audience had gone through

55

residential schools themselves or they had parents or grandparents who had gone through it who hadn't really talked about their experiences and their families were dealing with powerful intergenerational legacy issues.

Tracey: *What kind of impact did the film have on the audience?*

After the film there were big discussions, very emotional, some people prefacing their comments by saying they were sharing certain things for the very first time, and how important it was to see their story told in that way. It's one of those things where something horrible can happen to you and then it feels like it's being ignored by society at large, and when you see it transformed into a film and presented on a public stage it can be very validating and empowering. It just gives you another anchor from which to say, *Yes, this happened to me, and it was so wrong, and it needs to be addressed.* Seeing people's responses was incredibly powerful.

So the lesson was that we thought we were making the film for audiences who didn't know much about residential schools. And while these audiences have connected with the film as well, it had particular and profound impact on aboriginal audiences.

The Spark—Access

We've touched on several essential story ingredients, like narrative arc, originality and emotion. But no story can be told without *access*. It's the entry point to everything. This may be one of the first questions you, as a filmmaker, will hear when pitching possible partners: "What kind of access have you got?" In other words, how are *you* uniquely positioned to tell this story?

Access can have many meanings:

- How much do you know that no one else does, a.k.a. the "scoop" test?
- How far will your character go in revealing their dark side, a.k.a. the "warts and all" test?
- How deeply have you searched for an untold story, a.k.a. the "amplifying marginalized voices" test?

In each instance, you also bring your own unique perspective to the telling. How are you, as a media maker, affected by the story and potentially affecting those who are sharing it? Impact filmmaking is not the same as traditional journalism. While no one wants to hear a director on a one-sided dogmatic rant, we do expect you'll bring your personal passions to the project. A point of view is allowable, even encouraged. It's why this genre is often referred to as POV or *auteur* (French for "author") filmmaking.

Find a topic—or better yet, a *story*—that speaks to your heart. Consider the privilege of your position and use it wisely. Through your skills and hard work, you have the power to expose and magnify issues in the lives of others, with a goal of effecting positive social change. What a gift! Consider also the commitment. Documentary filmmaking is a time-consuming and under-resourced field. As we say to newcomers, "You know this ain't no get-rich-quick scheme, right?"

Given these challenges, and knowing that you may be living with a subject for months or indeed years to come, choose carefully. What injustice irks you? What or who inspires you? And, back to the concept of access, what story might you be able to unearth that others cannot? These ideas often surface close to home, with a family member or even oneself. Or they may reveal themselves through a community you are a part of, or have been afforded access to. If it bubbles up from within your core, a tale that *needs* telling, there's a better chance you'll stick with it through the inevitable difficulties. There's also a better chance it will resonate with audiences, especially all those people who will identify with your characters, seeing themselves in your film.

Michelle van Beusekom tells us about the emotionally charged experience of witnessing a community seeing its painful story on the big screen for the first time. The access respectfully secured for *We Were Children* allowed for the deeply intimate storytelling. The fact it is a well-crafted and sensitively considered portrayal is further validating for the people at the center of this historical abuse. And while it is an important shared experience for those who personally identify, the attention to originality, emotion, and quality will ensure the film also travels more widely and has the impact intended.

Like the sexual assault survivors in *The Invisible War* or the people with disabilities in *Shameless: The ART of Disability* or the black youth in *American Promise*, the film subjects in *We Were Children* bare their souls for the camera. These filmmakers have certainly passed the "amplifying marginalized voices" test. They took the time, built the trust and secured the **access** needed to make films poised to change the world.

Producer's Memo

(Please note that as with the three "Producer's Journals," the "Producer's Memos" are recreated documents based on real encounters. They are included to serve as a summary of the preceding section, reviewing each of the main elements in the context of an actual project.)

**Summary of Story Ingredients—*Carts of Darkness*
(Director: Murray Siple)**

Fine Cut Screening

Hi Murray,

Great session yesterday, thank you. I'm pleased we stuck to our guns through the difficult decision of replacing the editor. I do know that you and the earlier guy were friends from the Whistler ski film community, but this here is just such a different type of storytelling. As you are now seeing, Michael Brockington is a master at pulling a strong

"it feels like freedom".

Carts Of Darkness

MURRAY SIPLE ... TRACEY FRIESEN ... MICHAEL BROCKINGTON ... CHRISTIAN BÉGIN ... KEVIN SHERT ... MIKE McKINLAY ... PAUL VANCE ... JAMIE MAHAFFEY ... RINA FRATICELLI ... BIG AL, FERDIE BOB, GEORDIE, LITTLE AL, MAX, BUCKLES ... SCOTT POMMER ... BLACK MOUNTAIN LADYHAWK, KETIVER BISON, ALAN BOYD ... A NATIONAL FILM BOARD PRODUCTION

narrative out of material that's quite diverse, like yours. Really great at rolling up his sleeves to find—or help you "rediscover"—the story.

There's still work to be done and I've notes to share, but first ... the NFB marketing department has been tweaking the synopsis for our "work in progress" web page. How do you feel about this:

"Murray Siple's feature-length documentary follows a group of homeless men who have combined bottle picking with the extreme sport of racing shopping carts down the steep hills of North Vancouver. This subculture shows that street life is much more than the stereotypes portrayed in mainstream media. The film takes a deep look into the lives of the men

who race carts, the adversity they face and the appeal of cart racing despite the risk."

Nowhere in here does it mention your disability. I can't decide if that's a mistake or brilliant. Your thoughts? In a way, the fact that you are quadriplegic and use a wheelchair is the basis for how this whole thing came about. You wouldn't have been sitting in your North Shore home dreaming of mountains and speed, both no longer easily accessible to you. And likewise, would Fergie and Big Al and Bob have even opened up to you, had you not all bonded as outsiders?

On the other hand, this is not a film about disability. You are in it and your mobility challenges motivated it to a certain extent, but it's a film about these characters. Their lives, their addictions, their crusade to collect bottles, and of course the thrill of their improvised sport! Maybe that synopsis combined with the right image, might do the trick. Open to any feedback you may have?

Now regarding the cut itself and the bigger picture it represents, I'm going to organize my notes below into the categories we reviewed back at the development stage. Remember how many hours we talked about "the point"?! Was this to be a film about poverty, or homelessness, or the environment, or disability, or an extreme sports mountain movie?

I was really trying to encourage you to choose, or at least prioritize, put one goal front and center. I have to say I'm starting to see how it can be "all of the above," at least to a certain extent. The recent inclusion of your scratch narration has been a big help …

Narrative arc: Well, you did name it after Conrad's *Hearts of Darkness*, so obviously story structure was on your mind. I'm happy with how the beginning and middle is shaping up. Not so sure about the end, but more on that below. Classic elements of the hero's journey at play. There's you, and your efforts to expand your physical range, exploring further than you have since you became quadriplegic. The obstacles on your path to returning to filmmaking keep surfacing. To overcome them, you will in fact need to finish this very film and release it successfully into the world. Do you think you are clear in the film yet about what you are learning in the process?

And then there are your characters, easily seen as a composite. They struggle for stability, sometimes even survival, and

the gift they bring back to our world is to provoke empathy. Each of their inciting incidents is different, of course. As yet a storyteller you've elected—at least so far—not to give the specifics of their personal backstory. It's an interesting decision, even brave. They are already well on their journey when we meet them, the darkness of their pasts merely hinted at.

Originality: There is little doubt in my mind that this film will stand out as unique. Back when you first pitched *Carts*, we felt its freshness. Wasn't totally sure which direction it would take, but knew there was a wealth of possibilities. I was curious, intrigued, wanted to know more.

This is one of those films ideas that you do find yourself repeating to others in your life. "So there's this group of men, some literally living in the woods in North Vancouver, others squatting in trailers or cycling through shelters. They make pretty decent money collecting empties, especially on garbage collection day. Some (not all, but some) then RACE shopping carts down the steep hills! It's a free and fun leisure activity. Are they environmentalists, or athletes, or a dangerous nuisance? Their story is told by a director who used to be a ski and snowboard filmmaker, but an accident left him in a wheelchair. Now he can't shoot in the mountains. But he CAN film these dudes racing past his house!"

Emotion: There will be tears. Not that that's a prerequisite, but still I'm pleased with the sentiment that's been captured and expressed. There are some truly intimate moments, like when one guy helps another through his alcohol issues, or when Fergie uses his socks as a pillow, sleeping for the first time in his entirely unfurnished public housing unit, or when Bob counts the number of his friends on one hand and declares himself blessed. At times I feel manipulated by the big personality of Big Al, but there are enough subtle and vulnerable moments captured visually to be reminded of the many masks he wears.

There's room, I think, to go deeper into the matter of transcendence. The plot has a fairly clear and linear path, but from an emotional perspective are we seeing enough character development, either in your subjects, or within yourself?

Immediacy: Gold stars here, Murray. Thank you for letting us hang out with this group of men over a period of time, in the

present tense. Their circumstances change over the months, in terms of where they live, how they make ends meet, what support structures are or are not in place. Your own story is introduced adeptly, just enough background to make sense of today, and then the balance unfolding in real time.

A criticism we may face is in some of the "staged" sequences. It's pretty clear that although they do authentically ride the hills for fun on their stolen carts, you've set up certain scenes. At least, I suppose, you are quite open about that very fact. Not hiding your presence or growing involvement in their lives. For instance, filming the actual choosing of a cart (with all the criteria around which is best) and then loading it into a truck (production vehicle?) and shuttling to the top of the road, before releasing it for the thrill ride in front of your cameras. Uh, yeah, we may have some explaining to do on that one! I'll get that sequence in front of our lawyers shortly …

Simplicity: Your topic is not complex, or in need of simplification. What you've done with this film is quite the opposite—to take big issues and make them accessible. You've put a very visible and real face on homelessness and on disability, giving audiences an entry point into other worlds. The themes behind *Carts* are universal, the storytelling has made them personal.

Access: I'm pretty convinced no one else could quite tell this story the same way. It's interesting to observe that your use of a wheelchair endears you to these men. Or at least you pose no threat. They are seen as the "other" in our society, when they are seen at all. Just like you. It's given you this unspoken bond, brothers living somehow on the edge, on the fringes of the mainstream. There they've been, existing in our midst, and yet it's an untold story. This films gives them a voice, just as it gives the "new you" one. A chance to express yourselves, share your worlds, and let us, the audience, come to understand your realities better. And the men open themselves up to you in a way that I just couldn't imagine they would, say, with me. You've certainly passed the "scoop" test, the "warts and all" test, and the "amplifying marginalized voices" test. Well done.

The bottom line is that *Carts of Darkness* is well poised to smash stereotypes. You see a person with a disability in action, making a movie, not referring too much to his impairment. And you view him differently, as a result. You see homeless

men in action, collecting empties and racing shopping carts, not referring too much to their poverty. And likewise, your perspective on them changes, too. It's unexpected, the approach to both these threads, so it has impact. You've always been pretty clear that this is not a film with a concrete call to action, beyond this highly intentional awareness-raising.

My main concern right now is polishing the writing of the narration (should we hire a script doctor?), and the ending. It's very real, that Fergie has returned to the streets after his short stint in subsidized housing, and that Big Al continues to struggle after getting out of jail, and that earlier one of your secondary characters even died. But what about you? As already noted, you are certainly a major voice in this movie, too. How have you changed, Murray? What's exactly is the emotional transformation that you've gone through? And how can we "show it, not tell it"? Might need to do yet one more shoot. Think there are a few bucks left in the piggy bank …

Thanks again to you and Michael for all your long days these last several weeks in the editing room. I'll keep working on securing clearances for some of the high-end local Indie music you've been cutting to and are now overly smitten with. (Ugh, fingers crossed.)

Warmly,

Tracey

Flash forward

Carts of Darkness was in fact produced by the National Film Board of Canada in 2008. It went on to play over 20 festivals (with a "Top 10 Must See" mention at Hot Docs), win a Leo Award for best documentary, have one of the highest doc ratings up to that date on Knowledge Network and become an NFB bestseller. The film has been used as a tool by diverse grass-roots organizations focused on positive social change around poverty, addiction, disability, ecology—and sport. Murray's post-injury filmmaking career was kickstarted by this project and he continues to create innovative work.

Spoiler alert: In the final scene, Murray gives over all of his trust to his new mates. He is placed in a shopping cart *himself* and as human cargo experiences the thrill of racing down a mountain highway!

Worksheet 2—Your Story

Warming you up

Name a documentary that adheres to the classic hero's journey.

Name an effective documentary that entirely eschews the hero's journey.

Name a documentary that unfolds in chronological order, present tense, real time.

Name an effective documentary that is mostly "talking heads," thematically edited.

Name a project of your own that started out with one storytelling approach and ending up with a different one.

Your project

Arc: Does your proposed project have a beginning, middle and end?

Map it:

1. Who and where?

Then one day (the inciting incident)_____

2. What problems, complications, and events unfold?

Then, at the bleakest moment, help arrived (the climax) _____

3. What's the resolution and lesson learned?

Originality—will your project stand out? Check all that apply, with a phrase to describe how.

_____unique access
_____rare information
_____artistic form
_____mix of genres
_____framing device
_____juxtaposition

_____point of view
_____untold story
_____other?_____

PACT: How will your characters reveal a story that is:
Personal and intimate?

Authentic and honest?

Courageous and brave?

Transformative?

If your story world is complex, how will you simplify it?

If you story is simple, how will you add layers of depth?

If your story is universal, how will you make it personal?

If your story is personal, how will you make it universal?

Money

Money is Wind—
Driven by Mission!

My book of inspiration that led off the "story" section was *Switch: Making Change When Change is Hard*. My trusty bright blue book # 2 has "Good Pitch (with a halo over the 'h') New York 2014" written on the front. [11] Really it's just a nicely designed catalogue for a recurring industry event, but to me it represents much more. I lose track of time buried in its pages.

This publication is a microcosm of the full ecosystem of documentary and outreach finance: the wind that fans the flames of social-issue filmmaking, breathing air—and therefore life—into critical projects. Like the upcoming **money** chapters, there is a broad range of sources represented: **foundations (and NGOs), impact investors, philanthropists, brands, and crowdfunding platforms.**

I first went to Good Pitch in 2012 in San Francisco and it was a revelation. Here was a physical manifestation of my own growing obsession, the connection of story, money, and impact. A group of like-minded souls assembled together in one venue, hurtling love and support and checks and resources toward high-impact documentary films.

I returned to the New York event a couple years later with a keen eye trained to behind-the-scenes. Seven projects were presented to over

If filmmakers have more partners, foundations have improved impact outcomes, and changemakers have increased access to relevant tools, we all benefit.

300 organizations and hundreds of thousands of dollars brought to the table (both cash and in-kind). How do I bottle up the spirit of this enterprise and bring it back to my talented, if increasingly strained, community in Canada? And how do I attract other sectors to come and play in the media space?

Good Pitch is a project of BRITDOC, in partnership with the Ford Foundation and the Sundance Institute's Documentary Film Program. Other supporters are Chicken & Egg Pictures, CrossCurrents Foundation, Fledgling Fund, Hartley Film Foundation, Impact Partners, and Wyncote Foundation. There are invite-only flagship events in major centers like London and New York. Good Pitch[2] satellite sessions have been hosted in Mumbai, Taipei, Buenos Aires, and South Africa, among others.

One of their iconic images is printed on the inside cover of my *Good Pitch Catalogue*. It's a jigsaw puzzle. At the center is a piece called "**Film**," and surrounding that are all of the entities that might partner with a project to ensure its completion, escalate its reach, or increase its success. The other puzzle pieces are: "**Foundations, Philanthropists, NGOs, Broadcasters, Campaigners, Brands, Policy Makers**, and **Media**."

What's atypical here, from the point of view of conventional public pitch fests, is the lack of prominence of broadcasters. The television market is represented by a handful of attendees, but largely this is a mission-driven collective, people whose primary motivator is the belief that media can create lasting impact on a societal level. And while on the surface Good Pitch is nurturing constellations of support around documentaries, its value extends beyond these select films. The outreach required to fill the room with credible stakeholders has the effect of building capacity within the larger philanthropic and NGO communities. New potential funders and activists are shown how they might deploy media to further their own goals.

The front half of my catalogue gives key information on the films being pitched to the table of nine people, strategically hand-picked for their aligned interests. Project synopsis, status, team, and current needs, it's all briefly outlined. But it's the last half of the little book that pulls my attention: the blue pages listing the participating organizations. Thousands of representatives from dozens of countries have attended Good Pitch events since its founding in 2008. Who is going to be here in New York? There are names, photos, titles, contact info, and importantly, blurbs about the organization's vision and their involvement in film. It's like a take-away print version of the best cocktail networking reception, ever. I'm one of the only Canadians.

Canada's philanthropic sector has not historically had a relationship with filmmakers. Some organizations commission media projects for specific

purposes, but there is no real pattern of granting to films, or more broadly engaging in media-making practices. The Canadian Income Tax Act is restrictive, but ironically this disconnect may also be due in part to a public subsidy system for cultural industries that had more or less worked. This can no longer be taken for granted, as governments everywhere tighten their belts.

The Documentary Australia Foundation (DAF) had to respond to a similarly restrictive legislative environment. With time, perseverance, and savvy counsel, they broke through to create a model for tax-deductible philanthropic dollars to be donated to pre-approved projects. DAF's triad is framed as filmmakers (story), grantmakers (money), and not-for profits (impact). Their robust web platform hosts the financial transactions and is chock-full of valuable educational resources for all three parties.

An FAQ section explains why this practice, as in Canada, had not been widespread:

> Foundations have not been made aware of the importance and effectiveness of documentary and Australian filmmakers have not highlighted the ways in which their aims intersect with those of many grantmakers. Local foundations have not been offered simple mechanisms for giving to documentary projects and filmmakers have not provided compelling educational and outreach strategies.

This points to a need to cross-pollinate and learn more about each other.

In 2014 Australia fanned the flames by holding its first Good Pitch[2] at the Sydney Opera House. It was a spectacular success. Spearheaded by Shark Island Institute, along with DAF and community partners, at this event more than a million dollars was committed and dozens of new partnerships ignited.

The benefits of Good Pitch to the documentary industry, the philanthropic community, and the charitable sector are similar: new collaborative relationships further the missions of each. If filmmakers have more partners, foundations have improved impact outcomes, and changemakers have increased access to relevant tools, we all benefit. Everybody in the pages of these special blue books and beyond wins.

Motivation—Who Will You Make Change With?

The cab pulls up to a lovely house on a hilly road in San Francisco, in the middle of a sunny afternoon. This is the location of a rough cut focus group screening about to get underway for the documentary *The Genius of Marian* (director: Banker White). As an investor in the film, Impact Partners (see Chapter 17) has put together the gathering at the home of one of their members, a co-founder of Chicken & Egg Pictures, which empowers women filmmakers. I am invited, a loose connection from up in Canada, because I am in town for Good Pitch and beginning to get acquainted with this network of social issue media supporters.

The living room is turned into a makeshift theater, with kitchen chairs pulled in and curtains drawn. In the dining room are canapés, sweets, and tea. I look around and wonder about the dozen or so people milling about. Who are they and what has landed them in this world? What motivates them to give money to these projects? As I fill my plate, I smile at the man next to me.

After an ice-breaker, I ask: "So you've invested money in this film?"
"Yeah."
"And you don't necessarily expect to see it again?"

This is a form of philanthropy that's hands-on. I meet people who were semi-retired and yet vital and intelligent with much to contribute, beyond resources. They have ideas and contacts, in both business and cultural spheres.

"Well … perhaps … we'll see …"

"Why do you do it?"

"See that young woman over there, that's my daughter. She's always wanted to be in media …"

And so it begins. Perhaps it's obvious to others, but for me this is an "aha moment." The start of my education around money and motivation. Learning that there are multiple, complex, nuanced, purposeful, and sometimes even irrational reasons why people will part with their dollars.

This partner is interested in the documentary industry at a higher level, through a passion of his daughter's. By becoming involved as a funder in this film, they both have the opportunity to learn more. They get to read treatments, review budgets, scan schedules and crew lists, and come to feedback screenings like this one. It's one way of looking under the curtain of the filmmaking process, without registering for film school.

Impact Partners holds its Annual General Meeting during the Sundance Film Festival, so the table of investors get to meet in and around one of the world's premiere events for independent film. There's not only the potential for financial and social returns with this membership, but red carpets and receptions and your name in the credits. This is a vibrant and dynamic community to be a part of, particularly motivating when the films on the roster have a social change vision. Most members invest, but some also donate either personally or through foundations they may be affiliated with.

I learn that others are excited to have the chance to meet filmmakers, to learn about *their* motivations and creative lives and sources of artistic inspiration. It's deeply rewarding to deconstruct a film that is still in process, directly with its creator. Working through what's flagging, what's singing, what's boring, what's riveting; offering suggestions and then later seeing some of those ideas attempted or even implemented. So many people are capable of adding such value, but simply not in a convenient position to do so. Directors in the thick of the weeds need to widen the circle to include fresh eyes. Such input can be precious for the filmmaker and gratifying for the person offering it.

This is a form of philanthropy that's hands-on. I meet people who are semi-retired and yet vital and intelligent with much to contribute, beyond resources. They have ideas and contacts, in both business and cultural spheres. They say they're not into simply writing checks for galas and fundraisers and non-profits anymore, but want to be involved in projects in a more meaningful way.

Others are dedicated to the specific causes highlighted in the films being produced. They understand the power of media to spark change and would

prefer to give their financial support to a film that will have a multiplier effect, increasing awareness through reach, than straight to a charity. Whether the topic is climate change, or criminal justice reform, or gender equity, these people are driven by the need to have direct impact. Concern about the condition of our world is felt by citizens of all socioeconomic levels and political stripes. We're all touched by a deteriorating environment and human rights abuses.

On this day, the documentary is about Alzheimer's disease, a very personal story based on the filmmaker's mother. Banker is gracious and appreciative accepting feedback during the discussion that follows the screening itself. These people care. They have money in the film yes, but beyond that they are already becoming champions of project. Like the producers and the creators and the NGOs that form a part of the outreach network, these impact investors and donors passionately want the film to succeed. *The Genius of Marian* was selected by this particular collection of supporters precisely because the topic matters to them. They are **motivated** by the belief that this piece of art will make a difference in this world.

Worksheet 3—Your Needs

Warming you up

If you suddenly had oodles of money and could support social issues media, what would most motivate *you*? (place top five in order)

_____ meeting filmmakers

_____ supporting artists' careers

_____ getting a close look at different production processes

_____ giving creative feedback

_____ facilitating further introductions

_____ attending festival screenings

_____ being acknowledged in credits

_____ networking with high-net worth individuals

_____ financial recoupment

_____ learning about the topic

_____ giving a new tool to change-makers

_____ raising awareness

_____ seeing measurable impact

If you suddenly had the *attention* of someone else with oodles of money, what would you hope most motivated them? (place top five in order on the same list)

If you *are* a funder, what most motivates you?

What's the most unusual financing structure that you've been party to?

What were some benefits?

What's the ideal financing structure that you dream about?

What are some pitfalls?

Your project

What is your estimated production budget:

– at the shoestring level?

– at the "everyone gets paid full market rates" level?

What is your estimated outreach budget?

What people, if any, are already attached?

What organizations, if any, are already attached?

What is the rough budget shortfall?

Name one tax-related financing challenge you fear. Who will assist you in exploring how to overcome this?

Always keeping **impact** top of mind, name three organizations that will see your film as a valuable tool to deploy in their own social change work.

1.

2.

3.

Producer's Journal

Broadcasters (Money Source 1)—*Hadwin's Judgement*
(Director: Sasha Snow)

November 2007: Jonathan handed me quite the stack of proposals to read this weekend. That's what you get for going on vacation. Time to play catch-up. He was pretty excited about one in particular. Put it at the top of the pile, tapped it a couple times and with that grin of his said, *Here's a goodie.* He was right.

I just read the pitch for a film called *Hadwin's Judgement*, based on the recent best-selling book, *The Golden Spruce*, by Vancouver author, John Vaillant. Gripping tale from the late '90s of a so-called "eco-terrorist" who cut down an ancient majestic tree on Haida Gwaii to draw attention to unsustainable logging practices. Ironic, eh? And pretty crazy. His name was Grant Hadwin and he'd been a logger himself. Saw first hand what was happening in the bush. His action

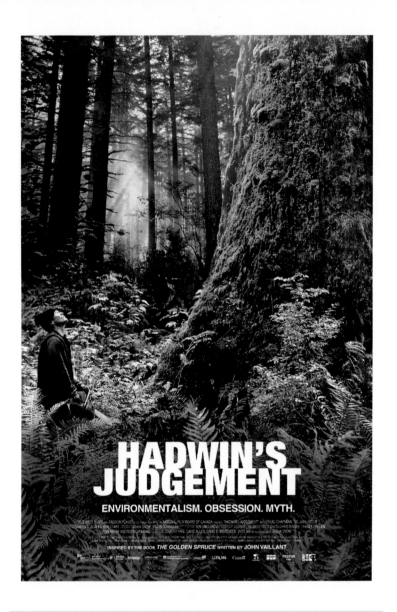

devastated the local First Nation's community who revered the tree, and—more awful irony—could have been allies in his crusade.

But then, when called to trial on the islands he decided to kayak there (!) and was never to be seen again. It's a serious open water crossing, like 30 miles. This was one

fit guy, but bottom line is he never made it. His boat and gear were found way up the coast later (in a somewhat "too perfect" display), but not Grant. He left behind a document, a manifesto of sorts, called "Hadwin's Judgement," half mad, half brilliant.

What a story! It's got it all. Strong narrative arc, emotion, ecological underpinnings, moral ambiguity, tragedy, mystery. Happened here on Canada's wild coast, has a First Nation's angle, and will get people talking about resource extraction and sustainability. Story, check! Impact, check! Now, money? Could be tricky that the director, Sasha Snow, is from the UK …

December 2007: Lined up the time zones today and spoke at length to Sasha in London. Great guy. He gave me more clues as to why he pitched the National Film Board of Canada with this project. Believes in our brand—the quality, the social goals, the institutional cred—plus the tale unfolded in our backyard. And the author is just down the road from our office.

He actually met John at the Banff Mountain Film & Book Festival. John was presenting *The Golden Spruce*, and Sasha his film *Conflict Tiger*. They hit it off, seeing in each other kindred spirits. Storytellers drawn to nuance, complexity, and characters that you first want to judge harshly, but then leave you wondering. (Apparently John is thinking about writing his next book based on Sasha's Siberian tiger film. How's that for cross-pollination!)

So John agreed to offer the documentary book rights to Sasha. Others had asked, but this was the first time John saw the same sensibility in someone else's artistic approach. Felt he could trust him. For a producer assessing a project, this option agreement is gold. But it's still a funky situation for me, the fact that Sasha is not Canadian. Have to put my thinking cap on. The NFB is a public institution. The mandate is to create cultural projects of relevance to Canadian audiences. It's unusual to work with foreign directors.

January 2008: I've decided to put some development money into the *Hadwin's Judgement* project. We're OK with the director residency issue, given that the story took place here,

the film will be shot here, and considering that Sasha is the anointed one. John just did not happen to give his story rights to a Canadian director ... Sasha has a relationship with Passion Pictures in the UK. They are producers of outstanding films like *The Imposter*, *The Age of Stupid*, and Oscar-winning *Searching for Sugarman*. It's not clear how they'll factor in—advisors, consultants, distributors down the line? But these guys are world-class fabulous, and great to have in our corner in any way that's workable.

March 2008: Yves Ma has recently joined our team as producer and one of the films I'm transferring to him is *Hadwin's Judgement*. He's equally smitten with the premise and will connect with Sasha shortly. The idea is to bring Sasha out to do a research trip on Haida Gwaii, begin relationship building, see locations, plus poke around British Columbia for other characters who can fill out the narrative. As executive producer now, I'll focus more on the bigger picture, including financing.

January 2009: We've just learned that another filmmaker is pursuing the same topic. She's European based and has early stage broadcaster support. She's moving ahead without a direct connection to John's book, just putting it together with what's on the public record. And, we find out, making personal inroads to the remote communities on Haida Gwaii. Speaking to some of the same folks there. Yikes. Is this a set-back? We're both in development only at this stage, both may not make it all the way. We don't know her timeline. In fact, we don't know ours. Should we consider collaborating? Or can the market (i.e. the "world") welcome two feature documentaries about this same story? It's not like it's a thematic doc, it's a plot-driven story. I'm worried. Guess we just have to get ours out first!

November 2009: I've just spent a nice day with Sasha Snow and his family in Kew Gardens outside of London. I'm on my way back from IDFA, the major documentary festival in Amsterdam. What a whirlwind. But I wanted to touch down here to put faces to names at Passion Pictures and to review with them and Sasha our progress on the project. To be honest, Sasha's stressing about the film. So many delays in trying to piece together this budget. He's losing momentum, and maybe even some traction with proposed subjects. Not to

mention income. He needs to keep other work flowing to pay the bills and it's tricky to juggle.

I gingerly float the notion of reducing the budget drastically, in order to lock financing sooner with a more simple scenario. But he's got a vision, which includes dramatic recreations and gorgeous crafting. After all this, he doesn't want to do it by half measures. I respect that. We want the same thing. He thinks he might be able to rustle up some private investors.

September 2010: The material captured in development for *Hadwin's Judgement* looks great, so does the trailer Sasha cut. It's not going to be an inexpensive film to make though. Remote locations, expansive landscapes, dramatic sequences. We're going to look for an independent Canadian co-producer to increase the options. NFB will still be a major part of the puzzle if it's an international co-production, but this way we can invite others in to play.

January 2011: Yves and I have been brainstorming possible producer partners for Sasha's film and have decided to approach Elizabeth Yake of True West Films. She's made (and more to the point, financed) both docs and successful dramatic features. I know her as someone who gets sh*t done! Tenacious, creative and a good Rolodex of international contacts.

April 2011: Elizabeth just returned from a trip to Hot Docs in Toronto to pitch *Hadwin's Judgement* and London to meet Sasha. They spent time too with Dave Allen at Passion Pictures and have begun drafting co-pro terms between the two companies. Dave feels pretty confident he'll be able to generate UK broadcaster interest. We're in the process of reverting the rights to her company and to position ourselves now as just part of the Canadian side of the financing that she is to raise. She's got nibbles from Super Channel here, and Toronto-based Films We Like (Ron Mann's company) might be open to theatrical distribution.

June 2012: The *Hadwin's Judgement* funding puzzle continues to confound. Elizabeth has indeed secured a pre-license from Super Channel (yay), and Passion Pictures has from Channel 4 (double yay). The treaty co-pro percentage numbers keep shifting though, depending on where further

financing is found. On the Canadian side, there's us at the NFB as equity partners, plus she was hoping for Telefilm's Theatrical Documentary Fund, but just learned the project was ineligible, in part again due to Sasha's nationality. She's applying to Canada Media Fund's POV stream. Passion continues to pitch the film to additional European broadcasters and funding agencies.

November 2012: Feeling a little stressed. I've given notice after 11 years at the NFB and leave within the month. We are **so** close to locking financing on *Hadwin's Judgement*, I can just taste it. But now there are new challenges, new questions being asked. Who will be the theatrical distributor, NFB or an independent who showed support early on? In terms of the recoupment schedule for the angel investors in the UK, who is on what tier to recover their equity? How do you strike a risk/reward balance between private individuals and a public (i.e. Canadian tax payer supported) institution? And to respect the international treaty terms, more money needs to land on the UK side of the budget, but Passion has exhausted their search. Where else to look?

Also, Elizabeth is just shy of the minimum threshold of broadcast licenses relative to the overall budget to qualify for Canadian Media Fund. And the once-a-year deadline is literally upon us. Either some of the other money has to get pulled out (feels devastating), or we need to find an additional broadcaster pre-sale to raise the percentage— by next week (feels impossible). We started making calls. Murray at Knowledge, Bruce at documentary channel, contacts in the US through our sales agent in LA. Clock is ticking. Meanwhile Sasha is at his London flat, polishing his lenses, keen to start shooting ...

February 2014: About to tuck into John Vaillant's book *Tiger: A True Story of Vengeance and Survival.* Crazy that's already written and launched and *Hadwin's Judgement* is still in the editing suite. Speaking of that, even though I left the NFB about a year ago, my former colleague David Christensen sent me a fine-cut screener. He took over the film from me right after the financing was locked. (It was a true 11th hour victory, all the pieces falling into place at the last minute. We ran around the office high-fiving and making fake cow bell noises. I damn near cried.)

In any case, I shared my feedback last week. Still work to do on story structure to increase the drama and stakes, but yes, you can see a real gem in there. A little more polish and it'll rock. No word either about that other competing film. Looks like Sasha's baby will actually hit the world first!

September 2014: Just saw this on Sasha Snow's Facebook feed: "2 kids, 4000 emails and 7 years after a phone call from John Vaillant, *Hadwin's Judgement* completed post production today. News on festival release dates TBA shortly."

I'm a little wistful that after all those years of piecing together financing, both Yves and I were no longer working at the NFB when the film actually went to camera. But it's in such good hands with that whole team and I'm proud to have been a part. Trailer looks stunning—can't wait to see the whole thing in a darkened theater with an audience. Though pulling together the *money* was a crazy house of cards, this is one *story* that I just know will have impact!

(See Appendix 1 for *Hadwin's Judgement* Financing Scenario.)

Money Source 2—Foundations

Again, in these next five sections, we have the chance to hang out with some of the top brass of the documentary funding world, in the informal glow of a campfire. Their full bios can be found in Appendix 3. But here they share stories, tips, and insights, all through the lens of their own deep personal passion and commitment. Hey, was that a shooting star? …

> I always look for artists that are working with imagination, and have a sense of mastery of their aesthetic strategies, whatever that cinematic language happens to be for them.
> CARA MERTES

The Firestarter—Cara Mertes, Ford Foundation's JustFilms

Cara is a non-profit leader with over 25 years of experience supporting and connecting independent film communities globally as a public TV executive, funder, curator, and teacher. Currently the Director of Ford Foundation's JustFilms initiative, she is responsible for funding content, networks, and leadership in using film and digital storytelling toward social justice goals.

THE FLAME—*CITIZENFOUR*
Directed by Laura Poitras, 2014, US

"*CITIZENFOUR* is a real life thriller, unfolding by the minute, giving audiences unprecedented access to filmmaker Laura Poitras and journalist Glenn Greenwald's encounters with Edward Snowden in Hong Kong, as he hands over classified documents providing evidence of mass indiscriminate and illegal invasions of privacy by the National Security Agency (NSA).

Poitras had already been working on a film about surveillance for two years when Snowden contacted her, using the name 'CITIZENFOUR,' in January 2013. He reached out to her because he knew she had long been a target of government surveillance, stopped at airports numerous times, and had refused to be intimidated … *CITIZENFOUR* places you in the room with Poitras, Greenwald, and Snowden as they attempt to manage the media storm raging outside, forced to make quick decisions that will impact their lives and all of those around them."[12]

The Campfire Convo

Tracey: *How are mission-driven funders thinking about media and social change?*

Cara Mertes: You know, all funders are "mission-driven" in the sense that they have goals that they want to achieve with their resources. What I've seen is that many in philanthropy are increasingly interested in connecting with filmmakers to help move their issues forward. Part of the reason I have been a part of designing and supporting efforts like Sundance-Skoll Stories of Change and BRITDOC's Good Pitch is that we are trying to create new networks, more common ground and ultimately increase resources and impact for all concerned; public, private, government actors, and artists. These efforts undertake the long-term process of educating people from different sectors about transformative potential of film in the search for more equity and justice.

Every sector has its way of organizing itself and aligning its work and its expectations. And we don't have a lot of familiarity across sectors, and so that's the starting place—putting people in situations where they're actually absorbing and learning how people in other practices or other disciplines actually think about their work. Because it's only then that you can begin to identify where your interests might overlap and where you might most effectively be able to work together. I believe that if you're trying to have the most powerful sort of impact, if you're actually thinking about where the film is going to go, and who your audience is, even as you're building the story, then you will achieve greater artistry, greater impact and ultimately greater potential for a transformative experience for artists, subjects, and their communities and for audiences.

Tracey: *In what ways does JustFilms contribute to capacity building in the impact space?*

Cara: The question of impact is implicit in any form of storytelling. For JustFilms, the focus is filmic stories, and the impact question is, for me, really a question about the artist's relationship to their audience. Everything else concerning impact and change stems from that first question: what do you want to communicate to your audiences?

Since JustFilms supports films and organizations to have impact in the social justice arena, it is our responsibility to articulate what we mean when we talk about impact—how we are assessing it, what its relationship is to aesthetic questions, and how we expect filmmakers and organizations to contribute to that discussion. All of this is something I have prioritized in the evolving JustFilms structure as we move through the first five-year commitment into an approach that reflects the way that Ford Foundation will be working in the future.

Tracey: *What's one JustFilms supported documentary that really stood out in terms of story development?*

Cara: I have worked with so many film teams over the years that I can never answer a question about "one" film very well, so I can ask, what does it take to a tell a story that's going to create change? I always look for artists that are working with imagination, and have a sense of mastery of their aesthetic strategies, whatever that cinematic language happens to be for them. Do they know how they want the narrative to unfold, are they in control of the visual elements, the sound design and composition, the information, the experiential elements? Do they understand how cinema works on its audiences; by that I mean the effect of all of the sensory stimulations that make it so powerful for humans? Who do they think their audience is and what do they hope to impart to them? Can we trust them as a guide? These are all questions I ask myself as a viewer/funder.

CITIZENFOUR is one recent example—it was awarded an Oscar and a host of other awards in the 2014/5 season. The filmmaker, Laura Poitras, has become part of the story. She exemplifies the changing role of the artist-journalist in the telling of the story. It's unlike anything we have seen or will see again.

Just the fact that someone like Edward Snowden would decide to contact an artist—an independent filmmaker—is a sign that the role of the independent filmmaker has changed. He knew the person he contacted had to have autonomy, bravery, aligned values and they would knowingly choose to put themselves at risk, protect their source, and would stand up to outside pressure and be unaffiliated in a way that could not be challenged. This is a rather precise description of many independent filmmakers. He was quite brilliant to understand that. Not that Laura was beyond pressure, but she made choices about her location, her funders, and supporters. And her tactical decisions about security so that she could avoid it for long enough that she could make the film she wanted to make without being stopped in the process—it's extraordinary.

Tracey: *What advice do you have for filmmakers about approaching possible funders?*

Cara: Give yourself a checklist: research your potential donor; can they be a partner in your project and if so, how? Try to understand their needs and interests to the best of your ability and identify where you and they might have common ground. Assume these people are knowledgeable about their area, professional and committed. They want to identify partners for their work as much as you want to identify support for yours. If they can't help, see if they can open the door to others who can. But the real job of the filmmakers is to know their story and to know their characters, events, communities, and approach, and to have a sense of how they're going to depict it, how they're going to turn it into a cinematic experience. Funders are often looking to learn new approaches and new angles on their areas, so to the extent that you can bring them new knowledge that helps them, the better the conversation will be.

A conversation with funders should be seen as a continuing conversation. Funders talk to each other, track careers, and want to understand where opportunities and talent are developing. If not this film, then perhaps the next project. A note on impact and engagement campaigns: I actually don't believe that all filmmakers have to be advocates on behalf of their film doing work in the world. I think filmmakers can make films for artistic reasons or expressive reasons, and it can be up to other people to identify how it can be useful in further change work.

Now that said, those filmmakers who are able to speak both languages—both the language of narrative, and also the language of impact—actually do have an advantage in certain situations, because they can advocate in both realms. They're able to translate for people that want to support storytelling that it is going to have certain kinds of impact. Other filmmakers need other people to do that translation for them, and I think that's actually capacity that we have to build in the field.

Tracey: *What are you optimistic about?*

Humans love power and privilege, but they also love freedom and justice. I am optimistic that the struggle between the two will continue with advances for freedom, justice, and equity, even as the powerful continue to defend their interests at the expense of the most vulnerable. Stories told about the powerful by those with less access to power matter profoundly; without them we lose sight of the ideal of a life imbued with dignity; the highest human aspiration.

The Spark—Foundations

 Cara Mertes is a rock star in the social justice media world. She's been connected to all the biggies, like Sundance Institute, PBS/ POV, Good Pitch, Skoll Foundation, and now Ford Foundation's JustFilms. As an initiative that's been investing millions per year into the sector, it's a significant global player, and Cara's leading the charge. She reminds us that how "humans build community is very much linked to how storytelling and narrative works in our cultures."

Foundation support for documentary film is far from a slam dunk, but at least in the US there is a solid history, plus steady growth. According to a 2013 Foundation Center report, an increasing number of US-based foundations supported media-related work between 2009 and 2011, distributing over $178 million in grants to film and video projects, with a median grant size of $25,000. In fact, dollars for media grants grew more than three times faster than overall grant making.[13]

There is activity in the UK, largely centered around BRITDOC (see Chapter 29) and its relationship with the Bertha Foundation. In the southern hemisphere, the Documentary Australia Foundation and Shark Island Institute are bringing together media-makers with foundations and philanthropic donors, in a favorable tax environment. And in Canada, such relationships are being explored by Hot Docs, Inspirit Foundation, and a handful of other pioneers.

These numbers should keep rising as more and more foundations understand the power of storytelling, particularly through film, to advance the positive change they want to see in the world. Again, it's all about mission alignment and mutual benefit. Filmmakers need resources and change agents need compelling and well-crafted stories.

To better understand this potential funding source, let's step back for a primer on the nature of foundations and charitable organizations. Foundations are grant-making non-profit organizations whose sole reason for existence is to give money away. While foundations are legally required to distribute money in accordance with tax laws, they have to do so with a specific purpose: to bring about public benefit based on their mandate.

Of course, not all foundations are created the same—one foundation's definition of "public benefit" can vary greatly from the next. Some foundations have broad discretion regarding the charitable causes to which their grants can be directed. Others are sharply limited, often legally, by the mandate of their donors. Some foundations are restricted to making grants only to certain causes; others have to restrict their grant-making to a specific geographic area.

For our purposes, there are two basic types of grant-making foundations: independent or private foundations, and community or public foundations. The most common are private foundations, which are generally founded with an endowment from an individual or family. They tend to be created for the purpose of funding one or several social or environmental causes or organizations.

Community foundations are operated by, and for the benefit of, a specific community or geographic region. Their funds are pooled from the donations of a variety of individuals. They give donors a way to establish

support for causes they're interested in, without having to set up their own independent foundation.

The vast majority of foundations will not give grants to individuals, but rather restrict their funding to another non-profit organization. In the US such an eligible organization is known as a 501(c)3, "five-oh-one-cee-three." If your production company is not incorporated in this manner, you may seek a mission-aligned non-profit "fiscal sponsor" to accept the funding on your behalf. After retaining an administrative fee in exchange for oversight, they will forward the balance to your project.

In Canada, the recipient organization of a foundation grant needs to be a registered charity. At present there is no established practice of fiscal sponsorship, but foundations can and do create their own media projects in-house, and fund other charitable organizations whose purpose may be the production or distribution of educational or social issue media.

It all boils down to this: the most important thing before approaching a foundation is to do your homework, and pay close attention to what they are looking for. If you do find a match, read through the application process carefully, give them what they ask for as clearly and concisely as possible, and start nurturing a relationship (yes, it's a bit like online dating) … As Cara shares about her colleagues in the **foundation** world: "they are desperately interested in connecting with filmmakers to help move their issues forward." In other words, we all need *each other*!

Money Source 3— Impact Investors

The Firestarter—Geralyn Dreyfous, Impact Partners

Geralyn is the Founder of the Utah Film Center, and co-founder of both Impact Partners Film Fund and Gamechanger Films. She has a wide, distinguished background in the arts, extensive experience in consulting in the philanthropic sector, and participates on numerous boards and initiatives.

If the film doesn't increase the philanthropic reach by a factor of 10×, we didn't make a good enough film!
GERALYN DREYFOUS

THE FLAME—*THE GENIUS OF MARIAN*

Directed by Banker White and Anna Fitch, 2013, US

"*The Genius of Marian* is a visually rich, emotionally complex story about one family's struggle to come to terms with the changes Alzheimer's disease brings. After Pam White is diagnosed at age 61 with early onset Alzheimer's, life begins to change, slowly but irrevocably, for Pam and everyone around her …

97

As she loses the ability to write, Pam's eldest son, Banker, begins to record their conversations, allowing her to share memories of childhood and of her own mother, the renowned painter Marian Williams Steele who died of Alzheimer's in 2001. *The Genius of Marian* paints a powerful contemporary portrait of the impact of Alzheimer's disease, the power of art and the meaning of family."[14]

The Campfire Convo

Tracey: *How can we all better understand impact funders?*

Geralyn: The ability to align missions and amplify the current investment of a philanthropist or a foundation is one of the most exciting new areas being explored: "strategic alignment." For a foundation to not have a media strategy is just a lost opportunity, and putting a small percentage of your funding into media is just a smart investment.

Then there's a whole ecosystem of where you invest, which I think can also align philosophically with what kind of a funder you are. So are you an early stage funder that gives money in the beginning and takes more risk? Are you a funder that's more interested in the impact so you can take the film out into the world? Are you a funder that really wants story and sees the value of getting involved in the production of a film, bringing all the other resources that you can bring to the filmmaker?

There are just so many ways when we all approach foundations to try to think about what are their goals, what is in their long-term strategic planning, what are some of the outcomes they want in the field and spheres of influence that they've invested in? There are so many stories now where people's lights go on. They're starting to see media as a more strategic investment.

Tracey: *What advice do you have for filmmakers regarding their communications with potential partners?*

Geralyn: Just like you need to know who your audience is, you as a filmmaker, you need to know who are you making this film for, and who are the most obvious natural constituents? Anybody that's given over $100,000 to a cause, can give a film $100,000 and should understand the leverage that this film is going to generate. If the film doesn't increase the philanthropic reach by a factor of 10×, we didn't make a good enough film!

You have to be able to use language they understand. This is only going to amplify the cause. Or it's only going to make donors even more committed to your mission, because they're going to see what this film can go out and do in the world.

More and more filmmakers need to understand how to talk to NGOs and to funders about that: *We're coming to you because we know you've already made this investment, you care deeply about this. We want this film to carry that investment out to the mainstream world, out to the choir that's already singing your song, and out to new people that have never even discovered how to sing.* It's not about scarcity, it's about abundance. It's about the way the world is moving. It's about collaboration, it's about how none of us can do this alone.

We're making it as easy as possible for philanthropists and for consumers to do the right thing! Let's take as many barriers away to it as possible. And media can do that, it can be instructive without being pedantic.

Tracey: *Many artists fear asking others for money. How do you coach them through that?*

Geralyn: Basically, I say you have to know how to do it. If you don't know how to do it, you have to have somebody that knows how to do it on your team. There's nobody that's going to hand you full financing for your film, nor should they. It makes the film better when you have foundations, equity, personal credit card debt, or your mother-in-law's money, because it makes you be accountable in ways that makes the film better. When you're asking somebody for money, it's really an invitation for them to be able to make a difference in the world.

Be thoughtful about who you ask. Don't just target somebody because they're rich or because they're a foundation and you think you deserve to have their money. If you find that common place where they can actually make a contribution that allows them to be bigger than themselves, that's a great privilege.

Sometimes you have to remind people that even giving people the opportunity to say no is a privilege, right? To just let them be able to think about it and imagine what they could bring to the conversation. And if they say yes, then to see what that did to them, what opened up for their families, or their co-workers, or what happened for them personally as a result—it's so amazing.

Filmmakers don't always do a good enough job of remembering how to thank donors. Director Rory Kennedy is impeccable about that. Every email that has made her cry, she sends to all of her funders saying, *I just want to remind you again of how grateful I am of what you allowed to happen by supporting this film.* And you don't think every single person that reads that email doesn't feel great for the rest of the day?

Tracey: *What to you are the most important story ingredients?*

Geralyn: The films that have the greatest impact are the ones that have emotion and character. We found that the films that have the largest reach are narrative-driven, and the films that we do that are specifically advocacy-driven have long tails, because they're targeted to people who are hungry for them. But the narrative, the best that a filmmaker can explain it to us, is the number one thing. Are there fresh ways of telling this story? So the first question I think that we ask is how are you going to tell the story? Tell us about your characters.

We definitely listen for language in terms of creativity, and originality. I don't know that we use the word "innovation" as much as we do "artistic sensibility." It's artistic potential, then commercial potential, then social impact. First we look at if the story's great, then where's it going to land, and then how's it going to have its impact.

Tracey: *What is a strong example of a film you supported that ties together story and impact?*

Geralyn: We might want to look at both *Genius of Marian* and *Alive Inside*. Because one of the things I think is really interesting and goes to the idea of how media's

changing is that it used to be, oh, there's already a film on music, there's already a film on how art changes Alzheimer's, it's *Genius of Marian*. But now there's a whole strategy around pods of films—building messaging and building on the momentum of another film and sharing that data. It's almost like you're standing on other people's shoulders. Both of them work—one uses music, one uses art, one's deeply personal, the other is very subject and character-driven. But I think that they're both just such heart-rending and joyful and beautiful and intimate looks at dementia, that I think they're a good companion pair.

Tracey: *What first attracted you to* Genius of Marian?

Geralyn: Well, Banker (White) is just such a lovely, quiet, and understated person, and it was clear that this film was very, very personal. When he started out, his mother didn't have Alzheimer's. He began making a film about his mother writing a book about his grandmother and her Alzheimer's. And then when *she* got it, it was almost too much to believe and take on. So his decision to document her dissolving literally right before his eyes, as a son and a filmmaker, was just incredibly brave.

So we were like, wow, if you can really pull this off, in a way that is as intimate as you're describing, this could be so important to families with Alzheimer's. It raised so many universal questions about how we want to be remembered, what do you want to remember before you forget? These kinds of questions are so poetically beautiful—your hair raises on every goose bump, every hair follicle standing at attention.

The Spark—Impact Investors

 Individuals who want to use their capital to create positive change in the world are often referred to as "impact investors." Unlike mainstream investors, who are primarily interested in the financial returns their investments will bring them, impact investors seek to place their money in projects that will not only generate a financial return, but also social impact. This type of investor may accept a lower rate of return, or even a loss, because the potential social impact will create "value" beyond the traditional financial definition of the word.

Putting money into the making and marketing of films is a risky business, one that rarely leads to big profits. Or any profits. I've learned by experience, and anecdotally, and by scouring the limited publically available sources of information on recoupment, that very few documentaries recoup what they cost to produce. If a full production budget is raised from the marketplace, then at least key talent, crew, vendors, and the creators may be paid living wages. But it's not that common for equity partners on documentaries to recover their initial outlay, let alone move into a phase of profit participation.

Impact investors have a slightly different agenda though. Some may choose to invest on their own or, to mitigate this risk, they may come together to pool their resources in a group like Impact Partners. As a private membership-based company, Impact Partners turns all of its considerable industry expertise toward evaluating the potential success of a film at an aesthetic, commercial and societal level on behalf of its equity investors.

It's a brilliant structure. There's an exclusive table of 30+ people. Each pays an annual fee, which covers the company's overhead, and each commits to investing a minimum six-figure amount per year in the pre-vetted films brought forward. The investors are open to choose exactly where their money lands, based on their own personal interest. It might all go to one project that perfectly aligns with a passion, or be spread across multiple documentaries. At times members might also step up with a personal donation or family foundation grant.

There are few companies in the world quite like Impact Partners, but the small list is growing. Chicago Media Project (see Chapter 18) is driven by the same objectives, as is BRITDOC's Circle Fund. Slated is an online marketplace, leaning more toward narrative features, and New Media Ventures (see Chapter 33) is a network of investors, diversified across multiple politically progressive tech platforms. Some initiatives are operating as charitable grant-giving organizations and others, like Impact Partners, as full financial partners.

For clarity, as an equity investor in your film, Impact Partners would typically contribute a percentage of your master production budget. They'd expect to see market support already in place and may come in to finance the balance or a portion of it. Once distribution revenues start flowing, they begin to recoup their investment. Some projects exceed projections, others never recover anywhere near the original investment. On average though, it's a more substantial return than a donor would get as a tax receipt for a charitable donation. And the good news is the money tends to stay in the "system," cycling its way through the next crop of films.

I appreciate that as a filmmaker accessing these investments may feel like a murky long shot, almost unattainable. But have hope. For instance, there are dozens of film titles listed on Impact Partners website. This means they've been in the trenches with dozens of filmmakers, working hard and sharing the vision that a compelling story, well told, can make a difference in our society. You know you need partners to get your film made and launched. But they need *you*, too. They scour the world for best possible projects. So what can you do to increase the odds? Focus on developing the best possible project.

Craft your story with originality, emotion, and a strong narrative arc. Build your strategic campaign to maximize engagement, reach, and social

change. In other words, tie together story, money and impact. If you are purposeful on these fronts, the funders will notice. And learn how to work together for mutual benefit. Active Voice publishes a guide called *The Prenups: What Filmmakers & Funders Should Talk About Before Tying the Knot*.[15] Check it out. And remember **impact investors** also want to change the world!

Money Source 4—
Philanthropists

The Firestarter—Steve Cohen, Chicago Media Project

Steve is a Chicago-based attorney who is nationally recognized for his representation of whistleblowers. He is a member of Impact Partners and Gamechanger Films, and co-founder of Chicago Media Group and convener of Good Pitch Chicago.

> At the very fundamental level, we think of people coming together to watch a film like what people used to do—gather around the fire, a fireplace, and have conversations. STEVE COHEN

THE FLAME—*THE INVISIBLE WAR*

Directed by Kirby Dick, 2012, US

"From Oscar®-and Emmy®-nominated filmmaker Kirby Dick (*This Film Is Not Yet Rated; Twist of Faith*) comes *The Invisible War*, a ground breaking investigative documentary about one of America's most shameful and best kept secrets: the epidemic of rape within the US military …

Focusing on the powerfully emotional stories of rape victims, *The Invisible War* is a moving indictment of the systemic cover-up of military sex crimes, chronicling the women's struggles to rebuild their lives and fight for justice. It also features hard-hitting interviews with high-ranking military officials and members of Congress that reveal the perfect storm of conditions that exist for rape in the military, its long-hidden history, and what can be done to bring about much-needed change."[16]

The Campfire Convo

Tracey: *Please tell us about the Chicago Media Project.*

Steve: The idea behind the Chicago Media Project really grew out of the reaction we saw from the Chicago community to the Good Pitch we put on in October of 2013. Those of us who were involved in organizing the Chicago Good Pitch felt that there always had been a community of people who not only believe in and loved film, but also believe in the power of film to help galvanize social change. We knew that there were these pockets of communities from the advocacy side, from the funders' side, from the individual patron's side, and from the foundation and philanthropic side. But there had never been anything that really brought them all together.

Well, Good Pitch was just that event. We had in one big tent members each of those various communities, and we presented the kind of films that had not only the cinematic quality but also the social action campaign strategy, the impact strategy, built into them. It brought to the surface what all these people were excited about.

And that's how we conceived the idea of the Chicago Media Project as a member-based, year-round network of people who love film, believe in its power and want to support it. So our idea was if we became the hub or magnet for these kinds of projects, we would be able to build a critical mass of people here who would come together to achieve the goal of supporting these films.

Tracey: *How do you talk to other potential funders about the power of media to effect social change?*

Steve: What we talk about is how film can be a source for both inspiring and igniting people to act. At the very fundamental level, we think of people coming together to watch a film like what people used to do—gather around the fire, a fireplace, and have conversations—that's what a film becomes, a new way to bring people together. We all know that the best way to get people to react is through storytelling.

Visual storytelling can be so much more powerful than even the oral or written word. We see film as that version of storytelling, of being the kindling for conversation, and then, you add to that an approach for how that film can be used within an impact strategy, and you have the makings of a social reform campaign. That's really what we tell people—what we try to do is bring films that are both cinematically powerful storytelling and have the extra important ingredient of seeing how the film could fit into and be part of the impact strategy.

Tracey: *What first drew your attention to the value of documentary film?*

Steve: Impact Partners was my entree. I was always involved in grass-roots and advocacy organizations, and I certainly had the love for film, but I didn't necessarily have an avenue that brought them both together. I found out about Impact Partners, which really is a microcosm of what we're talking about. IP is a group of like-minded people who are spread out all over the country, actually the world, and have the desire to be involved in supporting impact strategies towards social change and have an orientation towards film and media as a tool for that.

What Impact Partners does so well for its members is that it is a safe harbor for those of us who know the importance of film but don't necessarily feel we know how to pick a good film, a film that is both going to have the right amount of visibility and that is going to be able to get made in a way so that people will both see it and be moved by it. Because the Impact team is so good at selecting film projects and mentoring the filmmakers that are selected for financing, those of us in the membership have a much greater level of comfort about investing in the films. So it was really the perfect way for someone like me to tip-toe into social impact film investing.

Tracey: *What to you are the most important storytelling ingredients?*

Steve: The first thing is you have to have the right characters or subjects. For it to be a good story there has to be a subject who you can relate to, who you can feel connected to. That's the difference between a *Frontline* piece and an impact documentary. A *Frontline*-style piece, a journalistic-style piece, will look at a subject from a kind of a macro view. An impact documentary looks at a social issue from the perspective of the subject or the character who's in the film.

An equally important second ingredient has to be the story. Even though it's about an issue, it has to be the story part of that issue. And so the bottom line it has to be entertaining, it has to be a page-turner—just as a book has to be a page-turner, a movie has to be captivating.

Tracey: *Is there a film that really stands out in your mind in terms of how they've used story for social impact?*

Steve: I think one of the best examples of an impact strategy for a film was *The Invisible War*, because the film hit both levels of what I call impact. On the very first level, it was the kindling wood for a discussion about sexual violence in the armed services that simply had not been taking place. It was revelatory in that regard. People who saw that film walked out having learned about something that they had never even believed or imagined was taking place, certainly not at the magnitude described in the film. So at that very first level, it was revealing an issue—it was creating the public debate.

At the second level, that film became the galvanizing force for what ultimately became the legislative campaign to resolve this awful situation. And so from advocacy groups to Senate hearings that film has been cited, has been shown, and it has underscored why something needs to be done. And so it's a perfect example of an impact strategy campaign.

Tracey: *What advice do you have for filmmakers for considering impact and calls to action out of the gate, in order to strengthen their film project?*

Steve: The first thing I would tell them is that they should view the impact strategy not as something as an afterthought for their film but really the reason for the film to be made. It not only makes for a better film when the storyline is connected to something larger, but it's also practical. The purpose behind an impact strategy is to create greater visibility and greater gravitas for the film and its subject matter. So purely from the standpoint of wanting to have their film seen, an impact component is really something that is essential for a filmmaker to be thinking about.

Tracey: *What advice would you have to filmmakers in terms of approaching funders with their project idea?*

Steve: They have to think in terms of their strategy being more than *I'm going to make this great film and I'm hoping it can get on 1,000 screens or be seen by 10,000 people.* Although that's necessary, it's not sufficient to a good impact strategy, certainly not one that would bring investors toward that project as opposed to another project. I think it's really important for a filmmaker to understand it's more than just getting your film on the screen. It has to be something larger than that, more concrete than that.

The Spark—Philanthropists

 Given my love of the fire metaphor, I'm tickled that Steve Cohen peppers his comments with words like "kindling" and "ignite." He's seen the power of the media first hand and though his actual profession is as a high-profile attorney, he is now an active champion of impact documentaries. First a member of Impact Partners, then a convener of Good Pitch Chicago, and then founder of the Chicago Media Project (CMP). Indeed, this man is on fire!

It's not exactly accurate to place Steve's work under the banner of "Philanthropist." As a businessman, he anticipates a return on his film investments with Impact Partners and CMP. But at the heart of it, his intentions are around using wealth to stimulate social change, through films and social action campaigns. This is not just his own wealth, but crucially, he is also pulling in his larger network. Like Geralyn at Impact Partners, such well-placed impact media evangelists are benefiting our larger industry by connecting with their peers to grow the overall pie.

Chicago Media Project invites potential donors to consider this value proposition: "CMP's goal is to raise awareness of the power of media and amplify its effectiveness through grants and investments in film and media projects focused on specific social issues, creating a greater intimacy with

our philanthropy."[17] The hands-on nature of the membership, including dinners, speakers, screenings, and the chance to meet directors, is a drawing card. For filmmakers it's a blessing to have potential collaborators collected under one roof.

But if you are not in New York, or Chicago, or London, or Sydney, how do you find and create relationships with local philanthropists? If your film is not quite the scale to attract Impact Partners or Good Pitch, how do you connect with individual donors? Especially challenging to find are those who have never considered media as an outlet for their philanthropy, even though they may feel deeply for a certain cause.

Media production may seem overwhelming if it's not someone's area of expertise. The due diligence required and transaction costs can be onerous, and even then, many a trusting supporter has been burned over the years. As a producer, you must respect that high-net worth individuals have countless ways to invest and donate their money. The goal is to communicate with transparency and find common ground around impact.

To find common ground, you must first find the potential partners to begin with. But before haunting the golf courses and office tower elevators, know your needs and what you can offer.

- What phase requires support: development, production, or distribution/outreach?
- What other funders are in place and how might a new partner affect the scenario?
- What is your position on creative input and final ownership?
- Aside from money, what else is valuable: like introductions, mentoring, or in-kind services?
- Most importantly, how might your project further the mission of the person you are meeting?

Finding and creating relationships with individual donors is part art and part science. It takes time and patience. Try to cultivate deep connections on multiple levels:

1. **Yourself:** believe in yourself and show your passion, optimism, and positive attitude; feel confidence that your intentions are admirable. And a good, strong log-line always helps!
2. **Your cause:** research who is already supporting your issue; scour boards of directors, publicly available tax documents, conferences agendas, book acknowledgements, and film credits.
3. **Your community:** lean on your full network for any and all introductions, even if they seem tangential; your vision is solid

and pitch well rehearsed, so cast a wider net at more public events, gatherings, and on social media.

4. **Your potential partners:** show grace and gratitude when faced with a refusal, respect all professional associates, respect personal privacy and people's precious time, and offer back your own gifts (like creative ideas, links, introductions).

Many **philanthropists** share your passion, so find each other, collaborate, and make a lasting impact!

Money Source 5—Brands

The Firestarter—Brian Newman, with Patagonia

Brian is the founder of Sub-Genre, a consulting company focusing on developing and implementing new business models for film and new media. Current clients include: Patagonia, developing film strategies, including distribution and marketing for the feature documentary *DamNation*; Sundance Institute on the Transparency Project; Vulcan Productions; and several filmmakers.

It's like opening up a book and it's a page turner, you want something that is keeping the flow going. And that is what brands want as well; something that is keeping people engaged.
BRIAN NEWMAN

THE FLAME—*DAMNATION*

Directed by Ben Knight and Travis Rummel, 2014, US

"This powerful film odyssey across America explores the sea change in our national attitude from pride in big dams as engineering wonders to the growing awareness that our own future is bound to the life and health of our rivers.

Dam removal has moved beyond the fictional Monkey Wrench Gang to go mainstream. Where obsolete dams come down, rivers bound back to life, giving salmon and other wild fish the right of return to primeval spawning grounds, after decades without access. *DamNation*'s majestic cinematography and unexpected discoveries move through rivers and landscapes altered by dams, but also through a metamorphosis in values, from conquest of the natural world to knowing ourselves as part of nature …"[18]

The Campfire Convo

Tracey: *How should filmmakers approach funders who are interested in social impact?*

Brian: When filmmakers are looking for funding they often look in the classic sense. They are looking at a database of potential funders, people who are funding film, and that is not where you start. It is actually looking at who is funding the issue your film is about. And they may not fund film normally, but it's about finding the right person to talk to about why they should fund film or new media to have an impact on that issue. The list of people that are already funding *film* is smaller.

And so if your film is about the environment, you are probably not looking for environmental film funders as much as you are for who is trying to have an impact in innovative ways on environmental issues. Most of the funders funding documentary today aren't funding for the heart's sake and they are not funding just for the sake of story, they are funding to make some difference for their portfolio that they can measure.

Tracey: *How should filmmakers approach organizations that may use their film as a tool?*

Brian: The big thing there is to remember that groups that are activists on an issue have very distinct jobs they are trying to accomplish.

And so even you are making a film that you may think overlaps with an organization, you have to look at what their priorities are right now. And then try to talk to them and have conversations that are focused on what they need, not hey, *I'm making this great movie you guys should support it.* It is more about trying to approach them early on and say *we seem to have aligned interests, what would be the things that I could do in my film or in the way I get my film out that would help you do your job in the field better?* And be open to that feedback because, obviously the filmmaker also has to tell the best story but a lot of times what a filmmaker wants to make is not what an activist needs in the field.

Tracey: *This kind of "impact producing" must be a challenge for filmmakers?*

Brian: It is hard work. But at least try to find someone who understands the issue area that you are working in. It can be a team member, as robust as an impact producer. Or it could be as simple as an intern who is studying at university that exact same topic and can at least help with some outreach early on.

Increasingly in the funding world for independent documentaries funders are starting to say *We are not going to fund you unless you've thought this through.* That this is part of your plan, and usually in your budget.

It is hard, as a filmmaker, you spend your life trying to learn how to tell a good story, you are not necessarily an activist. And filmmakers shouldn't feel like they have to be activists, however you know approaching people for money is that much easier if they know that you have buy-in from the community you are trying to have an impact with.

The last piece of the puzzle is, I think consumers or audiences of our films are increasingly participatory. And a lot of people, if they watch a film about dam removal for example and they do want to get active, they are going to feel like they were let down if you didn't give them the resources to figure out how to take action.

Tracey: *Where should filmmakers start if they want to work with a corporate brand?*

Brian: I think what filmmakers need to realize is that it's not for everyone. But they should realize that the world is changing. It used to be that you could count on government support of the arts and that's changing around the world. And broadcasters are paying less for content than they used to.

At the same time, almost any type of brand, the good and the bad ones, are trying to find ways to reach consumers in their mind—we call them audiences and they call them consumers—but they are trying to reach them in more genuine ways because people are not paying attention to advertising the same way. And brands have a lot of money. And filmmakers need money.

Occasionally the interests of a filmmaker, what they want to do with a film, overlap with a brand. That can be a great opportunity, as long as you are maintaining your artistic integrity and control, to get a film funded by someone who has the exact same goal as you, which is to get the film seen by as many people as possible.

But when you look at what are different brands doing in the media space, you can see some clear trends. With Patagonia, you do not need to be a rocket scientist to look at their website and their marketing message and see that they care about the environment and sustainability, and those are the types of films that might appeal to them.

Or you see that Converse is doing a lot of stuff around music and musicians and youth culture. Or that Red Bull is funding extreme sports projects.

Tracey: *How did the film* DamNation *come about?*

Brian: In the case of Patagonia and *DamNation*, it was actually the other way around. Patagonia was looking for filmmakers who wanted to tell a story about dam removal. They found someone whose previous work they liked and they approached them with the idea. Over a period of time a deal was made where Patagonia would fund making the movie, give the filmmakers creative control, and then also help the marketing.

111

In addition to the theatrical release and online digital sales, there were hundreds of community screenings. More people have seen the film with non-profits than they did in the theater. And arguably it'll have a bigger impact because you are dealing with people that are going to help you promote the film. So instead of you having to take out an ad, the non-profit is promoting it to their mailing list.

Tracey: *What are the pitfalls in partnering with a brand?*

Brian: In some countries the national broadcasters, who tend to be the biggest buyers for documentary films, are prohibited from showing films that were paid for with sponsorship or with advertising. For example in the US, PBS will not show such films.

And there are definitely film festivals that, even if we guaranteed that the filmmakers had complete creative control, turned down the film because of Patagonia's involvement. They would tell us that off the record. It was a mixture of feeling that it was not fair to people who did not have that kind of support, as well as questions about whether or not it was pushing a particular corporate agenda.

Filmmakers also want to make sure that they are maintaining creative control and final cut on the movie. But my own feeling is that filmmakers have to make compromises with funding sources all the time. If you get funding from a state broadcaster, they have certain things that they want done. If you get funding from a foundation, they often times are only going to fund you if the story is something that fits their mission. So to me it's just another funder that you have to think about their idiosyncrasies and what it brings to the table and doesn't.

Tracey: *What to you are crucial story elements?*

Brian: There are multiple ways to tell a story but, it is often easier to get people to care about a social issue in a particular documentary, if they can connect to at least a few characters, if not one character. I would say that story arc is another big one. You want to be able to follow that narrative and be given some kind of plot line so you are not getting lost. It's like opening up a book and it's a page turner, you want something that is keeping the flow going. And that is what brands want as well; something that is keeping people engaged.

The Spark—Corporate Brands

In spite of what we learn in the film *The Corporation,* many businesses, just like foundations and philanthropists, wish to see positive change in our world. The era of "corporate social responsibility" (CSR) is well with us. Three-letter acronyms are everywhere. CSR, SRI ("socially responsible investing"), ESG ("environmental, social and governance" sustainability measurements), and the now well-known

Triple Bottom Line of PPP ("people, planet and profits"). Oh, and of course SMI ("story, money, and impact") …

I appreciate that there is cynicism around some of these initiatives. Many cases have surfaced of "green-washing," where companies try to appear virtuous with their environmental or sustainability practices, but are in fact misleading consumers to reap even great profits. But I also know we live in an era with an empowered citizenry. Corporate errors are instantly shared, and all of us, even chief executive officers (CEOs) and vice presidents (VPs) of marketing, can feel genuine concern for the degradation of the planet and human rights.

Brands have long played a role in Hollywood and network TV, with everything from product placement through to the full underwriting of affinity content. With those partnerships the theory is that loyalty for both compatible companies increases. Advertising agencies are all over the internet finding ways to amplify their clients' stories through short films, web series, extended ads, and online game worlds.

These relationships are newer in the documentary community. There's understandable skepticism, and even controversy, about bringing a corporate partner on board when the overt purpose of a project is to effect social change. Yet, there are companies and owners who share these visions. Yvon Chouinard, the iconic founder of Patagonia, said in his book *Let My People Go Surfing: The Education of a Reluctant Businessman*: "Evil doesn't have to be an overt act; it can be merely the absence of good. If you have the ability, the resources, and the opportunity to do good and you do nothing, that can be evil."[19]

Patagonia has the resources to invest in film. And Chouinard has the passion for the outdoors. Bring those together with a skilled storyteller and it's a perfect storm of opportunity. The result is *DamNation*. I've been told the spark for this film came when Chouinard was out fishing in a river and was hit with the urgent need to bring the story of "dead-beat dams" to a wider audience. He intuited the power of media to effect change.

Brands that are reliant on a healthy outdoor environment show up most often in the opening credit sequences of mountain-themed films. Whether in extreme sports or environment docs, brands like Northface, Arc'teryx, and Rossignol are making investments of money and products and services. Other companies are getting in on it, like Intel in *Girl Rising*, Puma's relationship with BRITDOC, and the ubiquitous Red Bull Media House.

Some may accuse these entities of purely self-serving motives, and yes, it is important to be alert and vigilant. It's all about uncovering possible areas of authentic mutual interest and as a filmmaker that means major research. Comb through websites, credit rolls, Good Pitch catalogues, and film festival guides. Or maybe you'll be their first partnership pitch? If so, go

armed with a deep understanding of their company culture and corporate social responsibility objectives.

Brian Newman reminds us that there are downsides to consider. They learned with *DamNation* that broadcasters, especially public ones, may balk, and festivals or tax credit schemes may disqualify your film as ineligible. Ownership and editorial control need to be carefully negotiated.

But I appreciate that Brian points out that all funders have idiosyncratic wishes that require consideration. Whether a network, a foundation, a government agency, or your aunt, the whole idea around mission alignment is that both parties must benefit. Unless you are making a film with a lottery win, please appreciate that it's the shared goals of your backers that will provide money to your project, yes, and also a chorus of champions.

The Canadian Media Production Association published three white papers on "branded entertainment" in 2014. In their best practices summary, there's some good advice for filmmakers, like remembering to be sensitive to the brands' needs and goals, and to seek a collaborative relationship, not just a funding source.

> The branded entertainment opportunity is being driven by the need for companies to tell the story of their brand value more frequently and on multiple platforms, including video, to their customers … Many experts argue that funds for truly innovative content campaigns may come from "alternative" or local budgets rather than standard marketing spends, or from visionary executives who are scouting for great ideas from producers or their agencies.[20]

Visionaries like Yvon Chouinard and the team behind *DamNation* used the muscle, reach, and resources of Patagonia to get that film produced and out into the world. **Corporate brands** can be welcome, if seemingly strange bedfellows, in our collective quest to improve our world.

Money Source 6— The Crowd

The Firestarter—Ayah Norris, Indiegogo

Ayah leads the film and creative verticals in Canada for Indiegogo, the world's largest crowdfunding platform. She works closely with creators across the country to bring their ideas to the world through Indiegogo, raising funds and building community along the way.

> When you can run a campaign and prove that there's an audience behind your film, that often opens you up to so many other sources of financing. AYAH NORRIS

THE FLAME—*A BETTER MAN*

Directed by Attiya Khan and Lawrence Jackman, 2015, Canada

"My name is Attiya and I want to make a film to help end violence against women.

I am a survivor of intimate partner violence … The man who abused me is taking responsibility for his actions … It took courage for him to talk to me about the things he had done. One of the things he said was, 'Attiya, I wish

I could have been a better man.' I'm making this documentary because I believe he, and people like him, *can* change, and I want to create a space for that to happen. *A Better Man* will tell our story, while also bringing to light the incredible work people are doing with men who are hurting others. It has the power to strengthen the movement to end violence against women through a deeper focus on abusive men."[21]

The Campfire Convo

Tracey: *Can you please tell us about Indiegogo and its documentary specific activities?*

Ayah: Film is one of our largest categories, and still a very fast-growing one. And documentaries are an awesome fit for crowdfunding. From what I see, they're definitely a big market. I think the reason is that with so many documentaries, it's actually fairly easy to hone in on why the story matters to the world, and who the people are that are going to be touched by this story. You can clearly identify your core audience, and the story that will motivate them to join your team through the campaign.

Docs are just a natural fit, and a successful campaign can help you in so many ways. As we go through so many cuts for documentary financing, other funders are interested in the numbers. They're focus-obsessed on the audience. It's no longer about somebody saying, yes, you have an interesting story, so here's all your money. Because of how tight the industry has become, we need to prove that there's this audience behind the project. So when you can run a campaign and prove that there's an audience behind your film, that often opens you up to so many other sources of financing.

Tracey: *As it relates to "story," what is the difference between the film itself and the crowdfunding campaign?*

Ayah: One of the big questions I ask is how can you take all of the beauty of this story and gift it to the audience? What's the essence of your story that can really connect to the hearts of your followers? First off, you need to know who the audience is and that this story matters to them. You need to get to the core essence of it with your pitch video, something that will pull in their attention. You want your audience to see a piece of themselves and what they believe in in that pitch video, because that's what's going to compel them to take action, contribute, and share the campaign.

Being really creative in the pitch video is super important. But the biggest thing is to get to the heart of why this story matters to your audience, and then have a clear call to action to really inspire them to join the movement, too. The creativity extends past just the pitch video. How will you weave in the world of your film throughout your campaign? The campaign itself is its own kind of storytelling medium. So between the pitch video, the perks, the update strategy, the social strategy, you are always asking, how can I bring this amazing world I was a part of to my audience in a really engaging way?

In crowdfunding the call to action includes explaining your needs, like *we need finishing funds*. But in the overall campaign, the focus is really about why this story

is important to the world. Once the campaign is finished, you're going to keep people engaged and let them know what's happening with the film. And when the film is out, what's the next call to action? What petition do they sign up for, who can they write to, can they host a community screening? What are all the outlets for action once they're inspired by the actual story?

Tracey: *Can you share an example where the campaign story was really effective?*

Ayah: We had a documentary called *A Better Man* do an Indiegogo. It will be— and already has been—an amazing part of the movement to help end violence against women. So the story started with: how can we help end violence against women by actually looking at the abuser, and how can we help heal them so that this doesn't perpetuate?

The pitch video is incredible. It's Attiya, the director, speaking of her own story, which really pulls you in. She tells you of an abusive partnership, what it was like, how she got away, and the work that she's done to heal—not only herself, but so many others through the work she does. Through her sharing her own story so personally, and then having these questions at the end about how can we help end violence against women by looking at it from this unique angle … I think it really spoke to people.

Because of how honest, vulnerable, and open Attiya was in sharing her story, there is obviously a great direct connection point to people affected by domestic violence. But it spoke to more people too, people just touched by the story and wanting to help in some way. Incredibly, it was just one of those pitch videos where you watch it and you're like, I have to be a part of this.

When you think about cool ways that you can open up your story to the world, perks are definitely an important part. The team really got creative here. Given the nature of this film, they figured this isn't something where you're going to give a t-shirt, right? What do we do for perks? They had amazing perks where you could contribute in honor of survivors. They also had really great experiences. Actress and director Sarah Polley is an executive producer of the film, and she actually offered a chance to have dinner with the team, herself included. They had four spots available for that, so if you were a big Sarah Polley fan, you can now have dinner with her … definitely a once-in-a-lifetime perk!

It was all very successful. *A Better Man* had a fair amount of people step up with $10,000 contributions, which was amazing to see. Singer-songwriter Feist made a large contribution, which was a great press angle for them, too. And some other companies contributed as well. Don't neglect pitching larger companies and investors to get involved—what may be a large contribution for your film, may be a drop in the bucket for them!

Tracey: *How does crowdfunding fit in to the larger funding process?*

Ayah: I always set the precedent with people that unless you are coming to the table with 5 million YouTube fans and followers, the chances of you raising 100 percent of your budget through crowd-funding are rare. Right?

117

When people talk about crowdfunding fitting into the alternative financing puzzle, it fits in for sure, but there's actually the broader benefit of it as an audience builder. The value of the campaign is like a public validator that says yes, there's the body of people behind this. And once you have that public support, you're no longer just pitching the idea with a sense of "trust me." Now you're pitching hard numbers, facts, demographics, what people have been saying, what messaging works. With that you can often go to sponsors and private investors, who are often looking for more of the concrete data behind things.

Tracey: *What about other platforms and projects with social change goals?*

Ayah: Ultimately a lot of things on Indiegogo fit because there is an alchemy of "here's what's in it for you, the contributor," and "here's what's in it for the world." That's often part of many people's stories, whether that's a cool technology product, a community project, or a film. Most campaigns do have some sort of broader angle on how this will change the world. They speak to the fact that *yes, this is a cool gadget for you, but here's the broader impact that this could have.*

Tracey: *What can you tell us about the motivations of backers?*

Ayah: People will give for different reasons. One backer will give because they're your great aunt, and they don't even care what you're doing—they'll help because they love you. There will be people that care about why this matters to the world and the implications, and they don't necessarily want anything for themselves. They believe in and are passionate about the subject. There's also another group of people that want cool things. Ideally your campaign will have elements that appeal to all these types of backers.

The nature of crowdfunding is really this beautiful puzzle where the creator gets to make the project that they care about, the contributor gets to have something that they care about, and the world gets to have this broader, amazing thing. The most successful campaigns have all these pieces, and communicate them really well.

Tracey: *In what ways are you optimistic about this kind of funding for media?*

Ayah: One of the things that I love most about crowdfunding is how it's really an awesome equalizer and door-opener for people to tell their own stories. I'm super passionate about diversity in the media and having more people represented—not necessarily tokenized but represented by people telling their own stories.

What happens is that people who were not able to get through the gatekeepers before can now prove and validate that there is an audience behind them. Then, hopefully, they come out with their product and it kicks ass, and now they can get into the traditional system. It's a really great opportunity, especially for those just starting out, to prove that there are followers, not only behind the story, but behind you, which is a great way to build your career. Hopefully then we'll have a much more diverse set of storytellers out there, really able to get their works out into the world.

The Spark—The Crowd

Ayah Norris is an energetic go-getter, a kind of cheerleader for the triad of story, money, and impact. Her mantra: if your crowdfunding campaign has an absorbing narrative (story), people will *want* to contribute (money), especially to projects with larger societal goals (impact).

Indiegogo released a field guide and its section on writing a campaign pitch reads like advice easily transferable to any stage of filmmaking or financing. These are the same questions to ask before meeting a foundation or broadcaster or corporate brand.

> Make it concise and clear. Who are you? What are you raising money for? Where is the money going? How can others support you? Make it personal! Tell a compelling story of why you are passionate about your project. Present the idea in a way that makes it something others would want to support. Put yourself in the shoes of your target audience. Ask someone else to proofread your pitch.[22]

(Gotta say, it's surprising how often that last point gets missed!)

Today Indiegogo and Kickstarter are the two most significant crowdfunding platforms for media producers, with somewhat different functionality. There are dozens of others, and countless more may come online before this book even goes to print. Crowdfunding is a child of the internet. Tech platforms make it easy, and social media makes it pervasive. And for years now entrepreneurs and artists have been cashing in.

A Better Man reached, then exceeded, its campaign goals. The filmmakers sought $75,000 and were pledged over $110,000, 148 percent of the ask. The director Attiya Khan wrote a thank-you note on the Indiegogo site saying how the additional funding would be used and expressing her overall gratitude. "It has been extremely moving to witness a community of almost 1000 people step up to support this film. This gives me strength to continue to tell my story and advocate for change."

Outliers and terrific success stories feed hopes of six-figure windfalls, but most documentaries pull in more like $10,000–$25,000 across a large number of modest contributions. And those dollars can be a hard-won portion of your budget. Crowdfunding is labor-intensive and time-consuming, from conception through to fulfillment. That means sending off all those perks. But the good news is that the process gives you a wonderful early incentive to sharpen your focus. Preparing a personal pitch video and writing up the details about your creative approach and campaign goals will benefit all fundraising efforts.

Crowdfunding doubles as early audience building. If you reach a person's heart (or pocketbook), they'll be more committed during your distribution and outreach. You can take "to the bank," sometimes literally, the fact that you've got a constellation of support already surrounding your film. If you keep them engaged through production, these backers will further spread the word when the film is released. Many see this as the real incentive behind launching a crowdfunding campaign. Yes, the money is helpful, but building these audiences early is priceless.

One risk on the crowdfunding horizon is donor fatigue. It's not only emerging filmmakers who are active in this space, but also more established players, who may be rounding out much larger budgets with contributions from their already existing fan base. With information overload in all of our in-boxes, only so many messages penetrate. We give because we know the creator, or believe in the cause, or are tickled at the innovation, or keen on the perks. But each of us has a limit. "Thanks, but I already gave at the office." Yet the number of crowdfunding platforms, and therefore projects, is growing steadily.

Game-changing advancements to keep your eye on are the mainstreaming of equity crowdfunding, and the issuing of charitable tax receipts. Regulations are varied across jurisdictions, and are ever evolving, so I won't commit to print what you can expect to see in which country. But an increase in options beyond the transactional "money-for-perk" model we commonly see now should keep vitality in the system. If supporters can get tax relief or "skin in the game" for placing their money in your impact project, then **the crowd** will keep being a viable piece of the funding puzzle.

Producer's Memo

Summary Of Money Sources—*Big Joy: The Adventures of James Broughton* (Directors: Stephen Silha and Eric Slade) Funding Pitch Meeting

Hi Stephen,

First, let me thank you for introducing me to the world of the late James Broughton! I was not familiar with the work of this audacious and wonderful American poet and filmmaker. I can see why he was an inspiration for so many in the experimental arts community, the gay community and for those attracted to alternative and spiritual lifestyles. Yes, I promise to take up his challenge to "follow my own weird" …

I appreciate also the level of preparation that you and co-director Eric brought to the development pitch meeting. Your treatment was well thought out, preliminary budget realistic, and team solid. And of course your enthusiasm for the project is infectious.

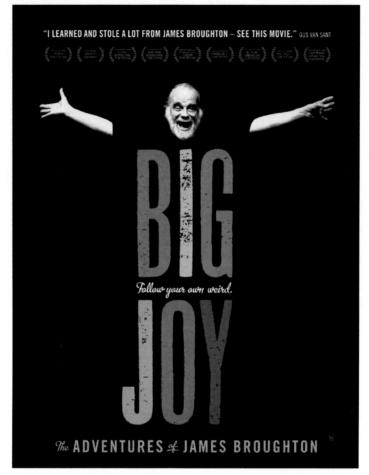

"I LEARNED AND STOLE A LOT FROM JAMES BROUGHTON – SEE THIS MOVIE." GUS VAN SANT

BIG

Follow your own weird.

JOY

The ADVENTURES *of* JAMES BROUGHTON

FRISKY DIVINITY PRODUCTIONS PRESENTS A FILM BY STEPHEN SILHA & ERIC SLADE "BIG JOY: THE ADVENTURES OF JAMES BROUGHTON"
FEATURING LAWRENCE FERLINGHETTI ARMISTEAD MAUPIN ANNA HALPRIN GEORGE KUCHAR KEITH HENNESSY AND THE VOICE OF DAVEY HAVOK
MUSIC JAMI SILBER & EVAN SCHILLER DIRECTORS OF PHOTOGRAPHY IAN RINKLE & ART ADAMS EDITOR DAWN LOGSDON & KYUNG LEE ANIMATION MICHAEL MANN
EXECUTIVE PRODUCERS STEPHEN SILHA AL BAUM JOX CHURCH PRODUCED BY MAX ST ROMAIN DIRECTED BY ERIC SLADE STEPHEN SILHA DAWN LOGSDON BIGJOY.ORG

Having said that, I'm afraid the National Film Board is going to need to take a pass on this one. I brought the *Big Joy* to our programming committee meeting earlier in the week and indeed the US-centric subject and foreign creative crew is a barrier. I know we discussed this, so hopefully the news is not too major a disappointment? As a publically funded institution the NFB can do projects with a non-Canadian storyline, and can work, in certain circumstances, with

non-Canadian directors. But not both. Resources are limited and our mandate is quite clear.

I would love to support your efforts though from the sidelines, in any way that I can. I know a couple of my colleagues here have a personal interest in the topic, too, and said they'd be happy to put their thinking caps on for you. In fact, at the committee meeting I took a few brainstorming notes which I will outline below. I know this phase is about turning over every rock to undercover resources and potential partnerships.

Your shorter glossy funding pitch document is strong. It's visual, concise, and gets to the point, in both a clear and inviting way. You've stated your overall budget projections, but then carved off an ask that's more bite-sized for this stage. You need $50K in order to conduct 30 key interviews, and you've raised $15K so far. I'm assuming that's the one foundation grant you mentioned, plus some individual donations?

In terms of motivations, this paragraph works well:

"It will be so wonderful to have you as a partner in this project. We hope you can dig deep, even in these challenging times. You will receive screen credit, regular updates on the project, tidbits of joy we find along the way—and of course the satisfaction of knowing you are adding heaping portions of Big Joy to our needy world. We will contact you within the next few weeks to see how you might be able to help."

You then list three direct forms of support: (nice touch with the third)

- Check or online donation to the White Crane Institute, a 501(c)3 in New York.
- Connections and suggestions for other sources of funding.
- Positive thoughts and prayers.

I understand you may be looking to move your fiscal sponsorship over to NW Film Forum to be closer to home and subject to a smaller administration fee. Makes sense.

So where to next?

Foundations: There are a few foundations on your initial fundraising target list. Grow it! A great job for an intern or enthusiastic volunteer is to comb through websites, catalogues, credit rolls, conference agendas, everywhere. Foundation Center (dot org) is an excellent start in the US. Make a spreadsheet, review criteria, and note deadlines for all the obvious ones. And then go a layer deeper. Be creative, channel your inner Broughton and think out of the box.

This research can be time consuming, and building the necessary relationships even more so, but it's key. These partners are valuable in that they are grant-giving, but they also become a part of your larger project ecosystem— the network that will help amplify the reach of your film. Another excellent resource is Media Impact Funders. It's an association of grant-makers, which doesn't offer money itself, but shares amazing research collected on its robust website.

Impact investors and philanthropists: The main difference between an investor and philanthropist, of course, is that the former has an expectation of some kind of financial return. In the documentary space, both are generally motivated by a social return on their contribution, but an investor may also seek equity or partial ownership of your film. This is worth considering if the offer is significant enough to justify the transaction costs, plus if you feel a simpatico connection to the individual. Someone with an actual stake in *Big Joy* could be a natural champion, perhaps offering introductions and expertise, and building buzz alongside you guys.

Your instincts have already led you to individual donors and I see you have some personal leads. Don't be shy (not that you are) in constantly putting out feelers to your community, requesting introductions. "Know anyone who might be excited by *Big Joy*, by the opportunity to create a legacy of Broughton's work?" The subject matter is niche, so you may have to dig a little deeper, but it's especially that narrow focus that has the potential to bring devoted allies out of the woodwork.

Brands: I see promise here with the corporate sector. There are brands who wish to align themselves with positive and, dare I say, "weird" stories, so as to be noticed in the crowded

marketplace. Any major business which has publically declared support for gay rights would be your no-brainer starting point. Think also about purveyors of experimental art, perhaps progressive media outlets—maybe even condom manufacturers. City administrations can be unexpected bedfellows, too. If an urban center is featured prominently in archival footage or with a present day shoot (such as San Francisco), you might be able to squeeze out a grant or another form of in-kind service support.

Crowdfunding: Have you considered a crowdfunding campaign? Kickstarter or Indiegogo are the two main go-to sites, though others are bubbling up. Know that it's labor intensive, but a fabulous way to begin building your core audience and project champions. And being that you are already in the mindset of earned income through merchandise (T-shirts, Broughton's books, jewelry, etc.), it may be easier for you to come up with the necessary clever perks.

The key here is a compelling story, not just for your film, but for your overall campaign. You need to be in it—and hey, you and Eric *are* compelling yourselves, so that's a big help! Appeal to the greater good. It's not just that you, as filmmakers, wish to produce this project, but rather that you, as creators, are working in service to humanity, bringing this inspirational tale to life. *Big Joy* will have a positive impact on our world.

On a practical level you'll need to set targets (I suggest realistic ones to start) and a timeline (1–2 months is typical). You also have to determine whether you want flexible funding (you keep whatever is pledged) or fixed funding (you only get the money if you reach your goal). And don't forget to research the tax considerations. No such thing as free money under the IRS (or our CRA).

Good pitch: Check out BRITDOC's signature partnership-building event. It started in London, but has spread to other locations, including New York and California. *Big Joy* feels like a perfect fit for San Francisco. It's rigorously competitive, as to be expected, but if you were selected, you'd receive hands-on workshops leading to a public pitch (more like a "love-in") to a table of carefully curated potential

partners, in front of hundreds of invited guests. Best part is the diversity in the room—foundations, brands, NGOs, platforms—all inspired by the power of film to effect change.

There are other valuable programs you can apply to as well, like labs, incubators and mentoring initiatives. They are often associated with major film festivals or industry organizations. Great way to get creative support, plus hook into a cohort of like-minded artists.

Stephen, I hope some of this will prove helpful as you continue your financing journey. Pulling together a scenario that works for all parties can be such a house of cards. I understand you are now heading to a small island off the West Coast to do a strategic retreat with your key team. It's a great time to confirm that your vision, values, and artistic and impact goals are aligned. This will bode well as you approach promising partners in the spirit of mutual benefit.

Though the NFB was not able to come on board, I will continue to follow your unfolding story with interest. Please do not hesitate to be in touch if you have any further questions.

Warmly,

Tracey

Flash forward

Stephen, Eric, and the team raised over $400,000 in production financing and released the feature documentary in 2013. A pivotal moment was an invitation to IFP's Independent Filmmaker Lab in 2012, one of ten projects selected from a batch of 230 submissions. *Big Joy* has gone on to play dozens of festivals in 14 countries, has been broadcast on public TV stations, and spawns a well-supported, robust website. Through Gathr, communities can arrange public screenings, and it's available for purchase on iTunes, Amazon, and others. I screened the joyous documentary during the DOXA Film Festival in Vancouver with a lively and appreciative crowd. Yes, after all Canadians *did* eat up James Broughton, Big Joy, and the chance to "follow our own weird"!

(See Appendix 1 for *Big Joy* Financing Scenario.)

Worksheet 4—Your Funding

Warming you up
List three typical ways to source new funders.

1.

2.

3.

List three alternative ways to source new funders.

1.

2.

3.

List three downright ridiculous ways to source new funders.

1.

2.

3.

What's the most successful example of stakeholder mission alignment you've seen in someone else's project?

What's the most successful example of stakeholder mission alignment from one of your past projects?

Your project
Your idea "sells itself" through your own passion and conviction.

On a scale of 1–10 how much do you believe (in your heart of hearts) that your project:

_____ is original?

_____ is viable?

_____ is meaningful to others?

_____ has the right team involved?

_____ will be well-crafted?

_____ is ready to go to market

_____ will have a positive impact?

Look at the lowest two numbers and write down one way to increase them!

1.

2.

List benefits and challenges of financially partnering with each of the following.

	Benefits	Challenges
Foundations		
Impact investors		
Philanthropists		
Brands		
Crowdfunding		
Broadcasters		
Theatrical distributors		
Educational distributors		
Institutions		
Public funds		
Friends and family		

Make a pie chart with your ideal blend of financial partners in your production.

Make a pie chart with your most *realistic* blend of financial partners.

Make a pie chart with your ideal blend of supporters in your social impact campaign.

Detail five resources, aside from money, that would be helpful to your project.

1.

2.

3.

4.

5.

How are you reaching out and increasing your connection to:
– your community and network?

– the cause at the core your project?

– to potential partners?

Impact

Impact is Fire—
Igniting Movements!

I've shared with you my special blue book number one, *Switch*, which gives me inspiration on **story**, and publication number two, *Good Pitch New York 2014*, which motivates me to think differently about **money**, and now we'll look at text number three, *The Dragonfly Effect*, as a way of framing **impact**. The social change outcomes we'll dive into over the next several chapters include **awareness-raising, engagement, context, behavior change, policy reform, and international action**. Movements are ignited when the fire of impact catches and spreads, and some powerful strategies to spark that are outlined in *The Dragonfly Effect*.

This little gem was passed to me while I was on contract as Director of Media for Mindset Social Innovation Foundation's *Access Our Medicine* initiative. Mindset had a partnership with the Centre for Digital Media in Vancouver, allowing us to work with a team of master's level students. Their collective thesis was to form the basis of our strategic campaign about more equitable access to life-saving drugs. One of the professors recommended *The Dragonfly Effect*.

The simple metaphor is that the dragonfly body represents the core concept, and the wings the necessary maneuvers for achieving change. All

> When designing a call to action, think about ease. Is what you are requesting crystal clear and simple to fulfill? Extra kudos if it's also fun.

four dragonfly wings need to work in harmony, or the unfortunate creature loses speed and direction, and could come crashing down. The wings are made memorable with "Focus & GET": focus, grab attention, engage, take action.

What became *Access Our Medicine* had a few iterations before I joined that team. It was earlier known as the *Open Health Initiative*, driven by a passionate businesswoman and philanthropist, who believed no one should die because of an inability to pay for medicines. She was critical of the pharmaceutical industry's costly research and development practices and inspired by innovators who sought more open source solutions. Mindset instigated a series of graduate research papers on the topic, and extensive, high-quality interviews with about 40 experts. Now, how to package this for public consumption? How to Focus & GET? How do you create impact with your project?

Focus: Massive topics are easier to wrangle if they have at their core one key objective. Ideally this goal is designed with the end user at the front and center. Consider what moves them, what motivates them? It should be clear, actionable in bite-sized pieces, and measurable. Can you quantify specific intended outcomes? Finally, bonus points if it brings happiness—to you, and to your audience. Remember the bright spots.

Grab attention: *The Dragonfly Effect* adds a subtitle to this section: *how to stick out in an overcrowded, overmessaged, noisy world*. Similar to the ingredients we covered in the story chapters, impact messages are enriched by a personal and emotional touch, and an element of surprise. Unique points of view and humor attract attention. Can you use imagery to show rather than tell people your tale, and even find ways to trigger their other senses?

Engage: Once you are clear on a goal and have people's attention, how do you maintain it? We return again to storytelling principles. Good narratives have suspense, tension, and significant barriers blocking our hero. The stakes are high. What could be more intense than someone living or dying based on whether existing drugs are within reach? You need your audience to empathize and to do that, you must empathize with them. Be authentic and curious and open about your values.

Take action: This is what leads to impact. When designing a call to action, think about ease. Is what you are requesting crystal clear and simple to fulfill? Extra kudos if it's also fun. Can you incorporate an element of game play, or competition, or a reward structure? Consider a range of options that can be customizable or selected à *la carte* depending on user preferences. Personalize the actions and empower people to spread the campaign further.

Now all four elements may not need equal weighting and they could change over time. The dragonfly configuration may shift for different contexts, stages, types of movements, and in response to others who are pursuing similar impact.

At the point when I was on the Open Health Initiative team at Mindset, we were working to repurpose the bounty of interview material, to put it into critical public service. A feature doc? A TV show? A series of shorts? Experimental animation? Interactive website? Educational modules? It was all on the table.

Quantifying reach, predicting impact, and forecasting a relative social return on investment (SROI) proved challenging however. Watch out for the chicken and egg game. Do you shape the stories at hand to build toward the most closely related social change opportunities, or declare resolute impact goals and reverse engineer and augment the material to achieve them? I wasn't able to solve this.

After my departure, one part of the project evolved into an online campaign with a Declaration for Universal Access to Affordable Medicine at its heart. There's a well-designed website with a live signature counter, infographics, ongoing news, and personal stories. A big red button tells you to "Add Your Voice. Sign the Declaration." Does it adhere to the Focus & GET model?

- Clear and measurable objectives for **focus**: check!
- Evocative imagery to **get attention**: check!
- Personal stories to more deeply **engage**: check!
- Easy ask that empowers people to **take action**: check!

The Dragonfly building blocks for *Access Our Medicine* are indeed evident. An impact funder and producer, with burning personal goals, got it off the ground. In a perfect world, it'll now take on a life of its own, morph and multiply. Over time, successful social campaigns, led by colorful and resilient dragonflies, transform from idea to mission to **movement**.

Motivation—
What Kind of Change Do You Want?

If you bookmark only one website on IMPACT, make it www.impactguide.org. BRITDOC's continually updated *Impact Field Guide & Toolkit* is a gift.

Back in the section on "story," we riffed on motivation and the meaning of art. The Culture Group gave us food for thought when considering how culture influences social movements. The *Impact Field Guide* offers something similar, with its own flavor.

1. Documentary makers rock at storytelling and storytelling inspires change.
2. Documentaries are culture, and culture leads change.
3. As catalysts from outside, we can bring new energy to an issue.

Storytellers witness, synthesize and then reflect back the issues of our times. Your personal passions might drive you to a certain subject matter, but it's your creativity that brings that issue to life. Many filmmakers have or develop deep roots into the organizations that ultimately use their films as tools for advocacy. Those on the front lines of social change are the important multipliers that press these projects into action.

As an external catalyst, media makers play a role in how a larger story is told, received and put to use. What kind of change do you want? And those you portray?

Let's be mindful as media-makers to respect the depth of commitment and knowledge of the activist community. As a filmmaker you might move from this topic to another, whereas the movement leaders may be dedicating their whole lives to this cause. To create fruitful partnerships, part of your job in development is to understand where the change efforts are targeted, from *their* point of view. What kind of change do they want? And then, what kind of story do you want to tell? Are they aligned?

Some social change struggles are hard to argue, so there is little resistance to related cultural products. How many people would openly declare that systemic rape in the military should continue unabated, or that child molestation, gender discrimination, or the inhumane treatment of animals, is a good thing? Filmmakers approaching these topics tend to have virtue on their sides.

Others are met with serious opposition, especially when those in charge prefer the status quo and do not want to make room for dissenting voices, a.k.a. "speaking truth to power." Documentaries profiling whistleblowers, eco-warriors, or even average citizens being critical of corporate culture can be trickier to get made.

At the NFB of Canada, I produced two films around the same time about the military and conscience. *Raised to Be Heroes* (director: Jack Silberman) features Refuseniks, Israeli selective objectors who refuse to participate in military operations in the Gaza Strip and the West Bank. They pay a steep personal price, but in the courageous act of sharing their story, they may inspire other conflicted youth to consider their options. Though the dialogue about peace and democracy is at a societal level, the change takes place within individuals. It's about personal responsibility and acting in accordance to your conscience.

Breaking Ranks (director: Michelle Mason), a co-production with Screen Siren Pictures, tells the story of US war resisters seeking refuge in Canada after fleeing the Iraqi war. The film hearkens back to the Vietnam War era, when US draft dodgers were welcomed by the tens of thousands. Then Prime Minister Trudeau famously declared "Canada should be a refuge from militarism."

This film seeks a similar response from the current Canadian administration. The majority of Canadians did not support the war, nor did the Canadian government, yet despite Parliament twice voting to let the resisters stay, they remain at risk to be thrown from the country. Immigration decisions are coming up negative. In this instance, the film seeks to affect public policy. One of the major characters is a lawyer (himself an ex-pat and draft dodger) and a through line is the very question of whether the war itself is legal, let alone moral.

There is no narration, so that the soldiers may share their stories and perspectives in their own words. Audiences are then free to make up their own minds, now that they are armed with more information regarding Nuremberg principles around what constitutes a war crime, Canada's refugee history, and the notion of the "poverty draft."

The War Resisters Support Campaign is featured throughout *Breaking Ranks*. Rallies, events, and meetings are shown, with a final on-screen cue to the viewer to learn more online. The Campaign's site contains template letters to politicians, summaries of court decisions, petitions, and a donation link to further support their advocacy actions.

As a public institution, the NFB could not promote a particular position related to these or any other subject. What it can do, with its arm's-length relationship to government, is to provide a space for an artist to express his or her views. Both films are considered POV projects, carefully researched and yet allowing that the perspective of the director will enter the creative treatment.

These examples also illustrate the difference, sometimes subtle and often fluid, between "bottom-up" and "top-down" change. The *Impact Field Guide & Toolkit* gives helpful definitions.

Bottom-up change, as seen in *Raised to Be Heroes*, begins at the level of individuals and their relations to each other. People see themselves, and the very dilemmas that touch their own families, portrayed on the screen. That personal identification process generates reflection and dialogue, an important precursor to activism: "the fundamental belief is that without these communities becoming stronger and understanding themselves better in their own right, no real change will ever be possible—however many famous victories are achieved."[23]

Top down-change, as seen in *Breaking Ranks*, squarely targets the system. How can we present a case that provokes a reconsideration of laws and public policy? Personal stories are used to show the real effects of the policy, and increasing public awareness is a step in process, but it's specific legislative reform that is the end game. Top-down change "says that the formal structures of society dictate pretty much everything about how that society works, and that as such the ultimate goal of change campaigns needs to be to change those structures."[24]

Of course, top-down change is accelerated if the masses at the "bottom" are activated, and bottom up change is finally entrenched when the "top" is converted. As an external catalyst, media makers play a role in how a larger story is told, received and put to use. What kind of change do you want? And those you portray? Be clear on the **motivations** of everyone and your film will have a deeper impact.

Worksheet 5—Your Goals

Warming you up
List three causes that are important to you.

1.

2.

3.

What actions, if any, have you taken to support them?

List three causes that are important to a close family member.

1.

2.

3.

What actions, if any, have they taken to support them?

List three causes that you think get too much media attention.

1.

2.

3.

Name one project, not your own, which inspired you to act.

© 2016, *Story Money Impact*, Friesen, Routledge

What was motivating?

Was it a top-down (i.e. systems) or bottom-up (i.e. grass-roots) approach to social change?

What was your action?

Name one social issues project that turned you off. Why?

Your project
Describe how the world is different five years from now when your project achieves its intended impact.

What excites you most about that?

What is the greatest barrier preventing that outcome?

Time to Focus & GET![25]
Focus—name one crucial goal for your project.

Grab attention—name one strategy for getting noticed.

Engage—name one story ingredient that will further involve your audience.

Take action—name one doable activity that will benefit your cause.

Now try it in a (majorly run-on) sentence:

The goal of my project is to_____,
by_____,
engaging audiences _____,
so that they can_____.

For example: (Inspired by *Just Eat It*. See Chapter 30.)
The goal of my project is to get people to throw away less food, *by* pledging myself to eat only scavenged food for six months, *engaging audiences* in a visceral way about the colossal volume of wasted food, *so that they can* be motivated to shop differently (*and* eat their leftovers)!

Producer's Journal

Awareness Building (Impact Outcome 1)
Shameless: The ART of Disability
(Director: Bonnie Sherr Klein)

October 2003: Lots to share about my day today. When I met Bonnie for lunch this afternoon I was awkward. And then awkward for being awkward and hating that I was that way. So then trying, overly hard, not to be awkward. The restaurant on Granville Island was selected in part for its accessibility. She and Michael have a condo nearby so she can motor her scooter over directly without having to deal with cars or cabs or any other such inconveniences experienced daily by a person with a physical disability.

Peg Campbell was to meet us at Isadora's Bistro. Peg and I got there first and picked a table. Close to the door, with room to maneuver. Peg, like Bonnie, is a filmmaker. She, like so many of us, knew and admired the work Bonnie did before

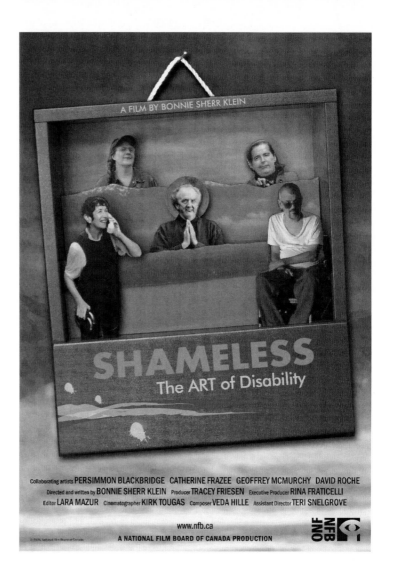

A FILM BY BONNIE SHERR KLEIN

SHAMELESS
The ART of Disability

Collaborating artists PERSIMMON BLACKBRIDGE CATHERINE FRAZEE GEOFFREY MCMURCHY DAVID ROCHE
Directed and written by BONNIE SHERR KLEIN Producer TRACEY FRIESEN Executive Producer RINA FRATICELLI
Editor LARA MAZUR Cinematographer KIRK TOUGAS Composer VEDA HILLE Assistant Director TERI SNELGROVE

www.nfb.ca
A NATIONAL FILM BOARD OF CANADA PRODUCTION

NFB
ONF

her stroke. Some of the National Film Board's most famous documentaries out of the Studio D era were directed by Bonnie. Most notable is *Not a Love Story*, about pornography, known as the first film about pornography from a woman's point of view.

Almost two decades before this lunch Bonnie had a massive stroke. She was in her mid-40s. After years of rehabilitation,

years spent getting used to a "new normal" as a person with a disability, getting to know a new community, finding her voice as a disability activist, she felt ready. Ready to reengage with the documentary world. Peg knew this and proposed a biographical story about her life. A woman at her artistic height experiences a major medical setback. Then the road to recovery and triumphing over the tragedy.

Lunch today was a "get acquainted" affair. Mostly for me. Of course, I'm fairly new to my job as a producer at the NFB. These women are much more experienced, many years my senior. And … I've had *so* little direct time spent with people with disabilities.

When Bonnie arrived there was a kerfuffle. I stood up and then sat down, then stood up and then walked over to the door. Greeted her by leaning down for a hug, meeting her where she is, in her chair. Awkward, but worked. And then managing, along with the restaurant staff, to ensure there was a clear path to our table. Then wondering, will she transfer from her scooter to a chair or stay put?

I realized she was going to attempt to shuffle across to sit on a chair. She grabbed her canes for support. Am I meant to assist, or get out of the way, or spot her like a gymnast? At that moment, it felt to me like this was the first time she'd ever done this maneuver and that she'd be sure to fall, perhaps breaking a bone. Of course, she does this all the time. All. The. Time. But for me, it was a first.

Without looking around the room, I felt eyes on us. Sympathetic, curious, some wanting to be helpful, others wanting to give us privacy. Bonnie made the move and then smiled at us, looking neither exhausted, nor triumphant. Just another dance step in her daily routine. I tried to look casual, scanned the menu and asked some small talk type question about whether either of them ate there routinely. Any recommendations?

Then I glanced at some of the other patrons. I found I didn't feel shy or embarrassed about the mini-scene; felt a kind of pride instead. But now I think it was maybe too much pride. Like, *look at me, integrating all sorts of different people in to my life*. But really, on the inside I was self-conscious. Wanting so much to "get it right" that I barely had half a

chance to just be myself. I sure hope I've got what it takes to produce this film.

January 2004: Met Bonnie and Peg at the office today. Seems the more Bonnie got into the idea of being a film subject, the more she thought about collaboration. And once collaboration felt within reach, she got to thinking about directing herself. Co-directorship came up, but I've concerns based on past experiences. Besides, part of the criticism with the collection of work done on disability-related subjects at the NFB (and elsewhere) is that almost all the films are *about* people with disabilities, rather than *by* people with disabilities. Bonnie has been reassessing her strength and energy and time, and feels that yes, she just might be ready to get back in the director's chair. We began negotiating a parting of ways with Peg, who is graceful and understanding.

June 2004: "Casting," if you can call it that, for Bonnie's documentary is done. Looks like we're going to pull off her vision of having other artists with disabilities co-create the film together with her. There will be five in total, including Bonnie, sharing their lives, warts and wheels and all. There's a range of disabilities—quadriplegia, facial difference, learning disability, and mental illness. There's a range of artistic disciplines—dance, comedy, writing, visual arts, and of course, film. There's also a range of sexual orientations, and people seem willing to go there. In Bonnie's words: "It's quite the motley crew!"

We've been looking at CVs for cinematographers, sound recordists, assistants. Unfortunately, we do not know any candidates with disabilities at this time. I hope that soon changes. But for now, this'll have to be a carefully curated professional crew. Lots of sensitivity needed, and patience— and humor. The more I get to know this community, the more I realize that wit and sass go a long way. And we're going to need all the help we can get. The shoot takes place in three Canadian provinces, including a small town in the Maritimes, plus a stint in San Francisco. Logistics are complicated. It's tricky for some people to fly, for others to put in a full day …

July 2005: Kirk Tougas, Bonnie's cinematographer, was in this morning, dropping off what should be the last of

the tapes. We're prepping the material for the editor. Lara Mazur is planning to hole up in a little cabin behind Bonnie's Sunshine Coast home for the next several weeks. The shoot has gone great, scads of material, and what fun it's been getting to know this gang. People I might not otherwise have become so well acquainted with. They're becoming friends.

October 2005: I'm on the ferry returning from Robert's Creek. I spent all day working with Bonnie and Lara on the assembly, which is nearly four hours long at this point. That's both scary, and to be expected, I guess. We made good progress on identifying what stays, what goes, what needs to be better set-up or paid-off to create a satisfying narrative arc. I can feel the power bubbling out of this film already, how it might affect audiences, our society. We're seeing people with disabilities as their full actualized selves. Talking—with each other—about sex and family and pain and art.

I particularly like the rough cut of the scene where the fivesome is trying to name the film. We honestly still don't have a title, and they shot a brainstorming session attempting to come up with one. On the shortlist: *Not a Crip Story, Piss on Pity, Exposing Ourselves, In Your Face, Shameless, A Freak Show* ... I'll add these to the dozens I have on my list at the office. Colleagues have made recommendations, so have family and friends. There's a bottle of champagne on the line for the winner!

May 2006: *Shameless: The ART of Disability* just had its world premiere as the opening presentation at Vancouver's DOXA Documentary Film Festival. What a night! Sold out performance in a huge venue and never have I seen so many wheelchairs in one place at one time. But candidly, it was the rest of audience, the general public, that had my attention. What were they experiencing, absorbing? There was lots of laughter, a few tears, vigorous applause. Great appreciation.

The first-person storytelling brings an authenticity that's fresh to this topic. This film, made by a group of artists, has not set out to change any specific legislation or societal behaviors. Its impact will be felt in the hearts and minds of viewers, and in shaping their attitude toward others. The

ripple effect of that can be huge. Many people simply do not have anyone with disabilities close to them in their lives. And yet, as Bonnie is fond of saying, if you are blessed to live long enough, you too will get to experience disability! It affects us all ... eventually ...

September 2006: Bonnie just got back from London. *Shameless* screened at the High Commission of Canada in front of dignitaries, politicians, media, and disability activists and artists: people who influence public opinion and can spread the film through their networks. Last month it was Cuba, where Bonnie was treated like a rock star. It's a radical move there, bringing disability out of the shadows and onto the (crumbling, nearly inaccessible) sidewalks.

Now, a couple years after that Granville Island lunch, I've had dozens and dozens of outings with Bonnie (plus many other media makers with disabilities like Murray Siple and Kirsten Sharp and one of the *Shameless* co-creators, Dave Roche ...) And, like all of us who are unique and complex, some people who are "differently abled" (a fashionable term today) are uptight about PC language and others not. Some are easy to offend and others not. Some are gracious, going out of their way to make everything stress-free for those around them, others not. OK, obvious perhaps, but we're all just folks. My **awareness raised**, people with disabilities have become a part of my everyday world.

Impact Outcome 2— Engagement

Back at the campfire, we meet five more guides. After a brief introduction to each and a short summary of a project they refer to, we again sit back and soak up the learning. (Again, longer biographies can be found in Appendix 3.) Their experiences are from the front lines, direct and relevant. After the conversations, I try to consolidate their counsel under themes, along with further practical advice. Grab the marshmallows …

Everyone, including donors, has their own agenda. That's the challenge of fundraising, to understand what their motivations are and determine if there is a way to work together. ANDREA SEALE

The Firestarter—Andrea Seale, David Suzuki Foundation

Andrea is the Deputy CEO at the David Suzuki Foundation. In addition to assisting the CEO in overseeing the entire organization, Andrea also leads the DSF Development team. As a volunteer, she has served on the board of Vancity Community Foundation, Modo (a pioneering car sharing cooperative) and the Association of Fundraising Professionals.

THE FLAME—*FORCE OF NATURE: THE DAVID SUZUKI MOVIE*

Directed by Sturla Gunnarsson, 2010, Canada

"This feature documentary profiles the life and work of world-renowned Canadian scientist, educator, broadcaster, and activist David Suzuki on the occasion of his last lecture in 2009—a lecture he describes as 'a distillation of my life and thoughts, my legacy, what I want to say before I die.' As Suzuki reflects on his family history—including the persecution of Japanese Canadians during WWII—and his discovery of the power and beauty of the natural world, we are spurred to examine our own relationship to nature, scientific knowledge, and sustainability throughout modernity and beyond."[26]

The Campfire Convo

Tracey: *What is the connection between the David Suzuki Foundation and Dr. Suzuki himself?*

Andrea: David is a public figure with a national following because of his work with *The Nature of Things*, his activism, and his career as a scientist and an academic. So he is a special voice for Canadians. Because of David's personal attributes and career, people listen to the David Suzuki Foundation in a way that they're not necessarily listening to all the other environmental groups that are doing great things.

Achieving an environmental mission is very difficult. In the last few years we have realized that there is a great need for us to engage the public more deeply for really finding ways for individuals to get involved in the work. So we've been making a lot of effort to build up and care for and encourage a community of individuals. Whereas before our focus would have been more on decision-makers or on politicians, a smaller group of people. Now we consider our "audience" to be much larger than ever before.

Tracey: *What sort of strategies have you brainstormed in terms of that kind of public engagement?*

Andrea: For us the spectrum of engagement begins with the broadcast kinds of media that we're involved in. For example, David has a weekly column called "Science Matters" that goes into hundreds of community newspapers and on many websites. Every week something from David and the David Suzuki Foundation is going out there to the world, including from our website. The first level of engagement is very, very broad. We're constantly putting information out there and it reaches millions of people but we don't really necessarily have deep interaction with them.

And then the next level of engagement would be the people who we actually know, the people who are on our email list, the donors. People we can actively speak to and they will talk back to us and work together. This includes volunteers—we have thousands of volunteers that work in different ways with us.

Then beyond that we have a group of people that we have invested in to support them to be environmental leaders in their own way. That's an example of our most engaged group, where it actually takes a lot of time to get to know them and build the relationships, and make it something useful to them and to our conservation purpose.

Tracey: *It's interesting to think about how media, specifically the* CBC's The Nature of Things *(on the air for decades) has been to the work of the Foundation.*

Andrea: Yes, *The Nature of Things* made David a household name. Since then we've done some research to understand how people perceive him. Do they see him as a television personality? Do they see him as a scientist? Do they see him as an environmentalist? We found that people see him as is an environmental activist. But *The Nature of Things* has contributed greatly to people's environmental awareness and curiosity about nature. It's an amazing show. For many Canadians this was their main exposure to the wonders of science for many years.

Tracey: *And then more recently there was the feature documentary* Force of Nature: The David Suzuki Movie. *Why do you think people seemed to connect so well with David and his story?*

Andrea: It wasn't what you'd expect. It wasn't solely about the environment and fighting for sustainability. It was the human story of parents and family. Many people could relate to David, around prejudice, struggle, achievement, family. We had a great experience with the film from the Foundation because it told the story of our co-founder in a new way. This was a different kind of attention than David had had before. And as one of the most famous Canadians, people really enjoy learning more about him and understanding his origins and his Canadian values. He's a hero to so many people, and the film illuminated more of who he is.

Tracey: *Does DSF get approached very often directly from media-makers who are looking for support or partnerships?*

Andrea: We definitely get approached and sometimes we have been able to put money into a project if it's really on point with a campaign that we're doing. Our budgets are never big and we don't usually make grants. But we have helped to fund a handful of media projects. We have given money, but we also try to get involved by publicizing it and getting people to it and being part of the content in some way.

When these opportunities come in it's often a quirky avenue and then if there's time, if there's capacity, if we have donors who are funding us for specific things, and if the film can fit into achieving some of those goals then great, we'd want to participate in it in some way.

Tracey: *When you think about your donors, maybe an individual philanthropist or a small family foundation, what are their motivations?*

Andrea: Everyone, including donors, has their own agenda. When I think about what funders want, it depends on what kind of funder you're talking about. It's so different for each one. That's the challenge of fundraising, to understand what their motivations are and determine if there is a way to work together. It takes a lot of time to figure that out and bring the right projects forward as possibilities.

I'm sure a lot of our donors would be interested in films and in media-making as a part of achieving their goals. There are probably some knowledge gaps with us as an organization, not fully grasping the potential or not having experienced what it could look like to be involved in a media project, yet we're the ones needing to sell it to the donor in a way. So we as the organization need to embrace it as a strategy first.

There's also a challenge in that it may require faith on the part of a donor to say, *Yes, I will fund this*, even though they may not know exactly how the final product will turn out, or what the point of view might end up being.

Tracey: *What advice do you have for filmmakers seeking partners?*

Andrea: You could look at it as traditional fundraising, I suppose. Finding out who donates to causes, getting someone to open a door for you, bringing a new idea to the donor. And I believe it's a good idea to consider individual donors rather than institutional foundations because foundations have more constraints on just how easy they can be with granting. You need someone on your team who is naturally good at making those kinds of connections, to build up a community of donors. Increasing credibility by having the right people involved as advisors or in some kind of formal way would also be helpful.

Film funding is opaque to most regular people, and there's an impression—probably inaccurate—that it's glamorous, and everybody's spending a lot of money. So there's learning that each of those three parties need to do in order to be successful together (filmmakers, funders, activists).

The Spark—Engagement

The David Suzuki Foundation, based in Vancouver BC, is a fundraising foundation that supports and conducts charitable activities, rather than a grant-giving organization. Its communication efforts center around building a community of supporters, those who believe in its core mission of protecting the diversity of nature. DSF's Andrea Seale introduces the critical concept of the "ladder of engagement." Also known as the "pyramid of participation," it's a clever way to understand how you are connecting with your friends, fans, and donors.

First some semantics: reach is not engagement, and engagement is not impact. For your important message to be heard, first you must **reach** your

audience. This is a tally of the number of people who are simply *exposed* to your project. Then you must **engage** those you have reached. These are the folks who take some sort of *action* as a result of seeing your work. Finally, to claim you've made an **impact**, those actions need to result in measurable *change*. Find them, inspire them, and then delight in watching them flourish as change agents in your shared cause!

The pyramid here is in the inverse, balancing on its tip. Your largest layer will be the first, at the top, and your goal around engagement is to move people toward more active participation. The final grouping is much smaller, but they are the pro bono rock-stars of your campaign, working alongside you to achieve your objectives.

1. **Watchers**—becoming aware of the issue.
2. **Responders**—liking and/or commenting on the work.
3. **Sharers**—endorsing your project by signing on or forwarding content.
4. **Donors**—giving money to you or the cause.
5. **Participants**—volunteering or becoming involved offline.
6. **Creators**—partnering with you or producing their own related projects.

You should communicate with each rung of the ladder in a different way. To the extent you can use robust online tools and management systems, you'll target people with a message appropriate to their current position, with the aim of converting them to an even greater degree of engagement.

To increase reach, the producers of *Force of Nature: The David Suzuki Movie*, maximized another crucial market segment: schools. Fitting your project into an educational curriculum enhances the valuable multiplier effect. One smitten teacher can lead to hundreds of pairs of (captive!) eyeballs over the years on your social impact film.

Led by the NFB of Canada, the distribution team created a four-part teacher's guide for secondary students. There are over 60 pages in total, chock-full of activities, assignments, and discussion topics, complete with pedagogical links to learning outcomes. "Selected excerpts from the documentary can be used to support the teaching of these topics individually or, when shown in its entirety, the film offers an extremely effective interdisciplinary examination of the ecological crisis at hand and the role of sustainable development."[27]

As part of the launch, Dr. Suzuki made himself available for two days' worth of Virtual Classroom sessions. Thousands of students and educators had real-time access to ask questions, share ideas, and hear more first-hand stories from the renowned and entertaining scientist. The level of connection was reportedly dynamic and lasting. Many of these youth likely climbed a rung or two on the ladder of **engagement**, now more active themselves in the protection of our environment.

153

Impact Outcome 3— Context

The Firestarter—Debika Shome, Harmony Institute

Debika is deputy director at the Harmony Institute, a research center that studies entertainment's impact on individuals and society. She leads a diverse team working at the intersection of media, social science research, data science, and technology.

> We wanted to give storytellers, and the people that support them, tools and knowledge that could help them reach and activate audiences. DEBIKA SHOME

THE FLAME—*AN INCONVENIENT TRUTH*

Directed by Davis Guggenheim, 2006, US

"Director Davis Guggenheim eloquently weaves the science of global warming with Mr. Gore's personal history and lifelong commitment to reversing the effects of global climate change. A longtime advocate for the environment,

Gore presents a wide array of facts and information in a thoughtful and compelling way. 'Al Gore strips his presentations of politics, laying out the facts for the audience to draw their own conclusions in a charming, funny and engaging style, and by the end has everyone on the edge of their seats, gripped by his haunting message,' said Guggenheim. *An Inconvenient Truth* is not a story of despair but rather a rallying cry to protect the one earth we all share. 'It is now clear that we face a deepening global climate crisis that requires us to act boldly, quickly, and wisely,' said Gore."[28]

The Campfire Convo

Tracey: *How did the Harmony Institute's focus on impact begin?*

Debika: Millions of dollars were being spent each year on media for social change but there was little work being done to understand what impact it was having on individuals and on society. We wanted to give storytellers, and the people that support them, tools and knowledge that could help them reach and activate audiences.

When we started doing this work in 2008, the funding community was leading the charge. They wanted to go beyond the anecdotal and that feeling in your gut to better understand actual impact. Certainly not quantifying it all down to one number, but being able to see a mix of the quantitative and qualitative, to see a social return on investment. Media makers were also really interested in understanding their impact but they were understandably cautious.

It's a controversial and evolving field. But we are not connected to any film or foundation so we try to be as impartial as possible. But it can be fraught with a lot of emotion when you are trying to understand the impact of something as hard to define as a story.

We started off looking at how media could affect audiences, in terms of changes in knowledge/comprehension, attitude and behavior and then we expanded that to look at change at a micro (individual), meso (group), and macro (societal) level. It's become a 3 × 3 matrix. Sometimes a film is created to change comprehension at an individual level and sometimes a film is created to change policy at a national level.

A movie like *The Cove* could check many boxes. It's an issue that was not widely known. So maybe their goal was to change knowledge. Whereas a movie like *The Invisible War* came out and the creators wanted to change legislative policy at a national level. Or *The Act of Killing* came out and they didn't necessarily want to change policy, but to open up and change the conversation.

Tracey: *Can you please describe StoryPilot?*

Debika: We had been doing these deep dives into individual media projects and spending considerable time and resources to understand impact. I think that is still valuable, but it made us realize that there was this untapped opportunity to go beyond a single media project and understand how each of these projects fits into the larger conversation. One movie about climate change is interesting but how does it relate to all the other movies that come out about climate change?

How do all of these in aggregate or individually relate to the changes in conversation about the issue over time?

StoryPilot is a free, interactive web application that helps filmmakers and change-makers explore the social impact of documentary film. It provides a holistic view of these films through innovative data analysis and visualizations. It gives filmmakers who may not have the resources or technical expertise to access this data and analysis on their own. They can gain a nuanced understanding of trends and strategies and opportunities for innovation. StoryPilot—the Beta version—launched in Summer 2015. At launch it had 464 documentaries across 16 social issue categories like education, environment and natural resources and health. We will keep adding films and issue categories in the future.

So StoryPilot gathers information from a collection of sources like film metadata, box office numbers, Wikipedia search volume, social media conversation, and Congressional-level policy discussion. We launched StoryPilot with a base amount of data and analysis, but we will be adding additional datasets and analysis as we progress with the app.

When you view all of this information together, you start to get a clearer picture of the role that media can play in social change over time. That comparative and longitudinal analysis is integral to understanding impact. With a lot of films you study the impact three months out and it might not be enough time to see the impact the film has had. We were talking about *An Inconvenient Truth* and it's still having impact now even though it came out many years ago.

Tracey: *Who are the end users for StoryPilot?*

Debika: Our target audiences are storytellers, media funders, social issue advocates, impact producers, media researchers, and educators.

Tracey: *What are central story ingredients to make an impactful film?*

Debika: It's funny because we're not storytellers. I'm a researcher, so all aspects of story are fascinating to me. We work with storytellers to understand their impact and start to see patterns and trends emerge. Personally, I think emotion is where many of these films succeed because if you don't connect with your audience emotionally you are going to have a hard time changing their attitudes or behaviors or leading to action.

Tracey: *What's one film you think best exemplifies powerful impact?*

Debika: I worked at Columbia University before I came to the Harmony Institute, and the big game changer was *An Inconvenient Truth*. For us climate change researchers you could definitely feel the "before and after" of *An Inconvenient Truth*. Before I would talk about what I did and people would say "oh that's interesting." They didn't understand it. It wasn't mainstream at that time to talk about climate change. And then after the movie came out, to this day it's a very different conversation and I definitely think that film could be credited with a great deal of that change.

157

I remember back in 2007, I was going to work and there were these two teenagers on the subway with me. And they were talking about *climate change* and even mentioned the film. And it just blew my mind! They had most of the facts correct and I started eavesdropping on their conversation, because it just never happened before that normal people were talking about climate change, and even about the science behind it. It seems antiquated now, but at the time it just blew me away.

I was so surprised by their interaction that I immediately wrote it all down so I wouldn't forget the details. The boy says, *if we don't do something in 40 years the temperature outside is going to be like 300 degrees*. And the girl says, *I don't believe you and anyways in 40 years, who cares I'll have had my kids*. And then the guy says, *but your children's children will never have a chance to have kids. And in 40 years it is going to be so hot outside you will only be able to survive if you have a damn good air-conditioner. But the solution is there we just need to invest in clean energy!*

I tell you, my head was going to explode. I'd been working on these issues for years and very few people cared or talked about it.

Tracey: *Why was* An Inconvenient Truth *so successful, in your opinion?*

Debika: I think it was a great story with a charismatic storyteller. It weaved in scientific information in a compelling way but was also a very emotional tale of one person's experience over time. It turned an abstract concept into something tangible and pressing.

They also had some innovative approaches to outreach. They launched The Climate Project that trained volunteers from around the world to spread the message at a grass-roots level by giving an adapted version of Al Gore's talk. I think those people are still doing that now. That was one way of magnifying and extending the reach of the film. The timing was perfect … But yes, when I heard those two kids on the train, it blew my mind.

The Spark—Context

In our media-saturated, noisy environment, you can't expect everyone to catch your message. In fact, realistically speaking, relatively few do. We all have countless ways to spend our time and thousands of topics to engage our attention. If I'm a passionate social issues media-maker, I know that even with my own unique voice and access, my film is a part of a larger context, an ecosystem of projects moving the needle on the cause.

Geralyn Dreyfous at Impact Partners talks about *pods* of films building on momentum, by "standing on other people's shoulders." Rather than declaring them competitive titles, one film on their roster about Alzheimer's was seen as complementary to the other. As a company,

they develop a certain expertise and a larger Rolodex of overlapping stakeholders.

Likewise at the research center of the Harmony Institute, they often think in *clusters*. Debika Shome and the team use big data analysis, impact measurement, and visualization tools to evaluate how media effects social change. What else is happening on a global scale at the same time? What systems level awareness is entering the public consciousness? What other films are contributing to a similar dialogue?

The Harmony Institute's StoryPilot is a web platform that allows users to examine certain films within a constellation of similarly themed projects, to learn more about the effects of context and critical mass on media activism. "No films exist in a vacuum. Discover how films are changing the world through their social issue connections, partners, online campaign strategies, critical and popular reception, and social media conversation."[29]

Not surprisingly Debika is a big believer in filmmakers designing for impact and then properly measuring it. HI's *Impact Playbook* makes an excellent case for paying careful attention to evaluation. So pay attention![30] There are intrinsic reasons (you and your partners will be better positioned to add value to the movement); community reasons (better audience engagement); pragmatic reasons (proving to supporters that you can make a difference); and strategic reasons (allowing you to modify your ongoing campaign, and better plan your next one). By feeding this analysis back into the system, we can all learn from each other how to make stronger media.

Though produced before this era of robust impact measurement practices, *An Inconvenient Truth* is still a superstar in the world of social-issues feature documentaries. Everyone has heard of this film, from the young man on Debika's subway ride to your grandma. In this instance, it's less a case of critical mass and more a matter of context, timing, and tone. The presentation approach and affable tour guide make this film accessible. It simplifies a complex topic and adds a dollop of emotion, key ingredients for effective storytelling. People may have been hearing the phrase "climate change" for a while, with a foreboding sense that they ought to ask more questions. *An Inconvenient Truth* lands as their just-in-time answer.

The further brilliance of the campaign was in training ambassadors (nearly 3000 to date!) to deliver the climate presentation in all corners of the globe. These gatherings would reflect local realities and create the conditions for community dialogue. Before joining the Harmony Institute, Debika co-authored the report *The Psychology of Climate Change Communication*. The value of group discussions is underlined. A range of experiences, skills, and types of information are brought to the table, and

people "devote more energy to implementing solutions after participating in a group discussion."[31]

This insight bodes well for filmmakers who roll out grass-roots screenings. The collective experience of watching a film, or cluster of films, together and then talking about it, amplifies audience engagement. Higher engagement means an increased chance of behavioral changes and actions. Set your project in a rich and ready **context** because, as we know now, action leads to impact.

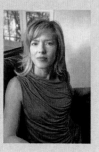

Impact Outcome 4— Behavioral Change

The Firestarter—Johanna Blakley, PhD, Media Impact Project

Johanna is the managing director and director of research at the Norman Lear Center, a research and public policy institute at the University of Southern California's Annenberg School. She is also co-Principal Investigator, with Marty Kaplan, on the Media Impact Project (MIP), a hub for collecting, developing, and sharing approaches for measuring the impact of media.

> People have this sense that story is something incredibly magical ... and that "capturing hearts and minds" is something that you can never really plan for. And I don't think that is true at all.
> JOHANNA BLAKLEY

THE FLAME—*WAITING FOR SUPERMAN*
Directed by Davis Guggenheim, 2010, US

"For a nation that proudly declared it would leave no child behind, America continues to do so at alarming rates. Despite increased spending and politicians' promises, our buckling public education system, once the best

161

in the world, routinely forsakes the education of millions of children. Oscar®-winning filmmaker Davis Guggenheim (*An Inconvenient Truth*) reminds us that education "statistics" have names: Anthony, Francisco, Bianca, Daisy, and Emily, whose stories make up the engrossing foundation of *Waiting for Superman* … However, embracing the belief that good teachers make good schools, Guggenheim offers hope by exploring innovative approaches taken by education reformers and charter schools that have—in reshaping the culture—refused to leave their students behind."[32]

The Campfire Convo

Tracey: *Can you please tell us about your documentary impact measurement project?*

Johanna: We had a series of conversations probably for a year with Participant Media's vice president of the social action division about how we should work together. They are about a mile away from us, and their mission is almost exactly the same as ours—in terms of finding ways to utilize entertainment and media and for positive social change.

We suggested that we do an academic study, where they would know whether their movies had some sort of impact. So we picked three films, *Food Inc.* as the pilot study, *Waiting for Superman* was the second one, and the third was *Contagion*.

The Annenberg School in particular has been a center for this kind of study, which is called Entertainment Education, since the late '70s. Mostly it was international work, so even people in the field don't think of it as being done much here in the United States. This work included things like radio soap operas in Afghanistan that teach people how to not step on a land mine. But once we established our Hollywood, Health & Society program with funding from the CDC, we were able to start using entertainment education methods in Hollywood with big prime time television shows. We felt like we were finally reaching a mega media industry that would produce a piece of content that would be seen by a billion people a year.

So with the Participant project, we convinced them that they needed an outside academic study of some of their films to see if they were succeeding or not. And so far, I think the evidence has been quite strong that they have succeeded. If you have the resources to do a social outreach campaign, if you have clear messages in your film, and if the film is really engaging there is a very good chance that you are going to have a lot of people who are profoundly affected by it.

Tracey: *Are there details you can share about some of the research, say with* Waiting for Superman?

Johanna: We created a control group which is the key difference between the type of survey research that we are doing and what is typical in the field of media effects research. So what we did is we checked to see if people who were otherwise very similar—ideologically, demographically, in terms of their aesthetics, and viewing habits—exhibited different behaviors based on exposure to the film. So we wanted to find out if a person who saw the film was actually more likely to do the kinds of things the film recommended, compared to a person who was very similar who did not see the film.

The social action team at Participant had some specific things that they were hoping that parents would do after seeing the film and I thought this was really the most moving set of results. We found that parents who saw this film, compared to other very similar parents who didn't see the film, were more likely to look up ratings for their local schools, and they were more likely to read with their children 30 minutes a day. This is a wonderful thing to be able to claim, that this film successfully convinced people to read to their kids more!

Tracey: *How many people responded in this study?*

Johanna: The full complement was 2700. It was a conscious effort on our part to try to figure out how small of a sample we could use and still create a matched control group. And it worked perfectly; we actually had more beautifully matched groups with this study than we did with *Food, Inc.* So we were very, very happy. We are excited because this lowers the barriers to entry for all kinds of indie filmmakers, who may not have huge audiences.

Tracey: *What have you seen and learned around story that can help a filmmaker design for impact?*

Johanna: It's psychology and sociology and communications and media studies and cinema—there's a billion different approaches. I'd say that the one that has really guided a lot of work in the field of entertainment education, where you are trying to embed certain educational messages into some piece of media, whether it's fictional or non fictional, has to do with behavior modeling.

People develop empathetic relationships with characters on screen. We have found in our research that they are more likely to remember educational messages that are uttered by people that are on the screen who look like them. So women remember what women say, Hispanics remember what Hispanics say, and the closer the person on the screen gets to your demographics, the more likely you will recall that message and the more likely you will act on it.

People have this sense that story is something incredibly magical and amorphous and there is no way that you can nail it down and that "capturing hearts and minds" is something that you can never really plan for. And I don't think that is true at all. I think you can do some very sophisticated survey research in order to figure out what kinds of story elements capture people's attention and really stick with them. You can do some very interesting analysis which we've done in the past in order to chart to what degree an empathetic response to a story is correlated with taking action later. So, how do you go about creating that engaging story that leads to social action? I think that survey research can really help you identify, *Aaahhhh, these are the key differences.*

Tracey: *Do you have anything specific that you might add as it relates to documentary filmmakers?*

Johanna: I think most documentary filmmakers, especially the ones that reach a fairly broad audience, get grant support and have some sort of action in mind. They realize that they have lots of choices that they can make, lots of aesthetic

choices and storytelling choices. I think many of them feel that it's not their job to do the social action part. But the filmmaker who truly is interested in trying to achieve some sort of impact should become literate about some of the methods they can use in order to optimize that possibility—with their website, with their social media presence, even the channels they decide to use.

Tracey: *I would love to hear how you see the intersection of story, money, and impact working at its best?*

Johanna: It works best when all of the missions are aligned. If the people holding the purse strings are in line with the filmmaker's mission, this is absolutely crucial. I think in the past there was a lot of misalignment, because the methods for measuring impact were too costly or not very sophisticated, and so filmmakers, and media makers of all kinds, could accept grants from organizations and promise certain kinds of outcomes, and then not really have any solid evidence to demonstrate whether the goals were achieved or not.

But from the studies that we have done over the last 15 years, we know that media can be very, very effective. If you can get people to watch it and it's well made then, at the very least, people will know more about the topic, and quite often if they agree with it, they will act upon that knowledge. We just haven't been very good about measuring connections between those things in the past. I think we are going to get better.

Tracey: *Sounds like you are coming from a place of optimism for the media in general?*

Johanna: Yes, because people are very dismissive of the field of entertainment. They think it is just this nasty distraction in the world. They don't take it seriously. (I think that people are just so overwhelmed by it that they dismiss it.) If we did have the kind of research on a large scale like we've been able to do here at the Lear Centre, people will take media more seriously. They will be more careful about what their kids are watching, and they will be more astute about what they themselves are watching and listening to. Critical engagement levels are going to rise. That is a great step forward for our society. Media plays a huge, huge part in our lives and I believe people will learn to take that more seriously.

The Spark—Behavioral Change

Johanna Blakley is intelligent and captivating, with a twinkle in her eye that hints a surprise may be coming. Just like with a great film, you lean in with anticipation. Her work at the Norman Lear Center's Media Impact Project is groundbreaking. Again, as with a great groundbreaking film, you appreciate the innovation and relevance.

I first saw Johanna speak at Hot Docs Canadian International Documentary Festival on the subject of Media as a Tool for Social Change.

Food Inc. was the main case study presented, with research commissioned by Participant Media. The results were conclusive—that documentary elevated viewers' awareness and changed their behavior. Those who saw the film shopped more at their local farmers' markets, ate healthier food and were more likely to talk to others about food safety.

The secret sauce in the Media Impact Project's rigorous process is the statistical practice of controlling for propensity. And if that sounds like scientific jargon, well, that's because it is inspired in part by medical research.

Again, before evaluating audience behavior changes in their next documentary study, *Waiting for Superman*, they split the survey sample into two groups of people with matching levels of predisposition to watch the film, but one group had and one had not. Sound simple? Not really, but Johanna reminds me that she has ready access to university statisticians. Not a luxury most filmmakers can boast, but thankfully MIP is committed to being as open source as possible with their techniques and findings.

Turns out *Waiting for Superman*, another Guggenheim film, is also doing powerful work in the media landscape, now quantitatively provable by the research. A great number of variables will always be tricky to measure, like context, timing, resources, and the alchemy of a specific production team. But in terms of sparking change, the social action group had clear impact goals and specific behaviors they were hoping to inspire. After seeing the film, people did indeed show a greater tendency to:

- look for information about improving public education;
- encourage friends, family and colleagues to demand better schools;
- donate books or classroom materials to schools;
- volunteer or mentor a student.

With some Media Impact Project input, Participant Media then went on to initiate The Participant Index (TPI). Combining targeted surveys with conventional data from a film's release across revenue streams and social media, the system assigns a score. The post-screening audience survey assesses the degree of knowledge of the issue, the emotional impact, and social actions taken.

The initiative was covered by the *New York Time*s:

> Do grant-supported media projects incite change, or are they simply an expensive way of preaching to the choir? Ultimately, the answers may help determine which projects get financed, which formats are favored and how stories are structured … More immediate, those behind the effort say, new measures of social impact will enable sharper focus and

rapid course corrections in what have often been guesswork campaigns to convert films into effective motivational weaponry.[33]

These tactics are not without controversy, with critiques bubbling up about methodologies, motives, and the potential of unintended outcomes. But a generous interpretation is to appreciate deep evaluation as one tool among many for those of us who strive to use media to effect social change.

For instance, as a filmmaker, how intentional are you being with your call to action? Are you working closely with your funders and impact campaign partners to ensure ongoing alignment? While staying committed to your artistic sensibilities and storytelling prowess, can you anticipate what behaviors your film might elicit? List them out!

It could be that awareness-raising is your main intention, or the dream is nothing short of massive legislative policy reform. Either way, personal behavior changes are key. They indicate that your message was heard, and they pave the way for larger movement building. Like the "ladder of engagement," behavior tracking is on a scale. On the simple end, people will look for additional information, or discuss your film and its issues with others. More motivated viewers might join an organization or contact a politician. It's all good. But you'll have a better chance of success if you strategize in advance and measure after. At its best, impact media-making is about changing hearts, minds and **behaviors**—and bonus points if you can later show proof that you did.

Impact Outcome 5—Policy Reform

The Firestarter—Sheila Leddy, Fledgling Fund

Sheila is executive director of Fledgling Fund, playing a key role in developing its overall strategy in collaboration with the president and board. She plays a leadership role in developing grant guidelines, reviewing projects, and assessing their potential to advance its mission.

> Ideally filmmakers would be using data in a way that's positive and that will continually inform their strategy and not be focused just on what was the end goal but thinking about it as a learning opportunity.
> SHEILA LEDDY

THE FLAME—*ESCAPE FIRE*

Directed by Susan Froemke and Matthew Heineman, 2012, US

"ESCAPE FIRE examines the powerful forces maintaining the status quo, a medical industry designed for quick fixes rather than prevention, for profit-driven care rather than patient-driven care. After decades of resistance, a movement to bring innovative high-touch, low-cost methods of prevention and healing into our high-tech, costly system is finally gaining ground.

Award-winning filmmakers Matthew Heineman and Susan Froemke follow dramatic human stories as well as leaders fighting to transform healthcare at the highest levels of medicine, industry, government, and even the US military. ESCAPE FIRE is about finding a way out. It's about saving the health of a nation."[34]

The Campfire Convo

Tracey: *What is the Fledgling Fund?*

Sheila: We are a small private foundation that works primarily with social issue documentary film with a primary focus on outreach and audience engagement. We are interested in how you connect film or story with the social change movements that are either existing or emerging. How do you put that story to work in the world in pursuit of social change around whatever issue the film is talking about?

Audience engagement grants could be early planning grants, somewhere in the neighborhood of $10–15K, to allow a filmmaking team to bring someone on to help craft a strategy.

Another category of grants are for implementation and would be for projects that come to us with a strategy and a plan in place but they have a specific funding need, and we think that our grant can play a role to take that project to the next level.

Tracey: *As a private family foundation, what was the original motivation behind putting all of these resources into the media impact space?*

Sheila: Fledgling Fund is about 10 years old and founder Diana (Barrett) really had the vision. She never wanted to be just a check writer. She wanted to look for a place for where we could use the funding strategically around social change. So we came to this space not as film funders but as funders of social change and with the interest and desire to affect large complex social problems. We did some experimenting in the media space and found that given our level of resources this seemed to be an area where we could add value, beyond just the grant. We could see gaps in this particular area of funding around outreach and audience engagement and we wanted to use story and film to do that.

I think we also understand that film is one piece of a large puzzle around social change. It can contribute to movements, but I don't think that you can point to too many films and say that this particular film solved it. But you can point to examples of where film has really had an impact on moving an issue forward in a significant way.

Tracey: *When you consider the grantees is there one project that really typifies that sweet spot of story, money, and impact?*

Sheila: *Escape Fire* is an interesting film as an example. They understood the larger change process, the target audiences they needed to reach, and how to reach

them. The story line around pain management in the military opened up opportunities to screen that film at the VA and at the Defense Department and it led to some policy change in terms of how that is managed.

The other thing that is interesting is that the team was looking downstream: how are we going to change and shift the way we view health care in the United States? They did a screening tour at medical colleges, to reach medical students, which was very targeted, very smart, very in line with their theory of change. They also figured a way to provide an incentive to really encourage practicing physicians and other clinical providers to see the film by partnering to make CME credits available. There is case study on our website that provides more detailed information on this project.

Tracey: *What is the difference between a "theory of change" and a "call to action" and how does story play into it?*

Sheila: A theory of change is how you see change happening and it helps you to build a strategy and vision for how your film can contribute, and who it needs to reach to have that impact. A call to action flows from that strategy but is more tactical.

At Fledgling Fund we are drawn towards character-driven films—where you can connect with a character and then you use that character to illuminate a larger issue. Of course, there are certain issues where you may need more experts in the film. It depends on how complex the issue is and what role you see that film playing. We also consider shorter films. Sometimes a 40-minute like *Inocente* or even a five-minute film can have huge impact and be a powerful tool when you are looking at a broader kind of movement.

Tracey: *What story elements do you think are most essential?*

Sheila: Take a project like *Food Chains*, the characters within that film are compelling. There are three different stories, which makes it more universal. The workers add something new to the equation in my mind. We don't often see the workers that pick our food. They really shone the light on that. And, it connects those workers to our own personal buying decisions. You can see how the story unfolds and how that product moves through the market.

Every storytelling/filmmaker who is engaged in this space probably comes at it for very different reasons. They are attracted to a story and feel a passion to tell it, for sometimes very personal reasons. When we are looking at grantees and potential film projects to fund, we are looking for that commitment to the social impact aspect of the project. To go beyond making the film but really seeing it used, and sometimes that means that the filmmaker will play a really strong and active role in the campaign.

Tracey: *What advice do you have for filmmakers in sourcing and approaching other partners?*

Sheila: I think that if you are looking at nonprofit partners who might help you either craft your campaign or even be a partner in the actual implementation

169

of that campaign, it's really important to focus on the mutual benefit—not just how they can help you but how the film/campaign can help them, how it might reinforce their message, how it might help them broaden their own base, reach new audiences.

It's best not to lead with *Can you send my film out to your listserv?*, but to really think about creating authentic partnerships where you're figuring out what the alignment is between the goals of these non-profit organizations and your own film and goals. Also, there are funders who may be interested in a particular issue that your film is addressing, so you want to think about how your film can help them achieve their mission, how it fits within what they are doing, or maybe how it helps their grantees.

As filmmakers are making their films and doing their research and developing their stories, they are coming into contact with organizations and learning about initiatives and campaigns that may down the line become partners. If you look at the amount of time that documentary filmmakers spend getting to know an issue as they are making their films it is pretty amazing. It's so critical to have the filmmaker involved in the impact campaign, because they really have been immersed in the issue. And then the impact producer can then help solidify partnerships and figure out other campaigns that may be happening.

Tracey: *What is your opinion of the emphasis on "impact evaluation"?*

Sheila: It's great to have more tools and they will continue to emerge. We have access to more information than we have had before, which I think is great, and we are figuring out new ways to aggregate that. All of that is valuable to the field and to filmmakers. The trick is figuring out the right tool for your particular project.

Ideally filmmakers would be using data in a way that's positive and that will continually inform their strategy and not be focused just on what was the end goal but thinking about it as a learning opportunity. Social change takes a long time. All of these projects are operating in an environment that is constantly changing, with lots of different stories and pieces of media coming out. Understanding where you're gaining traction and understanding how it is contributing to the larger goal is really valuable. Having data to help you understand that is critical; however, not everything can be measured.

I think that a lot of these tools have emerged because we have access to big data and it's easy to focus on the numerical metrics. But, we need to understand the *why*. Why are we measuring, over what time period? Why is it important? And most importantly, how are we going to use it? We also want to make sure that we don't lose the "small data" that helps give context to those larger numbers: The stories and anecdotal evidence. Ultimately we need to think about different kinds of data and evidence and recognize that each project will likely use a slightly different mix that is based on their own strategy and goals. We tell our grantees to think about developing an "impact story" based on multiple sources of information.

The Spark—Policy Reform

Fledgling Fund wrote the book on impact media. Well, if not the book, then certainly the *report*. And well before many of us had quite connected the dots. *Assessing Creative Media's Social Impact*, presented in early 2009, is a seminal work routinely referenced. The founder of Fledgling Fund, Diana Barrett, is also one of the founding members of Impact Partners. She's clearly carrying the media impact torch! Her first hire was Sheila Leddy, equally passionate about the power of film to effect social change.

Filmmakers produce one-off documentaries for as many different reasons, and combinations of reasons, as there are films. For some, it's a vocational pursuit, a stimulating way to earn a living. They might have entered via another craft, like shooting or editing. For others it's an art form, and perhaps they take their expression to an experimental level. We have such directors to thank for pushing the boundaries of the genre with innovative content that inspires growth in the field.

For many it's all that, and it's a valuable instrument, a means to bring attention to a cause about which they are passionate. If you create films to create change, then how do you measure and makes sense of your success?

Consider your own work as we look at a simplified version of Fledgling Fund's "Dimensions of Impact" model.[35] They've mapped out an effective methodology for capturing indicators.

1. **Quality media:** This is your primary tool, so make it count. Review the essential story ingredients, engage talented collaborators, and produce a gem.
 Sample ways to measure: Festival play, wide distribution, critical acclaim.
2. **Increased public awareness:** This is the first step on the path toward impact, so ensure your messaging is clear.
 Sample ways to measure: The size and diversity of your audience, press, your social media footprint.
3. **Increased public engagement:** This shows you that people are affected, so be certain you've given them something to **do**.
 Sample ways to measure: Active participation related to your film, both online and offline.
4. **Strengthened social movement:** This is that beautiful moment when things begin to take on a life of their own.

Sample ways to measure: Increased project partnerships, screenings for decision makers, and uptake of advocacy organizations using your film – running with it!

5. **Social change:** This is what it's all about …
 Sample ways to measure: A shift in public dialogue, policy reform, legislative change.

Sheila mentions *Escape Fire* as one strong example among several hundred films Fledgling Fund has supported. It is indeed an ideal case study on which to overlay their Dimensions of Impact approach. The film has an articulated theory of change, captured and shared in a thorough report created by Third Plateau.[36]

- The "Sphere of Control" or direct *actions* included making and distributing a well-crafted film, which would generate buzz and earn the attention of the public and decision-makers.
- The "Sphere of Influence" or intended *responses* were to build partnerships, increase understanding of the issues, and move the focus public discourse from "access of care" to "quality of care."
- The "Sphere of Concern" or desired *outcomes* were a change in industry practices and policies, and a more empowered population. finally, better health outcomes for **all**.

Achieving measurable positive change within entrenched social issues areas takes a multi-pronged approach—and time. More than just weeks or months, sometime years or even generations. The healing activated by *We Were Children* may be seen in the grandchildren of the residential school survivors. Even with the reach of film *DamNation*, it could be a decade before the last defunct dam is removed. Snowden's whistleblowing, made mainstream in *CITIZENFOUR*, will influence successive political administrations. The same can be said for *Escape Fire*: a forceful "impact arc" has a long tail.

Though ESCAPE FIRE-inspired legislation has yet to be written into law, the film has clearly been utilized as a tool to educate policy makers and validate issues surrounding healthcare in the military. The film has created a shared platform for policy makers to discuss issues and move forward to introduce bills that embody ESCAPE FIRE's call for higher quality and integrative healthcare.[37]

It's important to note that almost $500,000 in campaign funding was raised for *Escape Fire*, half from the Robert Wood Johnson Foundation. Yes, filmmaking can be costly, but so are the strategic activities related to getting a film out into the world to do the good work that it's been designed

for. That is why those rare organizations like Fledgling Fund are so vital. They put real money toward sector research, capacity building, skills development, and film campaigns. Quantitative analysis on impact metrics is crucial, but so is qualitative analysis, or the big picture story. Supporting the outreach of well-crafted media leads to stronger movements, **policy reform**, and positive social change for everyone.

Impact Outcome 6—International Action

The Firestarter—Beadie Finzi, *Britdoc*

Beadie is one of the founding directors of BRITDOC, a non-profit film foundation based in London and supporting filmmakers globally. In addition to executive producing a number of films at the foundation, Beadie is also responsible for global programs including Good Pitch and the Impact Award.

We are trying to measure the social impact of a piece of art—it's a complex thing. We say, embrace that complexity. But let's help each other, the filmmakers and the funders, to make smart choices . . .
BEADIE FINZI

THE FLAME—*VIRUNGA*

Directed by Orlando von Einsiedel, 2014, UK

"*Virunga* is the incredible true story of a group of brave people risking their lives to build a better future in a part of Africa the world's forgotten and a gripping exposé of the realities of life in the Congo.

In the forested depths of eastern Congo lies Virunga National Park, one of the most bio-diverse places on Earth and home to the planet's last remaining mountain gorillas. In this wild, but enchanted environment, a small and embattled team of park rangers protect this UNESCO world heritage site from armed militia, poachers and the dark forces struggling to control Congo's rich natural resources. When the newly formed M23 rebel group declares war, a new conflict threatens the lives and stability of everyone and everything they've worked so hard to protect, with the filmmakers and the film's participants caught in the crossfire."[38]

The Campfire Convo

Tracey: Virunga *is a film that seems to deliver on the promise of story, money, and impact. How did it come about?*

Beadie: Director Orlando (von Einsiedel) first came to see us at BRITDOC when he was going off to make a little short film for Al Jazeera about this fantastic program rehabilitating mountain guerrillas. We thought, that sounds like a lovely film about a great project but it's a short, not a feature. But while he was there, he began to stumble across a much more complex and interesting story. Absolutely classic, this happens all the time.

To make a feature length documentary you really need a solid and nourishing and complex story. That's story development. And classically filmmakers can get into something, can get fascinated or intrigued by a given topic and you just have to give it a bit of time to be able to tease out the complexity, and wait for change to happen.

So when he comes back and starts to tell the story about what's really happening there, what he really found, we were completely slack jawed. We were like, *Holy shit. First of all you need a really good lawyer and secondly you need some major security detail and protection around you.* And so keeping the filmmaker safe was important and assisting them with the best kind of creative support. I mean we were in the edit most weeks for a very, very, very long time. You have to be patient to wait for the story to play out.

Tracey: *What creative elements have contributed to* Virunga's *success?*

Beadie: Well it's an environmental thriller, isn't it? It is a highly dramatic "whodunnit." It's got the cuddly animals—will they or won't they make it—and that's been working naturally for decades. It's got our valiant heroes, absolutely classic kinds of narrative elements to it, which make it compelling. And it's complicated. Good filmmaking is often not made with the most simple stories. This is trying to figure out what are the forces at work here and what is really happening in the story. A challenge is presented and will they surmount it? It's wonderful because it works on so many levels. We successfully follow a number of characters, who are well sewn into the narrative. Very satisfying.

Tracey: *What are some additional story ingredients needed to make a high impact documentary?*

Beadie: The most base and elemental piece of connection from an audience member to the screen is usually your protagonists and what we feel for them. Are they compelling characters, do they move me—even if they are someone doing something very wrong—what do I feel? It's the human connection between characters. A filmmaker's essential skill is not only finding an extraordinary story but actually finding the best subjects to help tell it. That surely is the most fundamental piece of our craft. That instinct. The second thing is transition. Most long form films require some kind of change, whether that be in the life of the individual, or in the life of the institution. And you actually need the patience to let that happen, see that through and see how our subjects respond.

Tracey: *What were some of the other sources of funding on* Virunga*?*

Beadie: We assume in the current marketplace that almost no broadcaster will come in until the movie is nearly done. Or "rights holder," because in this case it was Netflix who ended picking up the lion's share of all the rights globally.

So a film like this absolutely relies 100 percent on foundation, philanthropy, special interests and a few international film funds like us. But because of the nature of the journalism it was actually quite tricky to share early details about the project. They had to be kept very under wraps. When the movie is done and it's fantastic, then it gets picked up by a major rights holder for a lovely big deal!

Tracey: *What advice do you have for crafting a strong call to action?*

Beadie: First thing is to understand what are the key messages of your film. And what is the context into which this film arrives in terms of the whole of the movement? Who is doing what, what are the key campaigns and goals and opportunities? We break things into four different kind of impact dynamics, which are: changing minds, changing behaviors, building communities and changing structures.

Then there is a whole piece of analysis of what's this movie really about and who needs to see it, given its properties and given the moment that it comes in. It's a really interesting piece of process—not only your own film and the effect it will have on people but actually on society right now and the strategic audience that you are trying to reach.

Tracey: *Please explain the value of impact measurement.*

Beadie: Without the evidence we are sunk. Now BRITDOC has always been entirely driven and motivated to help filmmakers make the very best artistic work, and where it is appropriate to help them create ambitious and really effective impact strategies with those films. And to connect them to new funders and campaign partners to make sure those impact strategies are realized. But for us, fantastic films comes first.

So we are actively encouraging evaluation. Why? Because first and foremost we believe filmmakers need to better communicate the extraordinary impact their films are having in the world. Secondly, they need to be able to evaluate that to secure new funders and maintain existing funders. If I'm going to ask a grass-roots organizer or leading campaign organization to partner with me, then I need to demonstrate what the project might deliver that their own army of experts, campaigners, lobbyists or researchers can't deliver?

Evaluation is not a congratulatory vanity exercise. This is not about scoring ourselves against other films. It is actually, if done properly, a process and you should be learning from it. And actually across the impact filmmaking field as a whole, we are learning from each other. Evaluation matters, because it is the key to make more change happen faster.

Tracey: *How are filmmakers responding to an increased emphasis on evaluation?*

Beadie: It can create real anxiety. People are freaking out thinking, what if funders become obsessed with the wrong kind of evaluation and they demand too much from us. Is it going to stifle creativity? We know all of this and we need to keep our nerve. We need to just keep reviewing all these options and keep asking the question, what is it that works for us?

What are the tools and the techniques that capture the very particular properties and qualities of our documentary film campaigns? Which, by the way are increasingly sophisticated strategies, taking place over years and playing out at multi-levels from grass-roots to the legislatures.

Let's calm the filmmakers, get them to think practically and sanely and strategically about what evaluation is right for them and their film. This is complicated. We are trying to measure the social impact of a piece of art, of a piece of media—it's a complex thing. We say, embrace that complexity. But let's help each other, the filmmakers and the funders, to make smart choices …

The Spark—International Action

Where do I start with BRITDOC? Full disclosure, I've an industry crush on these guys (well, actually it's mostly gals). They're the bees knees, media impact heroes. First off, I love their structure. BRITDOC is walking the talk of alternative funding models by being one themselves. It spun out of Channel 4, led by former commissioning editors there, who went on to add major supporters, the Bertha Foundation, and PUMA. Stop for a second and consider that. A charitable trust, supporting documentary filmmakers worldwide, which has been a partnership between a broadcaster, a philanthropic organization, and a corporate brand.

I've already sung the praises of BRITDOC's *Impact Field Guide & Toolkit*, which is to date the most fulsome online aggregation of documentary impact case studies and practical tools I've encountered. I've hinted at their Circle Fund, which they leapt to create as soon as they received charitable status in 2013. A small table of philanthropists hand-select a well-positioned independent project to give a no-strings-attached grant to in support of its completion or outreach.

Then there's BRITDOC's Impact Award, which honors films that have created "significant and measurable social or environmental impact."[39] Reviewing the thorough application form is itself instructive. They are looking for solid evidence of reach, of changes in awareness and behavior, of political and corporate impact, and of capacity building. For example: "what other organizations are using your film at the grass roots or for strategic campaigning?" A reminder of the importance of multipliers for your launch, groups who will say "at last, *just* the tool we've been waiting for!"

I attended the Impact Awards in 2013 when *The Act of Killing* won, an impressive and important documentary. But it was meeting characters from the nominated film *Bully* that had a lasting personal effect on me. It was an act of bravery for the parents of a child who had committed suicide to share their story on film. That night they saw how their publically articulated vulnerability had translated into a project that now touched millions of lives, and had quite possibly saved some, too.

But BRITDOC's global showpiece is Good Pitch (see Chapter 13). *Virunga* was one of the seven films featured in New York in 2014. Shadowing the event, I saw the team behind *Virunga* prep for a full weekend, then publically pitch their project in front of over 300 invited guests. Director Orlando von Einsiedel was mildly disheveled from an intense launch schedule but clearly passionate and affable. The next day he hosted a focused follow-up round-table session with potential supporters. That 90-minute brainstorm "summit" included just a half a dozen people, but they were all well placed to assist the project, and keenly interested in the topic. Aha, mission alignment …

What struck me most that morning was how the filmmakers never asked for money. The end goal, protecting the park, was always front and center. Their website, promo materials and campaign activities reflect that. The people in the room had much to offer—intelligence, introductions, ideas. They asked questions like: What does safeguarding look like? How will you empower local activists? Is there a system of information sharing? What is the UNESCO component? Where is litigation at? What's happening here in the US? What do you need from us? And (implicitly) would our financial

support assist you in your critical efforts? I've little doubt money later changed hands, but it wasn't made the focus of this meeting. Rather, it was the story and the impact.

Beadie Finzi says that to make a feature length film you need a "solid, nourishing and complex story." *Virgunga* may not have started out as a complex topic, but it definitely grew into one. Without BRITDDOC's hands-on and patient support, the film may not have achieved such a high-quality level, nor gained the traction it has. Because of its attention to compelling storytelling and courageous social change goals, this documentary incites **international action.**

Producer's Memo

Summary Of Impact Outcomes—*Just Eat It: A Food Waste Story* (Directors: Grant Baldwin and Jen Rustemeyer) Campaign Strategy Session

Hey Grant and Jen,

It was a real pleasure spending part of yesterday afternoon all together in that cramped little boardroom at the Hive. Next time a roomier space, OK? And hope you got home in time for the babysitter?

Phillip Djwa and his team at Agentic Digital Media are as thrilled as I am that your film *Just Eat It* won the VIFF Impact Award. A first for all of us. We're thrilled for the Vancouver International Film Festival to run with the idea of honoring a documentary best poised to create positive social change; for Agentic and Story Money Impact to partner as co-sponsors; and for you two. Well, you've already won a fistful of awards, but perhaps not one like this that gives

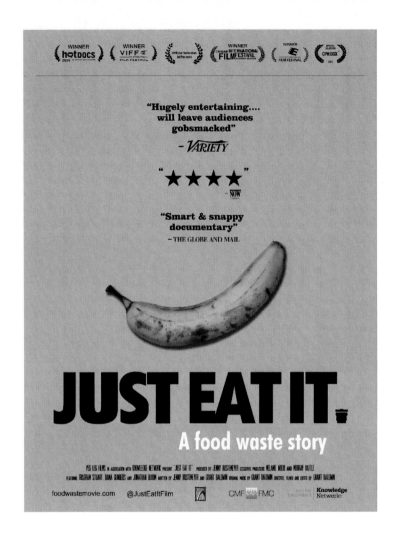

you some cold hard cash and in-kind support toward your outreach campaign.

Though you are clearly in the weeds with the intensity of your fall festival schedule, not to mention new baby boy (!), I think it's great that you slowed down long enough this week to talk about strategy for a few hours with me, Phillip, and his team. Hard when you are between premieres and airplanes: last week Calgary, next week California, soon Copenhagen and Amsterdam. But it's important to build time for

proactivity in and among all the reactivity you are inevitably facing when you have a runaway hit.

I'm writing today to summarize the notes that were all over the whiteboard. I've broken them down into the same topics as our meeting agenda. Further below I've listed what we could cover in a second campaign strategy session.

Engagement: First, I noticed on your website (looking better and better every day BTW) that your new press kit has been uploaded. I'm assuming this is now the locked off short synopsis:

"Filmmakers and food lovers Jen and Grant dive into the issue of food waste from farm, through retail, all the way to the back of their own fridge. After catching a glimpse of the billions of dollars of good food that is tossed each year in North America, they pledge to quit grocery shopping and survive only on discarded food. What they find is truly shocking."

I like it, very Upworthy. It's focused and attention-grabbing. Right now, this version lacks a concrete way for the audience to become engaged and take action. But then I saw these phrases on your site and they do make a more direct appeal:

"Delicious entertainment—you'll never look at your fridge the same way again."

"We all love food. As a society, we devour countless cooking shows, culinary magazines and foodie blogs. So how could we possibly be throwing nearly 50% of it in the trash?"

Remember that Phillip identified list building as a top priority. Getting people to opt in to receive your newsletter and updates is already a rung or two up the ladder of engagement. Likewise your clever idea about the Instagram #foodwaste and #foodrescue photo wall. This level of involvement can easily convert to more active participants, even co-creators within your campaign.

Context: *Just Eat It* exists within a body of work about food security/ insecurity, global agribusiness, nutrition, sustainability and waste. I know you've done extensive competitive title searches and there is no exact match for your film. With that list though are possible collaborators during the launch and social action phase of your project.

Generating pods or clusters of media pieces, even other cultural offerings, can multiply the effect of your work. Shared events bring new people together, surprising juxtapositions spark new ways of thinking about a topic, and heck, artistic partnerships with like-minded creators are just downright satisfying.

Behavior change: As a recap, on your VIFF Impact Award application, you ranked seven possible campaign goals and these were your top three:

1. Reach.
2. Raising awareness.
3. Personal behavior change.

If I recall, you further stated that reach was by default needed in order to raise awareness (also necessary) of this somewhat obscure topic, but that finally behavior change was your holy grail.

Then, specifically regarding personal behavior change, these were the top actions you wanted the viewer to **do** after seeing your film:

1. Talk about the issue of food waste with their friends and family.
2. Take personal action to reduce food waste.
3. Reach out to their community.

The first and third action are about spreading the word, sharing the idea. It's number two that allows for specificity. Buy "ugly" produce, get smart about expiry dates, decrease serving sizes, donate, compost ...

Policy reform and international action: In spite of our time together, it's still not 100 percent clear to me which societal level is finally best to target for the most effective large scale change? The individual consumer was covered above, but there are also institutions (schools, hospitals), downstream businesses (restaurants, grocery stores), upstream corporations (factory farms), and government. Policy plays a role around date-stamping, food safety, and tax law (both carrots and sticks). Then again, we don't want to dilute the strategy with too many objectives, across multiple tiers. More work to be done here.

It's indeed interesting how pervasive an issue food waste is and yet how underexamined. *Just Eat It* is well positioned to shine a spotlight on this topic and spark a movement. I appreciate that you've already highlighted bright spots and are continuing to add more through your ongoing campaign activities. Loved your short video on the rescued food restaurant in Copenhagen. There's opportunity to feature more donation centers, gleaners, lobbyists, personal "pantry pledgers," and educators on matters like the "best before" labels.

In our next session with Agentic we can tackle:

Vision statements: A number were brainstormed yesterday. "All food conversations should lead to food *waste* conversations." "Make wasting food socially unacceptable." "Donate don't dump." These need winnowing to one, word-smithing and locking.

Partnership-building: It's time to build a constellation of support around Just Eat It to amplify its reach and impact. The film is done and launched. In other words, your adventure is only half over! We'll talk about sourcing partnerships, understanding motivations, negotiating agreements, managing expectations, and keeping each other well informed.

In the meantime, think of what's valuable as you head full-on into your launch year.

For instance, other people and organizations might:

- use your documentary in their work (training, educating, advocating)
- organize screenings (I know you are getting lots of these requests now)
- build events or conference sessions around your film
- secure press coverage, both traditional and social
- create value-added content, like users'/teachers' guides or web resources
- promote it to their memberships, and even sell it (once you're in that mode)
- introduce you to other funders, or supporters, or donors
- give you money.

Yes, there are a few fantastic foundations who exist entirely to give grants to a film's outreach campaign. Most are in the US, but fortunately your subject matter and characters do cover multiple jurisdictions. And no doubt there are other grant-giving organizations with missions aligned to your central thesis that are not in the film space.

And don't forget you need to pay yourselves, too! You can't keep on eating salvaged and rescued food. There is no harm in earning some revenues back, to sustain your family, to fold back into your campaign and eventually to create a cushion that may allow you to develop your *next* project. Hard to imagine, I know.

Action: You had brought up the idea of building an "International Day of Action" around Earth Day in April. Sounds promising. Let's unpack that and map it out: opportunities, challenges, partnerships, resources, reach, potential for impact.

How much do you two expect to be present during this action, and in any additional web content overall? As Phillip's colleague Victoria reminded us, you are the protagonists and people have fallen for you. They love your banter, dry humor, humility. You are the heroes on this journey and it's your compelling personal touch that's inspiring followers. In my opinion, your mugs should brand the Day of Action.

Evaluation: Can't dodge it any longer. We need to look closely at your vision, your behavioral change goals, and your corporate and policy reform objectives, and set some targets. How will you know you're having the impact you're working so hard to achieve?

We can use as an additional framework the Center for Media and Social Impact's seminal paper: *Social Justice Documentary: Designing for Impact.*[40] It's a fantastic piece of work which should be in every filmmaker's toolkit. They've a great system for mapping out evidence-based indicators across a spectrum of project goals: quality, reach, engagement, influence and network building.

Let's also talk about bringing in some expertise to further advise around benchmarking, metrics, post screening surveys, and online feedback forms. All these techniques will

assist you in designing the best strategic campaign right now, and also in tweaking it, as needed, moving forward.

It's been a great ride already. Phillip and I are very proud of you two and look forward to our next session. In the meantime, remember to take care of yourselves and get some sleep along the way!

Warmly,

Tracey

Flash forward

Just Eat It was broadcast across North America on msnbc to over half a million people, and is one of the most streamed documentaries on BC's Knowledge Network. It won three Leo Awards (Best Doc, Direction, Musical Score), and in its first year played at over 50 festivals in 16 countries, winning 10 festival awards and placing in the top 20 audience choice for both IDFA and HotDocs. There have been over 100 community screenings, and the film has been translated into multiple languages including Greek, Italian, Spanish, and Japanese. At a grass-roots level, the team helped organize the first *Feeding the 5000* event in Canada where thousands of free lunches were made with rescued food and distributed in downtown Vancouver. With robust curriculum and learning resources, *Just Eat It* is now being fully embraced by the educational market.

Worksheet 6—Your Call-to-Action

Warming you up

Think of your own responses to calls-to-action in all kinds of media projects.
When was the last time you acted as a:

watcher—absorbed social issues media content?

responder—commented on a piece of work?

sharer—endorsed a project?

donor—gave money to cause?

participant—became involved offline because of a project?

creator—partnered with an organization?

© 2016, *Story Money Impact*, Friesen, Routledge

Have you ever felt yourself being moved up the "ladder of engagement"?

Did you appreciate it, or resent it—and why?

Name three films you've seen that entirely shifted your mindset. Perhaps blasted a stereotype you didn't even know you had? Couldn't shake it? Made you see the world in a new way? Might have prompted you to **do** something?

1.

2.

3.

Choose one and write out its call to action. At what point was that clear to you?

Your project

Where on this spectrum of social change are you aiming your impact?

awareness-raising behavior change policy reform

What are your audience's needs? How does your project improve their world?

Name existing change agents in this space from among:

Non-profit or charitable organizations

Governmental organizations

Corporate brands

Media outlets or platforms

Social influencers

Grass-roots associations

Write out **1** clear, measureable **call to action**, with directive language.

How will you incorporate this in your storytelling?

How will you later measure its success?

List two project specific indicators (real evidence) proving you'd have met your goals in:

Quality

1.

2.

Reach

1.

2.

Engagement

1.

2.

Influence

1.

2.

Network-building

1.

2.

© 2016, *Story Money Impact*, Friesen, Routledge

Allies

Impact Producers

In the following sections we meet experts whose professions complement or overlap with our firestarters above. In recognition of the breadth and depth of social issues media-making, I cast a wider net. Still aligned with the story, money, and impact impulse, their work is either in direct collaboration with documentary filmmaking (impact producers), or in parallel (online platforms and independent journalists). These leaders are paired up and then after the campfire conversations, we look at common themes drawn from their wisdom.

Let's meet a couple of Impact Producers directly, and see exactly what they do.

- Darcy Heusel is based in Brooklyn and employed by Picture Motion. Her job title is actually Senior Director of Campaign Strategy, but in her professional activities she has identified as an *impact producer*.
- Katherine Dodds is based in Vancouver where she runs her own company, Hello Cool World. Her card says founder and creative director, yet she too is comfortable wearing the title *impact producer*.

Tricky stuff these labels, because they evolve all the time. Real people's real daily work lives unfold in such a way that they often wear many hats. The

term "producer" generally denotes a certain degree of overall responsibility for a specific component of a project's execution. Sometimes it's financing ("executive producer"), or logistics ("line producer"), or supportive ("associate producer"), **or** it's all about the campaign strategy ("impact producer").

Whatever the title, it's the tasks below that interest us. Not all social issues documentaries will have the luxury of being able to afford a full-time person to manage outreach. But, if you wish to have the greatest reach and the best chance of achieving your impact goals, you want to at least understand the steps taken by the professionals. It could be that you are doing them yourself, or that you've fundraised six figures for the campaign and are overseeing a team executing your vision.

In many sectors there is a great divide between production and marketing/distribution/sales. I felt the silos myself when I worked at the NFB of Canada. It's clear everyone wants the film to succeed, but definitions of success can be different: critical acclaim for artistic innovation, a great leap forward in a filmmaker's career trajectory, international reach, strong revenue recoupment, measureable social change. These objectives are not mutually exclusive but they have to be managed sensibly.

In my opinion, there is nothing quite so dispiriting as seeing a filmmaker give over their heart and soul, and sometimes their marriage and mortgage, to get a passion project produced, only to have it fall flat at the marketing phase. Not enough time, or energy, or creativity, or money. But remember, once a film's sound is mixed and credit roll complete, its journey is just half over. You need to plan for this, find the stamina—and resources—to take a deep breath and say "OK, round two, here we come"!

This is where a great impact producer is gold …

When you are thinking about a funder, it's not just in terms of money but their networks, and how they can leverage that they've put all this money into a film.
DARCY HEUSEL

1. The Firestarter—Darcy Heusel, Picture Motion

(See Appendix 3 for full biography.)

THE FLAME—*AMERICAN PROMISE*

Directed by Joe Brewster and Michèle Stephenson, 2013, US

"*American Promise* spans 13 years as Joe Brewster and Michèle Stephenson, middle-class African-American parents in Brooklyn, N.Y., turn their cameras on their son, Idris, and his best friend, Seun, who make their way through Dalton, one of the most prestigious private schools in the country. Chronicling the

boys' divergent paths from kindergarten through high school graduation, this provocative, intimate documentary presents complicated truths about America's struggle to come of age on issues of race, class and opportunity."

The Campfire Convo

Tracey: *Can you please begin by describing Picture Motion and the type of work that you do?*

Darcy: Picture Motion is a marketing and advocacy agency for social impact documentaries. We almost always work in alignment with the distribution of a film. Our tactics change depending on where a film is in its life. Where Picture Motion is unique is we do the strategy and we do the implementation. Whereas I think a lot of individual impact producers either just do one or the other, and our team does it soup to nuts.

Tracey: *How would you define an "impact producer" to someone who's never really heard the term before?*

Darcy: People have been doing this kind of work for a while, at places like Participant Media, for instance, but the term "impact producer" is something relatively new. Part of it is recognizing the importance of social impact and marketing of a film. Giving the title of "producer" assigns a very specific role and task to it. Previously people might have said "social impact strategist" or just that I'm "working on a social impact campaign." But really, you're producing an impact campaign.

So one activity is overall campaign management. Making sure that everything happens. Staying on top of everything, managing all the pieces, and overseeing all the different parts: coordinating with PR, with the distribution company, with the filmmakers, with the grassroots team that might be doing on-the-ground fieldwork.

And then strategy is a big part of what we do. Usually we come around production, and view the film and then bring together stakeholders on the issue, a brain trust, to talk about where the film can be positioned to make a change—whether that be a policy change or political change or personal behavior changes. It's about working with people who are the experts on the issue.

Then we do partnerships. Which fits in with the strategy, because usually the people that are in that stakeholder meeting end up being some of those core partners. These are organizations that really take the lead on the film and will use it within their work. They inform on the strategy, on some of the messages and actions of the campaign.

The next is securing audience acquisition partners. That might be an organization that will send a newsletter or send the word out about it, but won't necessarily be able to do much more. Much of it is also about conferences and group sales and home video parties and tune-in events for broadcast and iTunes and VOD. Figuring out ways in which people can work together.

Then there are screening tours—also known as "non-theatrical distribution." We'll organize influencer and tastemaker events, as well as grass-roots community screenings, at schools, meetings, colleges, and conferences. Non-theatrical screening tours can not only get the film to places beyond where a traditional theatrical release may reach but also be a significant source of revenue for filmmakers.

Then the next piece is digital, which is really just a large communications piece. Sometimes it's social media, like Facebook and Twitter, but it's generally much larger than that, bringing the voice and the message to the campaign. Mobile, apps, e-mailing messaging, newsletter, any petitions, online to offline mobilizing, and digital partnerships.

In all cases, the filmmakers create the story and then we're looking closely at that story. We come in and inform what the call to action might look like after the story's been created. I think it can be a slippery slope when you're informing how a filmmaker makes their film for a call to action, because it can affect the storytelling element of it.

Tracey: *How do people contract you?*

Darcy: We usually do a flat fee for strategy for basically 6–8 weeks of work. That includes us writing up that strategy, pulling founding partners, building that brain trust, and coming up with a plan that can be then used to fundraise for money if you don't already have funders. And then we take a retainer on a monthly basis to work on the campaign. The amounts vary widely depending on the film.

We don't do fundraising itself, but we can build a strategy looking towards funding. Potential funders, what are their grant cycles, what are the questions they're asking, what are the campaign points that we can put in there or think about to fit this one funder.

Most often filmmakers come to us with some sort of planning grant. They have it built into their production budget, which I think is happening more and more as social impact campaigns become a bigger part of documentaries. Sometimes they're personally funding it …

Tracey: *Can you tell us the story of* American Promise*?*

Darcy: That's an example of not having distribution at all and money coming from funders who are invested in the issue. I joined that campaign in August of 2012, but that's a film that is 13 years in the making, following two boys from kindergarten through 12th grade. The filmmakers had been planning on the campaign for several years and somebody was working on fundraising.

One of the biggest partners of the film is Open Society Foundations. They have a campaign for Black Male Achievement, in which they fund organizations and media projects that are specifically working towards supporting black men in America. *American Promise* is a film that they came on because they really believed in the promise of this film to make an impact by changing perceptions around African-American boys.

It was definitely a perfect match with a foundation who really trusts the filmmaker and the vision, and is willing to go with the ride. The timeline and many other things changed along the way. It was a real investment on their part, not just in terms of money but also in terms of trusting the process.

That film didn't have traditional distribution. It was at Sundance, and it had POV/PBS. The filmmakers did theatrical themselves, and so the partnerships were really the core because there was no marketing budget for the film. Just money to book it into theaters, and a very, very minimal amount for newspaper ads. That theatrical was primarily driven by partnerships who were invested in the film and led conversations. We did that city by city.

Then we did another mobilization—we created Black Male Achievement Week, which was this week in which we leaned on all of our partners. When you are thinking about a funder, it's not just in terms of money but their networks, and how they can leverage that they've put all this money into a film. For instance, we worked with all their grantees.

Not everything about Black Male Achievement Week was around the film, but it was taking advantage of this week to lift up stories of work happening with different organizations around the country. We had a mobile application, there was a book, discussion guides, a new media project, short films. It was **all** about really using the film to create this community.

Tracey: *Would you describe yourself as optimistic in terms of the future of media for social change?*

Darcy: Absolutely. Stories work. I think we all know that it's a scientific fact that stories do change minds, change opinions. And now there's this opportunity to create community around online distribution. Once you have that audience and you're able to engage them, the possibilities are endless in terms of actually building those groups and giving them the opportunity to create real lasting changes. After you see a moving film you want to do something—it's just being empowered with the right tools.

> If you have a film and there are potential stakeholders, you have to not start with what you want to happen. You have to figure out how you can prove to them that your film will help their agenda. KAT DODDS

2. The Firestarter—Katherine ("Kat") Dodds, Hello Cool World

(See Appendix 3 for full biography.)

THE FLAME—*65_REDROSES*

Directed by Nimisha Mukerji and Philip Lyall, 2009, Canada

"Uncensored, Uninhibited, and Unbreakable: *65_RedRoses* explores what it means to be 23-years-old and faced with an unknown fate. Redefining the traditional scope of documentary film in an electronic age, *65_RedRoses* leaves viewers with a new appreciation of life and the digital world. This personal and touching journey takes an unflinching look into the lives of Eva Markvoort and her two online friends who are all battling cystic fibrosis (CF)—a fatal genetic disease affecting the lungs and digestive system."[41]

The Campfire Convo

Tracey: *Do you consider yourself an "impact producer"? It's not a term so widely in use in Canada …*

Kat: The term "impact producer" isn't one we've been using, but I think what it means is actually what we've been doing for a long time now. When I first was working on getting ready to launch *The Corporation*, through a series of introductions I ended up talking to the late Robert West with Working Films. He and I had a very interesting conversation where he said, *We finally got the foundations to understand that documentary films are a useful tool, but now they don't want to give money unless we can prove the impact.*

He got me thinking about that from my early days, and it wasn't a stretch because I had been studying social marketing, which by definition means having a measurable impact with regards to behavior or social change. So when we started to do the campaign for *The Corporation*, what was on my mind was how could this be turned into a long-term, social marketing campaign? Clearly it met one of the cornerstone criteria: defining the root cause of the problem, in this case the legal structure of the corporate form, and providing entry points for diverse audiences. How much we did or did not succeed at that is a source of my ongoing opportunity anxiety!

Having to prove the impact isn't a bad thing, but it is a different thing than just trying to get your film out into the world. That was always my goal with *The Corporation*, but the honest truth is that we were not funded to campaign as an impact film, let alone measure impact. Anecdotally, we have stories of the impact, but not what we could have if we'd had resources to measure outcomes over time. We delivered box office success, and we did an incredible amount with our money, including repurposing things and, bottom line, me working as a volunteer, is really what it came down to. In order to have a team, at a certain point I just stopped paying myself.

Tracey: *Please tell us about the work your company Hello Cool World did on 65_RedRoses?*

Kat: The subject Eva herself, and therefore the filmmakers Nimisha and Philip, wanted it to her legacy to have a campaign around organ donation. She wanted cystic fibrosis (CF) awareness as well, but organ donation was the main goal and the film followed the transplant story. As for successes, we were able to get a fairly significant chunk of money from BC Transplant, who early on saw the benefit of attaching themselves to the film. They were trying to reach out to younger audiences, and they saw this was effective. That is why they came on to license the film for all British Columbia teachers to use freely in their classrooms.

During the first year that we were doing the distribution, we had a co-campaign where we created a PSA out of footage from the film, an organ donor PSA. It was tagged with their sponsors who paid for the airtime, and it was broadcast during their April push. So we had this co-branded campaign via Eva, that was on buses and posters and various display materials, plus we had the PSA on TV. That didn't directly help us sell the film, which had already aired repeatedly but it certainly

helped us sell the campaign, which was our goal. It was a nice fit because they would not have supported a business. Even though people don't realize how little money documentaries make, out there in the world (or at least in Canada) they wouldn't have been able to spend donor dollars supporting the film itself, per se.

Tracey: *What do you know about the impact of the film, as in the increase in people signing up for organ donation?*

Kat: When it was first released, yes, there was a noticeable spike. Someone from BC Transplant said that when the film first came out, because of Eva's strong presence in BC and in Vancouver in particular, they saw a 300 percent increase of organ donation during that push. It was huge. But these kinds of numbers are hard to measure over time.

With the US launch of the film on OWN as part of Oprah's Documentary Club, we had hoped that with the "Oprah effect" we could have some sort of organization come on board in the US, and we spent quite a long time pitching Donate Life America. They are the umbrella organization for all of the transplant awareness programs in each state, which encourage organ donation. We had actually gone so far as to have phone meetings with the head honcho there, and while he was very interested and supportive, he was hinting that they had something in the works. We didn't know what. But what we didn't realize was that there was no way we could compete with what they were about to launch.

So what happened is that Donate Life America announced two days before the *65_RedRoses* launched in the US that they had this big partnership with Facebook—remember Mark Zuckerberg announcing that Facebook timeline organ donation status? So how can you compete with that, right? They had staggering numbers of organ donors as a result of this, and even if the film had been responsible for some of them, we were eclipsed. We had been putting all our eggs into the transplant basket so to speak. The CF groups are usually more interested in raising money for research, and sometimes it's hard to convince them that promoting a film will help that.

But in our favor, a few influencers posted it officially to their CF group in the US on Facebook, which had almost a hundred and fifty thousand people on it. It was shared in that network 800 times in 48 hours. That is an enormous viral reach, a huge impact. Those are the people who reach out to us, which is a direct out-come. We didn't spend any money to make that happen; we are the beneficiaries of that. But at the same time there is no further funding to optimize this potential.

Tracey: *What's the relationship between mission-driven supporters and media-makers?*

Kat: Well, with *65_RedRoses*, there are two communities that would obviously care. There's the transplant community, which is across many diseases, so to speak, and then there's the CF community. They have completely different objec-tives. They do come together around stories like Eva …

What that told me was that my idea about impact is really not important, which is hard for filmmakers to hear. So if you have a film and you have a strong goal

about the impact you want, you have to find stakeholders who agree with you to support a campaign. If you have a film and there are potential stakeholders, you have to not start with what *you* want to happen. You have to figure out how you can prove to them that your film will help their agenda. And both filmmakers and stakeholders need to focus on audiences. Our role is always to remind everyone involved, that audience engagement is the only measure of impact. Bums in seats is only half the equation; what we need to count is what they do when they get up off the couch.

Tracey: *What gives you hope looking ahead in terms of using media for social change?*

Kat: When I watched *Manufacturing Consent* decades ago now, that's when I realized that I needed to be in media as an activist. I have now seen things cycle around enough, and it can get depressing to see the same battles being fought again and again. But at the same time, it's so gratifying when we still get emails from people for *The Corporation*, *The Take*, *65_RedRoses* … They are discovering these films for the first time through nothing I am doing anymore, just because we put it out there. And they are reaching out to us. You can see very clearly what kind of impact it has.

The Sparks—Impact Producers

In sharing their processes, Darcy and Kat let us peek into the lives and essential activities of an impact producer. We see that in launching *American Promise*, the team at Picture Motion was responsible for tasks related to social action strategy, public screenings, online engagement and coalition building. *For 65_RedRoses* and other social media projects, Hello Cool World breaks its service offerings into Creative, Capacity Building and Monitoring and Evaluation. As a branding evangelist, Kat's pledge is perfect: "to make meaningful materials beautiful."[42]

Six summary sparks on impact producers:

1. **Workflow:** an impact producer's spectrum of activity goes from strategy to tactics to implementation to iteration to evaluation. Some people are capable in all areas, but you just might need to draw on multiple specialists.
2. **Primacy of story:** an impact producer will take *your* story and amplify it. Though they may come on board early in the process with valuable insights, keep your artistic conviction intact; you are still the creative lead on the film.
3. **Call to action:** an impact producer will help leverage your mission into a movement. You want to empower your audience with tips, tricks, tools, and concrete actions they can take when they share your fervor for the cause.

4. **Partners:** an impact producer can expand your community, exponentially. They might guide you toward campaign funding, secure non-profit distribution allies, build out your online lists, and assemble a "brain trust" around your film.

5. **Nimble:** an impact producer is alert and responsive. Having such dedicated focus on your outreach team means the strategy can be adjusted for external forces, plus proactive opportunities can be hunted down.

6. **Long term:** an impact producer's work is best maximized over time. If you can make a commitment to actively sustain your campaign for not months, but rather years, it'll reap great benefits in creating social **impact**.

Platforms

Let's now meet a couple of new media matchmakers and see how their organizations function.

- Christie George is based in San Francisco, hired in 2010 as employee number one at New Media Ventures. She is the Director of NMV, a network of angel investors who support politically progressive media and tech start-ups.
- Asi Burak is based in New York and heads up Games of Change, founded in 2004. He is President of this non-profit global advocacy organization, which seeks growth and sustainability in the sector producing digital games for social good.

Both Christie and Asi are avid opportunists. While they might not describe themselves as matchmakers, I do see Cupid in their actions. From a big picture vantage point, they look upon their chosen fields, roll up their sleeves, and work hard to connect like-minded parties, driven by the aligned missions. Impact investors with entrepreneurs, philanthropists with creators, NGOs with programmers, government with gamers. Their intention is to create greater resiliency in the overall system.

From the NMV blog:

> As early stage funders, our goal at New Media Ventures is to leverage relatively small amounts of money for a large impact … I think about our impact in three ways: first, the financial impact we have as funders and investors; second, the social and political impact of the portfolio that we fund based on the metrics below, and third, the impact of our program and community building work to build out the sector.[43]

The unique value proposition of NMV is the blend of granting and investment, and the emphasis on platforms over individual projects. Even within the social impact space, they've further identified political change as their sweet spot. Christie explains that advocates for other important issues may have more options for funding than those trying to use media and technology to highlight progressive political agendas. Their circle of investors is likewise keen on this mandate. It's precisely why they've joined. See, it's smart matchmaking.

Asi's Cupid tendencies sometimes lead to an exchange of money, but often it's an exchange of valuable information. Organizations want to use games, and gamers want to do good, but they just don't know each other's worlds. Games for change is a hub. As a meeting place, physically, virtually, and through their enormously popular annual conference, Asi and his team spread their gospel. "We aim to leverage entertainment and engagement for social good. To further grow the field, Games for Change convenes multiple stakeholders, highlights best practices, incubates games, and helps create and direct investment into new projects."[44]

As we have grown, we realize that people need way more than money. I think a lot of people are also motivated by being part of a community.
CHRISTIE GEORGE

Win, win, win!

1. The Firestarter: Christie George, New Media Ventures

(See Appendix 3 for full biography.)

THE FLAME—*UPWORTHY*

"Upworthy draws massive amounts of attention to things that matter. Every day our curators scour the web to find compelling, meaningful media—stories, information, videos, graphics, and ideas that reward you deeply for the time you spend with them. We share the best stuff with the Upworthy community, and they share it on to their own friends and family, engaging a total of about 50 million people each month on some of society's most important topics."[45]

The Campfire Convo

Tracey: *Can you please describe the business model of New Media Ventures?*

Christie: New Media Ventures is an organization that supports technology and media companies that create progressive political change. We have a network of funders that we work with, both angel investors and philanthropists. The range of investments has been from $50K to a million dollars. We also have a grant-making and investment fund called the New Media Ventures Innovation Fund that will support startups that are within our wheelhouse, but at a very specific period in their growth.

Tracey: *Do you receive a lot of interest from media entrepreneurs?*

Christie: Yes, but it's a fairly narrow criteria set. We are looking for things that are technology and media oriented, so infinitely scalable, and revenue generating. They must have an idea of a business model that is ideally self-sustaining in the long run.

Now, my background is in film so when I came to New Media Ventures, our initial interest area was media and very much content oriented rather than distribution oriented. But what we found in looking at one-off film projects is that when they are not integrated into a larger platform play we just don't feel like we can make the case as strongly for them as good uses of our very limited dollars as we might with a platform where we would be able to engage with a thousand films.

So for us an investment like Upworthy, that can in turn work with hundreds of independent filmmakers in getting their films out to new audiences, feels like a better investment than one film on one issue does.

Tracey: *I understand that you did support* The Story of Stuff *project?*

Christie: In that case the grant was less for content production, but more focused on the audience that they had managed to accumulate for their films. There were these films that at that time over 20 million people had seen, which were just outrageous numbers for a documentary of that length, on that subject matter. Yet the audience for them had not been activated and mobilized in as big a way as it could have been.

So our support was specifically around taking their existing audience and really trying to figure out how they could turbo boost it toward helping them grow as an organization. Probably *The Story of Stuff* is the closest example we've come to a pure content play and *Upworthy* is the closest to the kind of thing we want to do, because it affects multiple, multiple people.

Tracey: *How important is recoupment in your decision-making process?*

Christie: We tend to have a policy of not working with any investors who aren't impact oriented first on the spectrum of impact to financial returns. But then within that, it is totally dependent upon the deal. So we have some investments that people went into fully for the impact and would have been thrilled if they just got their money back. Those still *may* end up being incredibly successful

from a financial perspective. And then with other investments that might have seemed incredibly lucrative, people may just get their money back, or maybe will lose money and that's the reality of this kind of investment.

My sense is that the people that we work with believe that there are issues that we need to be better about, like gender equality, racial equality, marriage equality, and economic inequality, and we need to save the planet and we need to make sure that everybody who is eligible to vote can vote. Coupled with this interest in a progressive vision of the world is this very deep belief—often because of their own experience in the power of either media or technology—of the need to reach millions of people and to scale enormously. So when you take those two things together we thought what was missing was the money for these kinds of efforts.

As we have grown, we realize that people need way more than money. I think a lot of people are also motivated by being part of a community. That's a more valuable, deeper, longer term benefit to the organizations and the investors in the portfolio. This is such a Wild West territory. Seeing that there are other people doing it, meeting those people, hearing their stories, all of that stuff, all of the reasons why community is valuable, are no less true in the context of angel investors wanting to support technology companies.

That is one of the things that I love about my job is that we get to work with absolutely fascinating people, like entrepreneurs that are creating totally game-changing things that have ripple effects. And then on the investor side, people who have had deep expertise growing their own companies and are now wanting to use their expertise to help the next generation of entrepreneurs build things that are not just companies growing for the sake of growing, but companies that are actually going to make a difference on issues that are important.

Tracey: *How do you articulate the power of the media to effect social change when trying to attract partners?*

Christie: In the very beginning when I was first hired, all of my efforts were spent on recruitment. We went from 6 investors to 25 to 60 in about two years. In terms of having to convince people on the media and technology side, people are actually coming to New Media Ventures because we are narrow in our focus. For the people who care about this thing, they value the work, they are media people, or they are technology people. Entrepreneurs also want to do good and do well.

Tracey: *What might you tell media or tech people about the potential for impact?*

Christie: When I have seen filmmakers in particular think about impact from the very beginning it essentially means that they are thinking about distribution and audience and that people are going to actually see the film. This is of course what most filmmakers actually want. They haven't spent their blood, sweat and tears only to have a film that nobody sees.

But then also in the case of social issue documentary, if what people want is to either move the needle on an issue, change hearts and minds, bring awareness to something, if that is at least one goal of a piece of art that they are making,

then the likelihood of that happening is exponentially increased by bringing partners on sooner rather than later.

Everybody now is in this storytelling game. Whether they are actually telling a story in the context of a film or whether they are creating a technology company, which by definition is probably doing something that hasn't been done before, they are going to have to convince a whole bunch of people that it is going to make a difference, either as customers or clients or financiers. We always then refer to the usual stuff of the "hero's journey" and bringing people along with you on a narrative.

> Games, like documentaries, can raise awareness, so yes we can use them as a communication tool. And I have seen games that do a great job at that.
> ASI BURAK

2. The Firestarter—Asi Burak, Games for Change

(See Appendix 3 for full biography.)

THE FLAME—*HALF THE SKY*
Directed by Maro Chermayeff, 2012, US

"*Half the Sky Movement: The Game* is the first Facebook game with direct virtual to real-life translation; the tasks and issues portrayed in the game all have a real-world equivalent in donations and social action opportunities. Players will embark on a global journey which begins in India, and moves on to Kenya, Vietnam, and Afghanistan, ending in the US.

Along the way, players will meet different characters and take action in a very simple way by unlocking funds from the game's sponsors to make direct impact. For example, players can collect books for young girls in the virtual world and then activate a real-life donation of books to Room to Read (total of 250,000 books). Players can also choose to make personal donations to any of the game's nonprofit partners at any point throughout the game. NGO partners include the Fistula Foundation, GEMS, Heifer International, ONE, Room to Read, the United Nations Foundation, and World Vision."[46]

The Campfire Convo

Tracey: *How do you feel* Games for Change *complements or compares to film in terms of engaging audience and impact?*

Asi: We look at games as a stand-alone, which is very big shift in mindset. A lot of filmmakers are looking at games as the marketing side, like another way to promote the film. For instance, when we did *Half the Sky* they needed a stand-alone product that could live without the film. And in many cases they

are played by people who do not necessarily watch the documentary. Games, like documentary, can deal with social issues, real-world issues, and convey messages.

It's interesting because many games that have made an impact in our community do not necessarily tell a story. Games are, in the basic sense, around action. It could be action to make a choice between different narratives, or to solve a science problem. Story and script are important, but the heart is the mechanics and the actions.

Games, like documentaries, can raise awareness, so yes we can use them as a communication tool. And I have seen games that do a great job at that. We are doing our own impact analysis—an impact typology, which tries to break the potential "change" into categories. So learning is one, and raising awareness is another. But there is also behavior change. In games, we see that because it is so action oriented.

Tracey: *It's very generous for you to blog about the difficulties and lessons learned on* Half the Sky. *Can you please share one that is top of mind?*

Asi: Looking back, we were very influenced on *Half the Sky* by the social features and growth on Facebook. It came from our mission to say that we wanted to be on par with commercial games. So back then it was all about continuous engagement, like if you don't have a game that gets someone to play for three months, you are in trouble. So we created such a long story.

According to the numbers only thousands finished the full experience. So from say the 3 million that we sent to the game, and the 1.3 million that actually downloaded the game, accepted the provisions, and played—only thousands finish. Then you have to ask yourself, shouldn't I invest everything I have in a one-hour experience that could satisfy someone in say 30 minutes? You get the same numbers but the experience for everyone would be deep and compelling. And yet we built this very long game that takes weeks to finish, and we created so much content that only few see.

Tracey: *What are the other measures of success for that particular Facebook game?*

Asi: Beyond the great reach, it is the donations. It is the awareness. And the fact that the game generated so much press that is very related to the issue. Even the idea of light learning—we drove players who didn't know anything about the *Half the Sky* book or documentary to care about women's issues. That is a big deal. And we saw it in the numbers. We saw that we brought in people from countries like Egypt, in big numbers, Turkey … And it's just because they play Facebook games, so in a sense it is really "beyond the converted."

One thing that surprised us was that we started getting reports from mothers, that they were playing it with their kids. This was not something that we intended, this kind of inter-generational play. That always happens to game designers, by the way, those surprises.

Tracey: *How do you work with individual artists, or filmmakers, or creators?*

Asi: Something important to understand is that we (Games for Change) are not necessarily in the business in creating content. *Half the Sky* was a very unique case where we took on the game ourselves, almost as a demo project. Can we do something high profile, that would be played by millions of players, that would be attached to a bigger transmedia project, promoted by celebrities? But in the day-to-day Games for Change it is much more like a hub or a platform for others to create. We have our festival, which is a big event, plus we are incubating projects in different ways. Our interest is to raise the overall sector, to give people a way in.

Many of the projects are actually created and driven by entities—NGOs or government or corporate … It's a very unique community, you are dealing with people who want to make games, and don't even know how. And you have people who know how to make games, but they don't necessarily know enough about the subject matter. It is very different in many ways to film. A filmmaker is very passionate about something and goes out to make a documentary. But with games we are here to help in the facilitation.

Often, when people come to us, they want to innovate and feel that there is a young audience they are not necessarily connected to. And they say: *Let's try this. This is so sexy. This is so new. This is so exciting.* And basically they think that this tool will reach billions of people.

The challenge is that it is not easy to make a cool game. It is not easy to distribute a cool game. So sometimes they come with a lot of enthusiasm and then they say, wow, it is pretty tough. And it's not necessarily cheap. And so we are trying to build a sector that keeps doing sustainable, continuous efforts while most people come, do one thing and go away.

Tracey: *How do you talk to funders about the power of media and games for effecting social change?*

Asi: The conversion happens when people begin to understand how powerful games are, which by the way is still stunning, when they learn the numbers.

For example, *Dumb Ways to Die* is really fascinating because it is not trying to tell a story per se. It is a concept. The brief was that standing on the railway in the subway and falling in is a stupid way to die. What they did is they amplified it. This is something else that happens more in games vs. documentaries, taking the more positive, fun approach.

So they thought of many, many other ways to die and they turned them into very tiny game play moments. So you are on the mobile and you need to act very quickly otherwise you die. You are cut in half or coconuts are falling on you … all kinds of things. And again, they tell a story but through action. In the longer term they can really check the safety outcomes. They also showed that the brand itself, Metro of Melbourne, really improved with young people.

Tracey: *Are you optimistic about the future of media for social change?*

Asi: Yes, I am very optimistic. I have been in this for more than a decade and have definitely seen progress. Acceptance and the funding levels grow. People 10 years ago looked at what we were doing with the game PeaceMaker, and they thought it was completely insane. And today, I tell people that I made a game about the Middle East and it seems like, *OK, why not*. So the perceptions change, the funding changes, the understanding changes and the research is much more robust.

The Sparks—Platforms

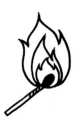

New Media Ventures has a double bottom-line orientation when it's doing due diligence on behalf of its network of investors. To expand its for-profit portfolio, Christie brings forward opportunities that will have social impact, and may also generate a financial return. And every now and then one hits it out of the park. Like Upworthy! That's the angel game at its best. The wins balance out the losses. In the case of impact investment, we all stand to benefit, as new money enters the system to be put to good use for positive social change.

Half the Sky Movement: The Game had its own unique form of windfall, orchestrated by Games for Change. Within its Facebook structure, players' virtual activities translate into real-world transactions between partner foundations and charitable organizations. Books, medical procedures, and pure donations to the tune of hundreds of thousands of dollars were raised in support of women and girls in challenging global circumstances. With creativity and tenacity, you can put technology to work for your own media impact goals.

Six summary sparks on platforms:

1. **Storytelling remixed:** In the multiplatform universe, the word "story" is reimagined. In games, it's about "actions," and in the start-up world, it may speak more to the narrative of the new company and its growth trajectory.
2. **Integrated:** Your target market is everywhere, on all devices, all the time, in control of their consumption. Some projects merit stand-alone treatment, but if you can swing it your best bet is transmedia, like *Half the Sky*: a book, a TV series, a game, equals the beginning of a movement.
3. **Scalable:** New Media Ventures asks that applicants demonstrate they've the potential for rapid growth. Technology lets you dream big; aim to reach millions with your message.

4. **Revenue:** It's the Wild West out there, with new monetization schemes and business models surfacing (and dying) daily. Overnight you could become a millionaire (or bankrupt) so don't quite bet the *whole* farm.

5. **Metrics:** The beauty of multiplatform storytelling is the ability to track user numbers and stats like crazy. A rough bums-in-seats count in a theater doesn't hold a candle to online analytics.

6. **Community:** Both Christie and Asi spoke glowingly of the value of sharing experiences and best practices with like-minded individuals. The financial part is understood, but people brought together equally appreciate growing their network and supporting one another.

Independent Journalism

Finally, let's meet a couple of journalism professionals and see how their work aligns with the principles of story, money, and impact.

- Steve Katz is based in San Francisco and is the Publisher of *Mother Jones*. It is a non-profit, but take ads, and is fiercely committed to independent journalism.
- Linda Solomon is based in Vancouver, BC, and is the Publisher of the *Vancouver Observer*. It is a for-profit, but take donations, and is fiercely committed to independent journalism.

These are two super cool people, in leadership positions with important operations, each with its unique approach to financial sustainability. The print version of *Mother Jones* looks like a conventional magazine on any retail rack, and yet it has 501(c)3 tax exempt status. The *Vancouver Observer* looks like an online news platform designed to serve the public interest, and yet it's an incorporated business. In truth, they are all of those things and more: classic hybrids, intent on keeping the lights on—and making the world a better place.

In his white paper *Non-Profit Journalism: Issues Around Impact*, Richard Tofel, President of ProPublica, gives us a framework for positioning this type of media-making. First he clarifies the difference between outcomes, outputs, reach, and impact, and reminds us that traditional news organizations and non-profit operations have a different set of obligations to uniquely different stakeholders.

All journalism, though, falls under a range of categories:

- **Hard news**—to inform.
- **Feature writing**—to entertain.
- **Opinion**—to persuade.
- **Explanatory**—to elucidate.
- **Investigative**—to effect change.

It's the latter two that are the bailiwick of *ProPublica, Mother Jones*, and the *Vancouver Observer*. While they may contain straight facts and op-eds, these entities are more focused on explanatory journalism, which is about reach and awareness-raising. Impact begins with building knowledge and engaging readers. One step further is investigative journalism, which "seeks to reveal something that someone with some modicum of power (a person, group or institution) seeks to keep a secret."[47]

With such goals, it's no wonder they seek alternative means for financing their operations, whether for their full-time payroll or their kitty for freelance contributors, storytellers like you. The opportunities abound for collaborations across these content forms or for moving between them. Many creators dip their toes in multiple pools: feature documentaries, digital interactive content, and independent journalism.

> I personally think the successful story for Mother Jones is when you finish it, and you may not agree with what you've read, but you hopefully also say, Wow, I didn't know that. STEVE KATZ

1. The Firestarter—Steve Katz, Mother Jones

(See Appendix 3 for full biography.)

THE FLAME—*MOTHER JONES*

"*Mother Jones* is a nonprofit news organization that specializes in investigative, political, and social justice reporting. We currently have two main "platforms": an award-winning bimonthly national magazine (circulation 240,000), and a website featuring new, original reporting 24-7. (In the past we've had a radio show and TV specials; theme parks are in the conceptual stage.) Why should you read or support us? Because "smart, fearless journalism" keeps people informed—"informed" being pretty much

indispensable to a democracy that actually works. Because we've been ahead of the curve time and again. Because this is journalism not funded by or beholden to corporations. Because we bust bullshit and get results. Because we're expanding our investigative coverage while the rest of the media are contracting. Because you can count on us to take no prisoners, cleave to no dogma, and tell it like it is. Plus we're pretty damn fun."[48]

The Campfire Convo

Tracey: *Can you please describe the business model of your organization?*

Steve: *Mother Jones* is first of all organized as a not-for-profit in the US. We describe ourselves as a hybrid organization, and what we mean by that is that we have a mix of revenue streams that are both characterized as earned revenue and as philanthropic. And that's intentional. We are both a mission-driven, change-oriented organization, and also a publishing entity. Our budget this year (2014) is about $13 million, and about 55 percent of our revenue comes from philanthropic support. Some of that is from foundations, but most of our philanthropic support comes from a network of about 40,000 individuals who are active donors to *Mother Jones*. That's hugely important.

It's actually a much better philanthropic mix of revenue than to rely on foundations, which have short attention spans and are fickle. And then there's the earned revenue side, which is primarily a mix of subscriptions and advertising revenue, both online and in print. As far as the magazine goes, there's still a market for people who want to have an actual physical thing in their hands, so a significant part of our revenue comes from subscriptions to the magazine, followed by advertising revenue. A growing percentage, though, comes from our digital operations.

We've been very fortunate over the last several years in being able to ride the ups and downs of any individual revenue stream, and maintain the integrity of our staff and our program. There's a link between this hybrid business model, the management of financial risk, and our ability to maintain a strong core of editorial staff and then have them have the freedom to produce the kinds of reporting that we want.

Tracey: *How would you describe the motivation of mission-based funders?*

Steve: Things have evolved over the years, both because of what people began to see happening in the business of journalism, to American newspapers in particular, number one; and number two, there was the disappointment and frustration that people experienced in the way that their tried-and-true media outlets in the United States covered the Iraq War. People began to change their viewpoints on whether they should include philanthropic support for journalism organizations like *Mother Jones* in their charitable portfolio.

And a lot of people think about it this way: you know, I'm giving my political money to these candidates I like, and then I have this pot of money that

I'm going to give to different kinds of aligned non-profit organizations who support and work on issues I care about. And historically, media was not in that portfolio. But people have come to recognize that they can't rely on their traditional sources of information, and so they're willing to diversify their support.

Donors expect a certain kind of impact from us. They have a standard of results. And our job is to illustrate those kinds of impact examples to the donors so that they feel that the support they're giving for great journalism is translating into new ways of thinking, new ways of looking at the world, new bodies of information, and new ways to change the world.

Tracey: *You mentioned the need to share stories of impact with potential supports, what's an example?*

Steve: I'm speaking at an upcoming conference about our coverage of gun violence in America. *Mother Jones* developed a baseline database of mass shootings in the United States over the last 20 years or so, because it did not exist. This is because the NRA had lobbied Congress back in the '90s to prevent the Center for Disease Control from collecting data about gun violence. So it was our job as a reporting organization to pull that information together, and then build our reporting on that data.

The reporting we did was on this sequence of tragedies that have affected this country over the last several years at a higher level of frequency, unfortunately. This work has definitely shaped the discussion over restrictions on access to semi-automatic weapons and background checks and the whole debate. *Mother Jones* has really inserted a verifiable fact-based component into a public discussion that was pretty much fact-free up until that point. That turned out to be an extremely important role for us.

Tracey: *In what ways does* Mother Jones *work with freelance media-makers?*

Steve: We definitely work with freelancers, but not as much as we have in the past. Most of our reporting these days is staff reporter-driven. But particularly on the print side, there are opportunities for future stories to come from freelance reporters. Much of that has to do with the relationship that individual editors have with their stable of writers. For freelancers, the main thing is to be present in networks where editors who work at *Mother Jones* or other shops live. As they come to know your work and see where there's a fit between what we're interested in and what you're working on, that conversation can become productive.

Tracey: *What do you feel are the essential elements for creating a story to have impact?*

Steve: I'd actually love to hear how our editors would answer that. But as a reader, when I read a good article in our magazine or on our site or when I read something good in the *New Yorker* or whatever, it always helps when there's wonderful language that creates the world that is being covered and very well-drawn characters that step out of cliché.

I personally think—and I believe our editors would agree with this, too—the successful story for *Mother Jones* is when you finish it, and you may not agree with what you've read, but you hopefully also say, *Wow, I didn't know that*. That is the experience that we want people to have. We want people to go outside of their normal bounds of comfort, even if it challenges their assumptions about the way the world works. I think that's the most successful story that we can produce. One that really draws you in and carries you along to the end.

Tracey: *How are you optimistic about the future of media for social change?*

Steve: I think this is the best possible time to be doing journalism. It's so interesting. It may not be the best time to get paid for it but boy, there's just so much good stuff out there these days. The tools that journalists have, and the ability for relatively small but really smart and nimble organizations like us to get out in front of audiences that we never could have been able to reach before, it's just so cool. It's the great promise of this moment. There are obviously big, nasty, dark things pushing back against that, but we're not going to talk about that …

I do think there is a coming recognition that good journalism relies for its sustainability on identifying a community of support. It's a complicated dance to do but I think that is the single biggest driver for a sustainability strategy: identify, work with, engage with, disagree with, the community of support that will carry the organization forward.

> My aim every day is to tell a powerful story, to tell a good story that people are really going to want to read, and then to put it in their hands. That's the role of the journalist. LINDA SOLOMON

2. The Firestarter—Linda Solomon, Vancouver Observer

(See Appendix 3 for full biography.)

THE FLAME—*THE VANCOUVER OBSERVER*

"The *Vancouver Observer* is an independent online newspaper. The site was founded in 2006 by journalist Linda Solomon as an online platform for Vancouver bloggers, writers, reporters, photographers and filmmakers … The Observer covers local politics, arts, the environment, technology, health, nutrition, and other topics. It also provides online events listings and a forum for individuals to upload their own stories. The Observer also has a YouTube channel, which features interviews and mini-documentaries.[49]

It's journalism in the public interest."

The Campfire Convo

Tracey: *Can you describe the business model of the* Vancouver Observer*?*

Linda: Our model is based on about 50 percent of our revenue coming from advertising dollars, and that's growing all the time. Most of the rest comes from direct funding of projects, either crowd-funding, or direct asks to individuals, or our readership. And then there's 7 percent that comes from what we call monthly subscriptions—people who are voluntarily "subscribing" to the *Vancouver Observer* because they like what we're doing and understand that even though they don't have to, they feel they probably should put some money into it. $10 a month or $15 a month, it's very small. We haven't been able to put a lot of energy into that, so I know that's one of our biggest potential upsides.

Tracey: *I'm interested in the motivations of funders of social change media. What is your understanding of why people get involved?*

Linda: What I've learned is both simple and complex. It's just that you have to be offering something of value. It has to intersect with somebody else's really deep values and aspirations. It's the belief that journalism can not only shed light on something that is happening today; it can tell a story that provides a basis for really profound change to take place. And so there has to be that aspiration for change in the potential funder. They have to honestly believe in that thing we call democracy, and that information is a vital part of that thing, for the system to function properly.

For people to want to donate anything significant to the *Vancouver Observer*, they have to be looking around at the landscape today and saying, *there are frightening gaps in the corporate media's role of providing information to the public.* And somebody needs to be doing it. So I want to fund this because it's one of the most important things I could do.

As one of our best funders said to me recently, he goes, *Linda, I look at* the Vancouver Observer *and I'm just so happy, because you guys touch every area.* We might be doing a series on injustices against disabled adults or we might be doing a pipeline thing or we might be talking about poverty in the downtown east side or First Nations issues. To fund the *Vancouver Observer*, your money ends up reaching into pretty much every aspect of society potentially.

Tracey: *How do you work with your staff, both full time and freelance?*

Linda: Honestly, that is the part of the job that I love the most. I try to really encourage people, I think that's the main thing. It's really this amazingly creative process where somebody has an idea for a story or I see something that somebody's put on their blog. I'm constantly trying to reach out and cultivate and develop relationships with writers who then become part of our community.

I do feel like the *Vancouver Observer* has a real community around it that you don't see. You think it's a website but it's really not, it's really a community of writers. People will come, they'll write for us for a year or a few years, and then they might move on. So we end up having this huge network of writers that we're connected to.

In the beginning everything was volunteer because there just wasn't any money. But as time went on, we started to figure out how to create revenue. My goal has always been that everybody would be paid. So now if we assign an article, it's always paid. But there is a fraction of people who really just want the publication platform. If we can, we're going to promote their work.

Tracey: *What to you are the most important ingredients for a good story?*

Linda: To me, story is huge—it's everything. If there's not a good story there nobody's going to read it, period. Unless it's that rare kind of thing, the breaking news element of it is so huge that people are just going to read it because of that. But 95 percent of material has to have a strong narrative arc. It has to be entertaining, it has to be dramatic. I'm always working with people on that. We don't always have enough time, but it's all the difference. I think it is what probably gives us our particular editorial voice—I emphasize "story" over everything else.

It has to have that "I've got to read it" feeling. From the very first sentence it just has to grab you, the headline has to grab you. It has to be really substantial. It has to be factually correct. It has to be well fact-checked. It has to have enough range of voices in it to be meaningful. To have weight. Editorial authority. That comes from interviewing enough people.

If we're doing a story about Kinder Morgan for instance (we've just been hammering on this pipeline issue for the last few weeks), it has to include Kinder Morgan's voice, or we have to have called and asked them for a comment. It has to have a sense that the reporter is out there really trying to tell a whole story, that we're not just advocating. We're there to document what's happening. In a lot of ways it does have to feel, in the written word, like there's a camera that's recording the scene.

Tracey: *How do you measure impact?*

Linda: Well, if we had a full-time person who was on development, we would do a much better job of this, but we don't, so we do the best we can. Usually when we really have to do it is in applying for awards. Then we sit down and we look at the last year and we look over the big stories we did, and we start asking, how can we show what impact it had?

Yet for a lot of reporting, the connections are not quick or direct. And it can be harder to show. More and more we're going to different kinds of funders, bigger funders, and right up front they want you to talk about your social impact. So we try to show how we have either had a role in a law changing, which we have a few times now, or at least altered the conversation or even simply helped the conversation happen.

Tracey: *In what ways are you optimistic about the future of media for social change?*

Linda: If I wasn't I could not still be doing this! I am motivated every day by my optimism about media's potential for social change. That is what infuses the work with meaning, and helps me to inspire other writers and reporters. Everybody

who's attracted to work for the *Vancouver Observer* really has that same motivation. It's just a natural culling process. We have an amazing team that way.

I come from a kind of a philosophy that says that even if I make the tiniest drop of change in my whole lifetime, that's enough. And I have to try to do that every day. I do not get attached to the outcome on these things. I don't see my role as even aiming to make a change when we're telling stories.

My aim every day is to tell a powerful story, to tell a good story that people are really going to want to read, and then to put it in their hands. That's the role of the journalist. Some people get burnt out because I think they're attached to the outcome, but for me the goal every day is to tell a better story.

The Sparks—Independent Journalism

 As we've seen, Steve and Linda are staunch about adhering to strict journalism standards, but unapologetic about their political leanings. These are left-of-center organizations, working to effect positive social change within our political and social systems. They take on thorny issues like gun violence, pipelines, political transparency (or lack of), and fracking. I include them in this book focused primarily on documentary film, with the appreciation that their journalism work is essential in the larger media impact space.

As *ProPublica*'s Richard Tofel asserts:

> Impact *is* the metric. That is not a conflict for us, but I recognize that it can be for others. We have the great luxury that our mission is very clear and we understand how we want to measure ourselves against that. Traffic is nice, prizes are nice, money is nice. But that is not the mission. We want to do journalism in a way that makes change.[50]

Many media-makers I'm in touch with are increasingly genre- and platform-agnostic. What is the issue and how is it best amplified? What is the central story and what creation does that inspire? Is the output a film, a book, a game, a podcast, an article? Contributing to independent journalism outfits like *Mother Jones*, the *Vancouver Observer*, and *ProPublica* is yet another viable means to reach audiences with your crucial message.

Six summary sparks on independent journalism:

1. **Narrative arc:** No surprise that compelling stories rule this land, too. Steve hearkens back to Mark Achbar, who we met in Chapter 7: "leave me with a *Wow, I didn't know that!*"

2. **Business models:** Like all sectors we've explored, the independent journalism field is trying on for size many blended forms of monetization. How can you be creative and adaptable to fit into—or generate—new revenue streams?

3. **Media consolidation:** Control of the "airwaves" is in increasingly fewer hands. In addition to your media-making practices, stay active around developments related to net neutrality and corporate monopolies.

4. **Risky topics:** With fewer independent voices receiving traditional funding, the story money, and impact pitch here is about protecting democracy. Can we stabilize the resources required to make quality media for the public good?

5. **Solutions:** By rights, the Solutions Journalism Network merits a chapter on its own.[51] This is equally rigorous reporting, but focused on offering positive responses to social issues, something *Mother Jones* and the *Vancouver Observer* do intuitively, as well.

6. **Community:** Like everyone we've met from Participant to NFB to Impact Partners to BRITDOC to New Media Ventures, these journalism organizations and their hardworking contributors thrive in community.

It's our interconnectedness, shared values, and aligned missions that keep us all going. Impact Producers amplify the quality work of storytellers, online platform evangelists introduce new resources and stakeholders into the system, and independent journalism outfits provide further distribution opportunities and reach. Firestarters every one of them, fanning the flames to **spark media for social change**!

The Jam Session
CBC, WNYC, Roundhouse Radio

Lately, I've been binging on audio. Podcasts mostly, from NPR, CBC, PRX, and a handful of creative independents. This is an intimate form of storytelling, very personal, one-on-one, direct. I listen on my iPhone, while jogging or on transit, or I tune in while driving or making dinner. I've come to feel a connection to these voices. I look forward to the stories they source, craft, and share.

I've started a new gig, as director of programming at Roundhouse Radio. It's a commercial radio station with a community focus. Its founders ask: can radio be used as a force for good in this world? Can it improve relations between neighborhoods, reduce urban isolation, effect positive social change? Roundhouse is a brand new number on the dial—98.3 FM—a low-power signal in the center of the city of Vancouver. Mostly spoken word, with a bit of music. The content will be hyper-local, discussions of relevance to those who live, work, and play in the downtown core.

It's an ambitious plan, backed by four British Columbia families. There is no major broadcast conglomerate behind Roundhouse, just sufficient start-up capital to get us off the ground—and a whole lot of passion. The

Consumers, with infinite choice, will gravitate toward quality and relevance. Well-crafted audio that is local and meaningful, accessible where and when it's desired, should always have a following.

CEO Don Shafer has almost 50 years of experience in radio, but even for him this is fresh territory. There isn't a precise blueprint to follow. No one's yet demonstrated that a station inspired by the intelligent quality of public radio can thrive in a commercial context. But Don's belief in the concept is contagious. It's a legacy project for him and he aims to do things differently. Almost to prove it, after winning the license, his first hiring move was to bring in a programmer from outside the radio industry. (Me!)

The offer came from left field and I really had to give it a think. I was intrigued, flattered, cautious. I'd been heads down on initiatives under the banner story, money, and impact and felt passion (and traction) related to these pursuits. I adore the documentary community and am convinced that more reciprocal partnerships can be found by focusing on impact. Having seen successes in other jurisdictions I was committed to getting such practices on the radar of my community. I still am.

It was my mentor, Al Etmanski, who saw this not as an "either/or," but rather an "and" situation … It's still media, it's still social change, it can still include the exploration of alternative business models. It's simply a different *canvas*. No less important to connect neighbors with each other, emerging talent with audiences and citizens with City Hall, than it is to seek transformation at a systems level. It's all needed. I saw that the values and work were aligned, not mutually exclusive, plus heck, Roundhouse could be a gas! How often does one get the chance to be in at the ground level of a new enterprise?

I reached out to my former NFB boss, Cindy Witten, now in senior leadership at CBC Radio. The Canadian Broadcasting Corporation was founded eight decades ago. It's currently funded by government at roughly $1 billion per year, and through advertising, largely on TV. They know a thing or two about bringing people together through talk, both local and national. Canada is a vast country with a small population. For some people, especially in remote areas, CBC has been a lifeline to their fellow citizens. CBC "Radio 1" is an almost uniformly beloved offering.

Cindy helped me to understand what it takes to make audio that reaches both the heart and mind. Their flagship morning show *The Current* continues to attract their largest audience. How do you pull that off? Well, you hire expert researchers, talented writers, and skillful producers. Ideally there may even be a crop of interns, creative and eager, from which to draw future team members. And as the adage goes, you need a host that you'd be keen to spend five hours with on a road trip. Curious, smart, witty. Tells a good tale, but also asks probing and insightful questions. I did a mental head count on the staffing needs. Humbling, from where I was sitting.

The next chapter in my crash course came in New York City, with a visit to public radio station WNYC. Like National Public Radio (NPR), WNYC is part of that gold standard club of audio storytelling, along with CBC in Canada, BBC in the UK, and ABC in Australia. This tour and further training were facilitated by radio guru and consultant John Parikhal. His task was to figure out what transferable skills I brought to this new field and then to begin filling in some of the major gaps.

While we waited in the lobby for program director Jacqueline Cincotta, I admired the colorful wall display, naming dozens of people. "Many friends have supported the growth of New York Public Radio. We thank those who have led the way." Revenue sources are diverse: government, foundations, corporations, and individuals, at an impressive 34 percent.[52] Millions of listeners love this programming and are willing to pay for it.

Jacqueline led us through the building where, again to my naïve surprise, hundreds of people worked. I was a little star struck seeing a pillar in an open concept floor plan imprinted with *Radiolab*. Right there were the creatives who produce those renowned shows blending story, interview and sound design. We then sat in the studio as the Brian Lehrer show went live to air, its host supported by several savvy call screeners, a board operator, producer, and intern. He's been broadcasting for over 25 years and it shows. These are intelligent conversations about important issues, hosted in the spirit of curiosity and respect.

I came away inspired, yet daunted. Roundhouse is a scrappy start-up, with 30 people on the roster, across *all* areas—programming, sales, admin. And yet these publicly funded radio stations themselves struggle, financially, was well as in growing (or even retaining) audiences in an era of fragmentation and digital distribution. They tell great stories, but share similar challenges around money and impact. Business models, and ways of improving reach, are always under scrutiny and being pushed, transformed, reinvented.

Perhaps, ironically, the innovation that has been disruptive to so many industries may be the very thing to save radio. In an increasingly wired society, the internet is home to the world's content, and consumers, with infinite choice, will gravitate toward quality and relevance. Well-crafted audio that is local and meaningful, accessible where and when it's desired, should always have a following. At Roundhouse there's a recognition out of the gate that the multiplatform services are essential. In fact, they may outpace the FM signal in short order.

But it all comes back to excellence and impact. From the campfire to the antenna tower to the web, whatever the delivery, we all lean in to strong storytelling. To recap the wisdom of the firestarters we've met along our

journey, let's consider once again the powerful sparks that ignite the blazing trail of change.

Meaningful media depends on these **story ingredients**:

1. **Narrative arc:** Does your story have a beginning, middle, and end?
2. **Originality:** Is your concept or approach fresh and surprising?
3. **Emotion:** Does your story speak from and to the heart?
4. **Immediacy:** Is your story unfolding in the present tense?
5. **Simplicity:** Have you made a complex idea easy to understand?
6. **Access:** Are you uniquely equipped to tell this story?

When the CBC's Cindy Witten needed to find a new host for the radio show *Q*, she chose Canadian artist Shad. Cindy has worked in TV, documentary film, animation, digital interactive, and now radio, and knows that the common denominator for success is accessing emotion through people's stories. "We were looking for someone who is an original thinker, curious and emotionally intelligent ... Whoever has the most insightful, poignant, compelling insights into the human condition and the conditions we live in ... That's who I want to have at the desk."[53]

Whichever your chosen platform, a focus on a dynamic narrative and an eye to impact may open doors to the possibility of new partnerships.

Savvy artists investigate these **money sources**:

1. **Broadcasters:** Is there a traditional home for your story?
2. **Foundations:** Have you researched organizations that share your mission?
3. **Philanthropists:** Can you find individuals similarly motivated?
4. **Impact investors:** Is there potential for a financial as well as social ROI?
5. **Brands:** Are there corporations trying to connect with the same consumers?
6. **The crowd:** Can you rally a herd to back your project?

John Parikhal:

> It takes money to make great radio. Mostly to hire talented people, like producers, writers, readers, reporters, and editors, among others. However, even more than money, it takes imagination and the ability to train and coach people to do their best work. If you can demonstrate this leadership and focus it creatively on topics that matter, there

should be no shortage of foundations, philanthropists, brands, and, most of all, listeners who will support you.

When missions are aligned, then artists, financiers, and activists are all pointed in the same direction, seeking beneficial relationships to move the needle on important causes.

Change-makers aspire to these **impact outcomes**:

1. **Awareness-raising:** Will audiences be challenged to think in a new way?
2. **Engagement:** Can you move people from "watchers" to "doers"?
3. **Context:** Have you placed your project within a larger eco-system?
4. **Behavior change:** Is there a clear, personal call to action?
5. **Policy reform:** Have you identified a systems level change target?
6. **International action:** Should you aim for a global reach?

Roundhouse Radio's Don Shafer:

> I've always loved the magic that comes out of that little box called radio. And who says commercial radio cannot have social change goals? Thoughtful, heartfelt words, and a pallet of emotions and sounds, can bring our imaginations alive. In this era of globalization we need to celebrate our local community and culture. I am excited to see what magic we can make by allowing everyone a voice to share their stories on air and online.

One of the most important insights I've had on this journey so far is an appreciation of personal **motivation**. As humans, we are all driven by our own unique set of values and interests. Some are supremely altruistic, and some are perhaps more self-serving, but it's these passions that inspire us to get up daily and devote our time, energy, and resources to specific pursuits.

To bring this valuable learning to our practice as social issues media-makers, we need to slow down and get to know one other. Never assume the storyteller or funder or activist sitting in front of you is motivated by the same belief structure as you are. Like all of us, they will have brought to this very moment a lifetime of both triumphs and tragedies that shape their decision-making. Take the time to ask questions, and then to listen deeply.

In so many cases, we all aspire to the same end-game. In the social change space, it might be summarized as "making the world a better place." If we better appreciate each other—our past experiences, our present motivations, and our future dreams—then the sweet spot at the center of story, money, and impact can be sparked for the benefit of all.

Worksheet 7—Your Media Vision

Write out answers to these 18 questions. What is the status of your project in relation to:

1. Narrative arc:

2. Originality:

3. Emotion:

4. Immediacy:

5. Simplicity:

6. Access:

7. Broadcasters:

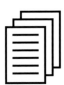

8. Foundations:

9. Philanthropists:

10. Impact investors:

11. Brands:

12. The crowd:

13. Awareness-raising:

14. Engagement:

15. Context:

16. Behavior change:

17. Policy reform:

18. International action:

Next steps
Review motivations:
Why are you using this form of art to affect social change?

Why do you think your current or proposed funders might wish to participate?

Why might your target audience mobilize into action leading to impact?

Find mentors, people you can trust to give honest and productive feedback on:
your creative treatment

your proposed financing scenario

your strategic campaign

Vision portal:

Project yourself exactly one year into the future and briefly tell your long-lost cousin what an amazing year you've just had on a professional level. How it exceeded all expectations. Use present tense and don't be shy and humble. This is the moment to toot your horn, even if privately—so go for it!

Here's mine:

> Hey, thanks for asking, yeah, it's been a *great* year! Did the *Story Money Impact* Conference at Hollyhock on Cortes Island and it nearly sold out! So pumped to have seen dozens of media and change-makers, young and established, come together for four days of deep discussions. Can't wait for next year's gathering.

> Then Roundhouse Radio launched in the fall with a kick-ass team and it was crazy how much buzz it generated. And so fast! Immediate fan base meant immediate revenues. We're already sustainable enough to add staff and resources and reach even higher. And the community's been super responsive. I can feel us making a difference, not only on the air and online, but even on the street.

> Yeah, and I was writing on Ian MacKenzie's film *Amplify HER* about female electronic dance music artists. It was released in the winter, and has been doing gangbusters on the festival circuit! Soon theatrical, broadcast, the transmedia project (*Animate HER*), and then the educational market, where it's well poised to have real social impact.

> Oh, and of course my book for Focal Press came out! I hope *Story Money Impact: Funding Media for Social Change* can now do the work it was designed for—to nurture understanding and connections between artists, funders, and activists who use media to make our world a better place.

> And you, how was your year?

Sample Financing Scenarios

A.1.1 *Hadwin's Judgement*[54] (international co-production)

Budget $1,025,000 CAN

CANADA:

NFB	equity	30%
Broadcasters	license	11%
CMF	top-up	12%
Bamboo Prize	grant	1%
BC Film	loan (non-recoup)	1%
Tax credits/producer investment		15%

UK:

Broadcaster	license	8%
Bamboo Prize	in-kind	2%
Private investors	advance	20%

A.1.2 *Big Joy: The Adventures of James Broughton*[55]

Budget $514,000 US

In-kind donations	$230,000
Foundations	$90,000
Crowdfunding	$87,000
Producer investment	$32,000
Grants	$24,000
Individual donors—cash	$23,000
Individual donors—stocks	$12,000
Trust	$10,000
Arts Council	$3,000
Merchandise	$3,000

Resources

Films Cited in the Book

TITLE	DIRECTED BY	DATE
65_RedRoses	Nimisha Mukerji and Philip Lyall	2009
A Better Man	Attiya Khan and Lawrence Jackman	2015
American Promise	Michele Stephenson and Joe Brewster	2013
Amplify HER	Ian MacKenzie	2015
An Inconvenient Truth	Davis Guggenheim	2006
Being Caribou	Leanne Allison and Diana Wilson	2004
Big Joy: The Adventures of James Broughton	Stephen Silha and Eric Slade	2013
Breaking Ranks	Michelle Mason	2006
Bully	Lee Hirsch	2011
Carts of Darkness	Murray Siple	2008
CITIZENFOUR	Laura Poitras	2014
Conflict Tiger	Sasha Snow	2006
DamNation	Ben Knight and Travis Rummel	2014
Eco War	Randy Thomas	1991
Escape Fire	Susan Froemke and Matthew Heineman	2012
Food Chains	Sanjay Rawal	2014

Food, Inc.	Robert Kenner	2008
Force of Nature: The David Suzuki Movie	Sturla Gunnarsson	2010
Girl Rising	Richard Robbins	2013
Hadwin's Judgement	Sasha Snow	2015
Inocente	Sean Fine and Andrea Nix	2012
Just Eat It: A Food Waste Story	Grant Baldwin	2014
Last Call at the Oasis	Jessica Yu	2011
Manufacturing Consent: Noam Chomsky and the Media	Mark Achbar and Peter Wintonick	1992
Misconception	Jessica Yu	2014
Not a Love Story	Bonnie Sherr Klein	1981
One Day in September	Kevin Macdonald	1999
Project Nim	James Marsh	2011
Raised to Be Heroes	Jack Silberman	2006
Searching for Sugar Man	Malik Bendjelloul	2012
Sergio	Greg Barker	2009
Shameless: The ART of Disability	Bonnie Sherr Klein	2006
Spoil	Trip Jennings	2011
The Act of Killing	Joshua Oppenheimer and Christine Cynn	2012
The Age of Stupid	Franny Armstrong	2009
The Corporation	Mark Achbar and Jennifer Abbot	2003
The Cove	Louie Psihoyos	2009
The Genius of Marian	Banker White and Anna Fitch	2013
The Imposter	Bart Layton	2012
The Invisible War	Kirby Dick	2012
The Story of Stuff	Louis Fox	2007
The Take	Naomi Klein and Avi Lewis	2004
The Ties That Bind	Su Friedrich	2001
This Film Is Not Yet Rated	Kirby Dick	2006
Virunga	Orlando von Einsiedel	2014
Waiting For Superman	Davis Guggenheim	2010
We Were Children	Tim Wolochatiuk	2012

Organizations and Companies Cited in the Book

NAME	LOCATION
Active Voice	San Francisco
Agentic Digital Media	Vancouver, BC
Alaska Wilderness League	Washington, DC
Banff Mountain Film Festival	Banff, Alberta
BC Transplant Society	Vancouver, BC
Bertha Foundation	London

Big Picture Media Corporation	Vancouver, BC
BRITDOC and Good Pitch	London
Canada Media Fund	Toronto, ON
Canadian Broadcasting Corporation (CBC)	Toronto, ON
Canadian Media Production Association	Ottawa, ON
Catapult Film Fund	San Francisco
Centre for Digital Media	Vancouver, BC
Chicago Media Project	Chicago
Chicken & Egg Pictures	New York and San Francisco
Creative Capital	New York
CrossCurrents Foundation	Washington, DC
David Suzuki Foundation	Vancouver, BC
Documentary Australia Foundation	Paddington, NSW
DOXA Documentary Film Festival	Vancouver, BC
Fistula Foundation	San Jose, CA
Fledgling Fund	New York
Force Four Productions	Vancouver, BC
Ford Foundation	New York
Free Range Studios	Oakland, CA
Gamechanger Films	Brooklyn, NY
Games for Change	New York
Harmony Institute	New York
Hartley Film Foundation	Westport, Conn.
Hello Cool World	Vancouver, BC
Hollyhock Leadership Institute	Cortes Island, BC
Hot Docs	Toronto, ON
Independent Filmmaker Project (IFP)	Brooklyn, NY
Impact Partners	Brooklyn, NY
Indiegogo	New York and San Francisco
Inspirit Foundation	Toronto, ON
JustFilms	New York
Kickstarter	Brooklyn, NY
Media Impact Project	Los Angeles
Mindset Social Innovation Foundation	Vancouver, BC
Mother Jones	San Francisco
National Film Board of Canada	Montreal, PQ
National Geographic Society	Washington, DC
New Media Ventures	San Francisco
Norman Lear Center	Los Angeles
National Public Radio (NPR)	Washington, DC
Open Society Foundations	New York
Participant Media	Los Angeles
Passion Pictures	London
Patagonia	Venture, CA

Picture Motion	New York
Planned Lifetime Advocacy Network	Vancouver, BC
ProPublica	New York
Robert Wood Johnson Foundation	Princeton, NJ
Room to Read	San Francisco
Roundhouse Radio	Vancouver, BC
Screen Siren Pictures	Vancouver, BC
Shark Island Institute	Moore Park, Australia
Skoll Foundation	Palo Alto, CA
Sundance Institute	Park City, UT
Super Channel	Edmonton, AB
Telefilm Canada	Montreal, PQ
Tribeca Film Institute	New York
True West Films	Saltspring Island, BC
Vancity Community Foundation	Vancouver, BC
Vancouver International Film Festival	Vancouver, BC
Vancouver Observer	Vancouver, BC
Vulcan Productions	Seattle, WA
WNYC	New York
Working Films	Wilmington, NC

Full Interviewee Biographies

Mark Achbar

Mark Achbar, Big Picture Media Corporation, was the driving force behind the two most successful Canadian feature documentaries ever made. His five-year collaboration with Peter Wintonick resulted in *Manufacturing Consent: Noam Chomsky and the Media* (1992) and six years working with Joel Bakan and Jennifer Abbott gave us *The Corporation* (2003). Both surprise box office hits, they won a combined total of 48 awards, among them 14 audience choice awards, including Sundance. In recognition of *The Corporation*'s success, Telefilm Canada granted Achbar's company a precedent-setting "performance envelope" of $2.4 million, allowing him to help finance and executive produce several award-winning feature documentaries: *Fierce Light: When Spirit Meets Action*, Velcrow Ripper (2008); *Pax Americana and the Weaponization of Space*, Denis Delestrac (2009); *Waterlife*, Kevin McMahon (2009); *Bananas: Poison In A Banana Republic*, Fredrik Gertten (2009); *Surviving Progress*, Mathieu Roy and Harold Crooks (2011); and *Neurons To Nirvana: Understanding Psychedelic Medicines*, Oliver Hockenhull (2013). In addition, as an executive producer, he supported *Blue Gold: World Water Wars*, Sam Bozzo (2008); *Marmato*, Mark Grieco (2014); and *Fractured Land*, Fiona Rayher and Damien Gillis (2015).

Leanne Allison

Leanne Allison is a filmmaker based in Canmore, Alberta. She has directed two award-winning documentaries with the National Film Board of Canada (NFB), *Being Caribou* (2004) and *Finding Farley* (2009). Both films are based on long epic personal journeys through remote wilderness areas in Canada. Each journey shapes the next, including her first foray into the world of interactive through *Bear 71*. *Bear 71* (produced by the NFB) premiered at the Sundance Film Festival New Frontier exhibit, won the 2012 FWA, and a Cannes Lion Creativity award. Leanne is a producer with the Banff Mountain Film Festival.

Grant Baldwin

Grant Baldwin is a director, cinematographer, editor, and composer based in Vancouver, BC. He has an eye for creative cinematography and a varied background working with sports films, narratives, and documentaries. His work can be seen and heard on F/X, TNT, CBC, National Film Board, Knowledge Network, and ESPN. Grant directed and shot the documentary *The Clean Bin Project* (2010), which won 10 festival awards. *Just Eat It: A Food Waste Story* (2014) is his second documentary and garnered him many awards including Best Emerging Canadian Filmmaker at HotDocs 2014.

John Battsek

John Battsek runs Passion Pictures' film department and is one of the most successful and prolific feature documentary producers in the industry. In 1999, Battsek conceived and produced the Academy Award-winning *One Day In September* and he has since been responsible for over 30 high-profile feature documentaries, many of which have achieved international distribution. These include: Academy Award nominated *Restrepo*, Bart Layton's 2013 BAFTA Outstanding Debut Winner, *The Imposter*, and Malik Bendjelloul's *Searching For Sugar Man*, which won the 2013 Best Documentary Academy Award. Margaret Brown's *The Great Invisible* won the Special Jury Award at SWSX 2014. Passion premiered three films at January's 2015 Sundance Film Festival: Stevan Riley's *Listen To Me Marlon*—the definitive Marlon Brando cinema documentary uniquely told from his own perspective; Ilinca Calugareanu's *Chuck Norris vs Communism*, and Douglas Tirola's riotous *Drunk Stoned Brilliant Dead—The National Lampoon Story*. Battsek has been nominated three times for a PGA Award in 2010, 2011, and 2013 for *Sergio, The Tillman Story* and *The Green Prince* respectively, and was the recipient of the 2013 prestigious Grierson Trustees Award for Outstanding Contribution to Documentary.

Johanna Blakley

Johanna Blakley, PhD, is the managing director and director of research at the Norman Lear Centre, a research and public policy institute at the University of Southern California's Annenberg School that explores the

convergence of entertainment, commerce, and society. Johanna performs research on measuring media impact, politics and entertainment, digital media, and intellectual property law. She has two talks on TED. com and she often speaks in the US and abroad about her research. She is co-Principal Investigator, with Marty Kaplan, on the *Media Impact Project* (MIP), a hub for collecting, developing, and sharing approaches for measuring the impact of media. MIP seeks to better understand the role that media plays in changing knowledge, attitudes, and behavior among individuals and communities, large and small, around the world. This project is supported by a grant from the Bill and Melinda Gates Foundation, with additional funding from the John S. and James L. Knight Foundation and the Open Society Foundations.

Asi Burak

Asi Burak is an award-winning game creator, tech executive, and social entrepreneur. He is the president of Games for Change (G4C), a non-profit with the mission to catalyze social impact through digital game. As the executive producer of the *Half the Sky Movement* game, he orchestrated partnerships with Zynga, some of the world's leading NGOs and Pulitzer Prize-winning authors Nicholas Kristof and Sheryl WuDunn. The Facebook game has reached 1.3 million registered players and generated nearly $500,000 in sponsored and individual donations. Prior to that, Burak co-founded Impact Games and created the internationally acclaimed "PeaceMaker" and "Play the News" gaming platforms. He also served as a consultant to companies such as EON Productions (known as the producer of the 007 movies and video games), Newsweek, and McCann Erickson, around the strategic use of games to further brand engagement. A native of Israel, Burak was vice president of marketing and product at Axis Mobile (acquired 2008), where he introduced pioneering mobile apps and games to a worldwide market (Asia, Europe, US). He is a faculty member at the School of Visual Arts' MFA in Design for Social Innovation and holds a Master of Entertainment Technology from Carnegie Mellon University.

Steve Cohen

Steve Cohen is a Chicago-based attorney who is nationally recognized for his representation of whistleblowers. Since 2009, Steve has broadened his involvement with impact documentaries and media. Steve has helped finance or co-executive produce dozens of award winning documentaries, both individually and as a member of Impact Partners. Steve is also a partner in the Gamechanger Film Fund, whose mission is to finance and produce women-directed feature films. Steve has helped finance and co-executive produced dozens of films including *Hell And Back Again, The Island President, How To Survive A Plague, The Crash Reel, Inequality For All,* and *The Overnighters.* In 2014, Steve co-founded The Chicago Media

Project, a member-based non-profit organization that connects Chicago funders and advocates and provides funding, partnership resources, and visibility to impact media projects. Steve also spearheaded the Chicago Group that organized the first Good Pitch in Chicago in 2013, which is now hosted by CMP. In 2012, President Obama appointed Steve to the Board of Trustees of the Harry S. Truman Scholarship Foundation, an independent federal agency that provides scholarships to students seeking professional careers in public service.

Phillip Djwa

Prior to 2000, Phillip worked for 10 years as an award-winning composer for dance, film and theater. Kent Monkman's *A Nation is Coming*, which Djwa scored, won Best Experimental at the 1997 Alberta Film and Television Awards. Since 2000, Phillip has led social change web projects at Agentic Digital Media, a Vancouver-based web design agency. He has worked on many social impact projects including *the Corporation*, APTN's *Digital Drum*, and CBC documentaries such as *Censor This! Ouest qu'on parle* français, and *8th Fire*. He has won numerous awards, and produced the online project for the 2010 Cultural Olympiad Digital Edition (CODE). In 2012, he co-produced a digital media doc project *Battle Castle.TV* for History Television and Discovery UK. Phillip also produced a series of workshops for Telefilm on marketing feature films, and from 2010–2013 Agentic ran *Melting Silos*, which was a project to pair digital media companies and filmmakers in an innovative, and supportive, development process.

Katherine Dodds

Katherine Dodds, a.k.a. "Kat," got her start in advertising at Adbusters, and learned to run a company through her work with *The Corporation*—Canada's top-grossing documentary. Founder and creative director of Hello Cool World (2001) she is known for highly effective and heartfelt campaigns—in film, video, print, and web. Hello Cool World's entire mission has been about producing impact, whether a project is very localized or whether it is broad in scope. Using the power of branding for storytelling campaigns that take on social issues and use social media to engage publics, they are at the forefront of new ways to evaluate community-based research projects. Demonstrating success through stories will feed-forward to new work—a process they like to describe as "going spiral." Kat is a frequent public speaker and workshop leader when not working on community media projects, PSAs, documentary films, and health promotion campaigns. Kat has an MA from the University of Leeds, UK, and a BFA from the University of Victoria. In 2007 she received a "Woman of Vision" award from Women in Film for her work in interactive media. Recently she co-authored the book *Picturing Transformation, Nexw'áyansut* (2013, Figure 1 Publishing).

Geralyn Dreyfous

Geralyn Dreyfous has a wide, distinguished background in the arts, extensive experience in consulting in the philanthropic sector, and participates on numerous boards and initiatives. She is the founder of the Utah Film Center, a non-profit organization that curates free screenings and outreach programs for communities throughout Utah. In 2007, she co-founded Impact Partners Film Fund with Dan Cogan, bringing together financiers and filmmakers so that they can create great films that entertain audiences, enrich lives, and ignite social change. In 2013, Geralyn co-founded Gamechanger Films, the first for-profit film fund dedicated exclusively to financing narrative features directed by women. Her independent producing credits include the Academy Award-winning *Born Into Brothels*; Emmy-nominated *The Day My God Died*; Academy Award-nominated and Emmy Award-winning *The Square*; Academy Award-nominated and Emmy Award-winning *The Invisible War*; and multiple film festival winners such as *Kick Like a Girl*, *In A Dream*, *Dhamma Brothers*, *Project Kashmir*, *Miss Representation*, *Connected*, *Anita*, and *The Crash Reel*. Geralyn was honored with the International Documentary Association's Amicus Award in 2013 for her significant contribution to documentary filmmaking. Variety recognized Geralyn in their 2014 Women's Impact Report, highlighting her work in the entertainment industry.

Beadie Finzi

Beadie Finzi is one of the founding directors of BRITDOC, a non-profit film foundation based in London and supporting filmmakers globally. Having worked in documentary for over 20 years, Beadie is in heaven in her role at BRITDOC—whose mission is to befriend independent filmmakers, fund great films, broker new partnerships, build new business models, share knowledge, and develop audiences globally. In addition to executive producing a number of films at the Foundation, Beadie is also responsible for global program, including Good Pitch and the Impact Award. She is also an experienced filmmaker. Her last film, *Only When I Dance* (2009), had its world premiere at Tribeca Film Festival, was theatrically released in the UK and US and shown on international TV including ARTE France and Channel 4. Beadie also produced *Unknown White Male* in 2005 about a young amnesiac rediscovering his life, which played at the Sundance Film Festival and was Oscar-shortlisted.

Louis Fox

Louis Fox is an author, strategist, puppeteer, and trained filmmaker dedicated to looking at the world as it truly is, while also envisioning it as it could be. Since co-founding the values-based communication firm, Free Range Studios, in 1999, he's created some of the most successful online "cause-marketing" campaigns of all time. His work for clients like Amnesty International, Patagonia, and Greenpeace has been featured in

The New York Times, USA Today, The Washington Post, CNN, FOX News, NPR, The Colbert Report, and *Fast Company* magazine, which named him one of the 50 most Influential Innovators of 2007. As a filmmaker, he has directed and co-written over 100 short animated and live action films. His most successful projects, *The Meatrix, Grocery Store Wars*, and the ongoing *Story of Stuff* series, have been viewed by more than 60 million people and have garnered top honors at dozens of international festivals. Louis' passion for exploring "the world as it could be" has led him to study Taoist philosophy, "flow" psychology, Aikido, and the design science of "permaculture," which is the topic of his first book. *Sustainable [R]evolution—Permaculture in Ecovillages, Urban Farms, and Communities Worldwide* was released in March of 2014 by North Atlantic Books and Random House.

Christie George
Christie George is the director of New Media Ventures, the first national network of angel investors supporting media and tech start-ups that disrupt politics and catalyze progressive change. At New Media Ventures, she has overseen the investment of over $4.5 million into a portfolio of non-profits and for-profits, including NationalField, Sum of Us, and Upworthy.

Christie has spent her career supporting individuals and institutions that are making media that matters—from independent filmmakers documenting powerful stories to social entrepreneurs disrupting the way media is created, distributed, and promoted. She started her career at a venture capital firm, spent six years managing sales and marketing for Women Make Movies, the world's leading distributor of films by and about women, and is a co-founder of Louder, the crowd-promotion platform for ideas that matter. She serves on the board of the Roosevelt Institute and was recently named a Social Citizen Ambassador by the Case Foundation.

Christie holds a BA from Yale University and an MBA with distinction from the University of Oxford, where she was a Skoll Scholar in Social Entrepreneurship and graduated with the Said Prize, awarded annually to the program's top student.

Darcy Heusel
Darcy Heusel's expertise in impact film stretches from social media and online engagement to film marketing and distribution. Her projects at Picture Motion include *Fed Up, American Promise, Bully, The Crash Reel*, and *Herman's House*. Previously, Darcy was the director of programming and marketing at Constellation.tv where she oversaw business development, client relations, social media, and digital strategy. While there, she also directed new media events for The *Vow, Magic Mike*, and films from the Criterion Collection. Prior to Constellation, Darcy was director of

acquisitions and marketing at Screen Media Films where she acquired and oversaw distribution (Theatrical, DVD, VOD, Digital, and more) and marketing for over 50 films. Darcy serves on the advisory board for the Minority Independent Producers summit and volunteers in her free time with Ghetto Film School NYC. Darcy graduated with a BA in political science and writing from Washington University in St. Louis.

Steve Katz

Steve Katz joined Mother Jones in 2003, and was named the non-profit journalism organization's publisher in 2010. In addition to serving Mother Jones' public affairs needs, Steve directs Mother Jones' hybrid business model along with CEO Madeleine Buckingham, which includes a diverse mix of earned and philanthropic revenue that helps ensure operational stability and creates robust opportunities for future growth. Steve has nearly 40 years of experience working in the fields of journalism, environmental advocacy, the arts, social justice, and neighborhood-based housing development, and has served on a number of non-profit boards. Steve received his PhD in Sociology from the University of California at Santa Cruz in 1987, and his BA from Oberlin College in 1974. He lives in the San Francisco Bay area with his wife, Rachelle, and their dog, Mingus. His son, Noah, is completing his acting studies at the Juilliard School.

Bonnie Sherr Klein

Bonnie Sherr Klein received an MA in film at Stanford University. She has been directing films at the National Film Board of Canada since 1967 in the Challenge for Change program and the feminist Studio D, including *VTR St. Jacques*, the first Canadian experience in community video, and predecessor to community access cable TV; *Speaking Our Peace: A Film about Women, Peace, and Power*; and the infamous *Not a Love Story: A Film about Pornography*. At age 46, she experienced a catastrophic stroke due to a congenital malformation in her brainstem. During many years of rehabilitation, she created radio programs and wrote *Slow Dance: A Story Of Stroke, Love And Disability*. She co-founded KickstART Festivals of disability arts and culture; and directed *Shameless: The ART of Disability*, a collaborative film with five disability artists. She has been recognized with honorary doctorates from Ryerson University and the University of British Columbia, a Persons Award, and investiture as an Officer of the Order of Canada.

Sheila Leddy

Sheila Leddy, executive director, has worked with Fledgling Fund since its founding, playing a key role in developing its overall strategy in collaboration with Fledgling's president and board. She plays a leadership role in developing grant guidelines, reviewing and developing projects, and assessing their potential to advance Fledgling's mission. In 2008, she co-authored the white paper, *Assessing Creative Media's Social Impact*. Prior

to Fledgling, she was a senior associate with The Crimson Group, a firm that provided customized management education programs for physician leaders and senior managers of large healthcare organizations. Sheila received her MBA from Boston University Graduate School of Management and her BA from the University of Notre Dame. She also serves on the executive board of the Milton Foundation for Education.

Cara Mertes

Cara Mertes is a non-profit leader with over 25 years of experience supporting and connecting independent film communities globally as a public TV executive, funder, curator, and teacher. Currently the director of Ford Foundation's JustFilms initiative, she is responsible for funding content, networks and leadership in using film and digital storytelling toward social justice goals. She was director of the Sundance Institute Documentary Film Program and Fund from 2006–2013. In addition to directing their granting program and labs, she was a co-founder of BRITDOC Foundation's Good Pitch model, spearheaded *Stories of Change* with the Skoll Foundation, launched the Sundance TED Prize Filmmaker Award and set up multi-year partnerships with regional documentary organizations in the Middle East, India, and China. Prior to Sundance, she was executive producer of the *OV* documentary series on PBS from 1999–2006, where she received multiple Emmy, George Foster Peabody, and duPont-Columbia awards. She has executive produced several Oscar-nominated films, including *Street Fight, My Country My Country* and *The Betrayal (Nerakhoon)* and has led major Ford Foundation funding and support for Academy Award winner *CITIZENFOUR*. Mertes earned a BA degree in English and Film from Vassar College, was a Whitney Independent Study Program Helen Rubenstein Curatorial Fellow, and completed Harvard University's Owner/President Management Program as a Ford Fellow.

Brian Newman

Brian Newman is the founder of Sub-Genre, a consulting company focusing on developing and implementing new business models for film and new media. Current clients include: *Patagonia*, developing film strategies, including distribution and marketing for the feature documentary *DamNation*; *Sundance Institute* on the Transparency Project, a new project to collect and analyze film revenue and expenses; Vulcan Productions; and several filmmakers on fundraising, distribution, and marketing.

Brian is also the producer of *Love & Taxes*, a narrative feature in post from Jake and Josh Kornbluth, and executive producer of *Shored Up*, a documentary feature by Ben Kalina. Brian has served as CEO of the Tribeca Film Institute, president of Renew Media, and executive director of IMAGE

Film & Video. Brian is chair of the board of Rooftop Films, and serves on the board of Muse Film & Television. He authored "Inventing the Future of the Arts: Seven Digital Trends that Present Challenges and Opportunities for Success in the Cultural Sector" for the book *20 Under 40: Reinventing the Arts and Arts Education for the 21st Century*. He was born in North Carolina and has an MA in Film Studies from Emory University.

Ayah Norris

Ayah Norris leads the film and creative verticals in Canada for Indiegogo, the world's largest crowdfunding platform. She works closely with creators across the country to bring their ideas to the world through Indiegogo, raising funds and building community along the way. A passionate crowdfunding advocate, Ayah speaks across Canada at events on crowdfunding, finance, film, digital media, technology, and social entrepreneurship, and is regularly featured as a voice for Canadian crowdfunding in media including *The Globe and Mail*, *Toronto Star*, *National Post*, *Huffington Post*, CBC, *Elle Canada*, *Playback*, *The Hollywood Reporter*, and *Variety*. A storyteller at heart, Ayah is also co-creator of *The INSIGHT Project*, an award-winning, crowdfunded digital media platform sharing the stories of grassroots, creative game-changers. She is a graduate of the Queen's School of Business, and led national initiatives in strategy and marketing for one of Canada's leading hospitality brands before making the leap into the creative world. When not crossing the country for Indiegogo or the globe on her next great adventure, Ayah calls Toronto, Ontario home.

Elise Pearlstein

Elise Pearlstein is senior vice president of Documentary Films at Participant Media, where she manages the company's slate of feature documentaries from development to release. An Oscar®-nominated, Emmy®-winning film producer prior to joining Participant as a full-time employee, Pearlstein produced four feature documentaries for the company, including *Food, Inc.*, *State 194*, *Last Call At The Oasis*, and *Misconception*. Pearlstein's additional credits as a producer include *Protagonist*, released theatrically by IFC Films, *The Living Museum* for HBO, *The Guide*, and the three-minute *Meet Mr. Toilet*, which has received over one million views online. She also co-produced and co-wrote *Smoke And Mirrors: A History Of Denial*, a feature documentary about the tobacco industry's manufacturing of doubt that was shortlisted for the 2000 Academy Awards. Pearlstein created her first film in 1998, a portrait of the iconic Los Angeles hot dog stand Pink's, and went on to produce and write long-form documentaries for Bravo, MSNBC, Discovery, NBC News, and ABC News. From 2000 to 2005, working with Executive Producer Craig Leake, Pearlstein produced and wrote prime-time documentaries for Tom Brokaw and the late Peter Jennings.

Jen Rustemeyer

Jen Rustemeyer is a writer, producer, and passionate zero-waster who spends a fair share of her time both in front of and behind the camera. She produced the 2010 film *The Clean Bin Project* (and is the woman behind the blog of the same name) which documented a year living zero waste. She has coordinated a 30-city, self-supported film tour across Canada by bicycle, has spoken around the world on the topic of recycling and waste reduction, and was the recipient of the MOBI award for Journalism and Media from the Recycling Council of BC. *Just Eat It: A Food Waste Story* is her second feature film.

Andrea Seale

Andrea Seale is dedicated to engaging Canadians in a deeper understanding of environmental issues and inspiring them to create a sustainable future. In 2010 Andrea joined Canada's most influential environmental organization, the David Suzuki Foundation. Prior to that, as founder of Blueprint Fundraising and Communications, she worked with leading non-profit organizations to raise money, build loyal communities of supporters and communicate with flair. Andrea has an Honors BA in Communications from McGill University and a Diploma in Public Relations from Mount Royal University. She has taught non-profit management, communications, and donor development to hundreds of organizations. As a volunteer, she has served on the board of Vancity Community Foundation, Modo (a pioneering car sharing cooperative) and the Association of Fundraising Professionals.

Debika Shome

Debika Shome is deputy director at the Harmony Institute, a research center that studies entertainment's impact on individuals and society. She leads a diverse team working at the intersection of media, social science research, data science, and technology. She joined the Harmony Institute from Columbia University's Center for Research on Environmental Decision where she served as assistant director from 2005–2009. In addition to her work conducting and coordinating research at the center, Debika led CRED's outreach and public policy initiatives. She is the co-author of *The Psychology of Climate Change Communication*, released November 2009. Debika's work bridges the worlds of social science and real-world social change. She is passionate about interdisciplinary work, collaborative environments, and finding innovative solutions to complex issues.

Stephen Silha

Stephen Silha, *Big Joy: The Adventures of James Broughton* documentary co-director, executive producer, and project director, is a communications consultant, writer, and facilitator. He oversees web and film operations,

raises funds, and inspires. He was a friend of Broughton's and brings a journalistic approach. He has reported for magazines and newspapers including *The Christian Science Monitor* and *The Minneapolis Star*, covering education, communications, arts, community affairs, and youth issues. He has worked with a range of philanthropic organizations, including The Charles Stewart Mott Foundation, Bill and Melinda Gates Foundation, Northwest Area Foundation, and Idaho Commission on the Arts. His non-profit clients have included the United Nations, Libraries for the Future, Children's Express, Washington Council for the Humanities, Digital Partners, AIDS Housing of Washington, and Seattle's Metrocenter YMCA. He co-convened the first national symposium on the media and philanthropy, which spawned the local research project Good News/Good Deeds: Citizen Effectiveness in the Age of Electronic Democracy. Today, in addition to producing *Big Joy*, he co-facilitates Journalism That Matters, a think-tank on the future of journalism.

Murray Siple

Murray Siple attended Emily Carr College University for film and video in the early '90s and moved to Whistler to pioneer action sports filmmaking. A cult-classic skate and snowboard video, *The Burning*, was the first of its kind incorporating live DJ'ing into the entire soundtrack.

In 1996 his career at Whistler was cut short by a motor vehicle accident that rendered him as a quadriplegic. Living in North Vancouver led Murray to find homeless men who collected bottles and rode shopping carts down the steep streets of North Vancouver. His documentary, *Carts of Darkness*, is one of the top grossing documentary films for the NFB of Canada. Recently Murray completed a solo round-the-world trip in his wheelchair and returned to Whistler to make the short films *Black Cocaine* and *Turn Them Black*. Throughout his entire journey he never stopped drawing, designing, photographing, and filmmaking. Currently Murray is making a video projection for a theatrical production at the 2015 Para PanAm Games and continuing to write scripts for future films.

Sasha Snow

Sasha Snow is a British film director and director of photography who makes films for cinema, TV, and a wide variety of commercial and charitable organizations. He started out as an architectural photographer in San Francisco before joining the BBC as a film editor in 1991. His first film won a BAFTA Scholarship to study Documentary Direction at The National Film & Television School (1997–1999). His work since has taken him to challenging environments as far afield as Greenland, Siberia, and Zimbabwe, collaborating with convicted murderers, tiger hunters, and property tycoons. His talent for crafting gripping, nuanced, and tightly structured stories on the borders of documentary and fiction has garnered

him numerous awards and international recognition. In 2006 he was nominated for an RTS Award in Documentary Lighting and Photography for the film *Arctic Crime & Punishment*. His subsequent film, *Conflict Tiger* (2006), won 17 international film festival prizes and, in 2010, he was honored as "Environmental Filmmaker of the Decade" at The Green Planet Movie Awards. His most recent film, *Hadwin's Judgement*, was released in April 2015.

Linda Solomon

Linda Solomon Wood founded the *Vancouver Observer* and the *National Observer*. Linda's journalism career began in Nashville, Tennessee at The Tennessean where she worked as an investigative reporter and won awards including the United Press International awards for Best Public Service journalism and Best Investigative Reporting. Linda built a team of journalists that have won the Canadian Journalism Foundation's award for Excellence in Journalism twice in the last three years, and been nominated once. Linda is the recipient of the Vancouver Board of Trade's Wendy Macdonald Award for Entrepreneurial Innovation.

Michelle van Beusekom

Michelle van Beusekom is the executive director of programming and production at the NFB—Canada's public producer and distributor. She oversees creative direction, operations and finances for six production studios from coast to coast. The NFB's English Program has about 100 projects underway at any given time and releases approximately 35 works annually in its core genres: documentary, animation, and interactive. Michelle joined the NFB in 2006 as the assistant director general of English Program. She was part of the management team that established the NFB's first interactive production studio in 2009. In 2008 Michelle produced *Capturing Reality*, a Gemini-nominated feature documentary showcasing the voices of 33 of the world's leading documentarians. She co-conceived and was content editor for the interactive documentary *Here, At Home*. Before joining the NFB, Michelle worked as a program development manager for CBC and as a production executive for the Women's Television Network. She was co-programmer of Planet in Focus: Toronto International Environmental Film Festival from 2000–2002. Michelle is a firm believer in the role and possibilities of public media. She has an MA in political science and speaks English, Spanish, French, and Portuguese.

Notes

1 Heath, Chip & Heath, Dan, *Switch: How to Change Things When Change is Hard.* New York: Broadway Books, 2010.

2 Aaker, Jennifer & Smith, Andy, *The Dragonfly Effect: Quick, Effective, and Powerful Ways To Use Social Media to Drive Social Change.* San Francisco: Jossey-Bass, 2010.

3 Heath, *Switch*, p. 228.

4 The Culture Group, *Making Waves: A Guide to Cultural Strategy*, Jan 2014, p. 2.

5 Ibid., p. 10.

6 http://thecorporation.com/film/about-film. Accessed July 4, 2015.

7 http://www.spannerfilms.net/films/ageofstupid. Accessed July 4, 2015.

8 http://www.takepart.com/foodinc/film. Accessed July 4, 2015.

9 http://storyofstuff.org/. Accessed July 4, 2015.

10 https://www.nfb.ca/film/we_were_children/. Accessed July 4, 2015.

11 BRITDOC, *Good Pitch New York*, June 2014.

12 https://citizenfourfilm.com/about. Accessed July 4, 2015.

13 The Foundation Center, *Growth in Foundation Support for Media in the United States*, Nov 2013.

14 http://geniusofmarian.com/about-gom. Accessed July 4, 2015.

15 Active Voice, *The Prenups: What Filmmakers & Funders Should Talk About Before Tying the Knot*, 2009.

16 http://www.notinvisible.org/the_movie. Accessed July 4, 2015.

17 http://www.chicagomediaproject.org/benefits/. Accessed July 4, 2015.

18 http://damnationfilm.com/the-film. Accessed July 4, 2015.

19 Chouinard, Yvon, *Let My People Go Surfing: The Education of a Reluctant Businessman.* New York: Penguin, 2005.

20 Canadian Media Production Association, *Branded Entertainment: A New Production Financing Paradigm, White Paper 2: The Canadian Experience*, Jan 2014, p. 20.

21 https://www.indiegogo.com/projects/a-better-man. Accessed July 4, 2015.

22 Indiegogo, *Field Guide for Campaign Owners*, 2013, p. 5.

23 http://www.impactguide.org/2.1.1.php. Accessed July 4, 2015.

24 Ibid.

25 Aaker & Smith, *The Dragonfly Effect*, p. 162.

26 https://www.nfb.ca/film/force-of-nature-the-david-suzuki. Accessed July 4, 2015.

27 National Film Board of Canada, *A Teacher's Guide to* Force of Nature: The David Suzuki Movie: *Towards a New Perspective*, 2012, p. i.

28 http://www.imdb.com/title/tt0497116/plotsummary. Accessed July 4, 2015.

29 https://storypilot.org/home. Accessed July 4, 2015.

30 Harmony Institute, *Impact Playbook: Best Practices for Understanding the Impact of Media*, 2013, pp. 5–6.

31 Center for Research on Environmental Decisions, *The Psychology of Climate Change Communication*, 2009, p. 42.

32 http://www.takepart.com/waiting-for-superman. Accessed July 4, 2015.

33 Cieply, Michael, "Participant Index Seeks to Determine Why One Film Spurs Activism, While Others Falter," *New York Times*, July 6, 2014.

34 http://www.escapefiremovie.com/synopsis. Accessed July 4, 2015.

35 The Fledgling Fund, *Assessing Creative Media's Social Impact*, 2008, p. 7.

36 Third Plateau Social Impact Strategies, *Escape Fire Impact Report*, June 2014. p. 6.

37 Ibid., p. 21.

38 http://virungamovie.com/#about. Accessed July 4, 2015.

39 http://www.britdocimpactaward.org/big-idea. Accessed July 4, 2015.

40 Center for Social Media (now Center for Media and Social Impact), *Social Justice Documentary: Designing for Impact*, 2011, p. 25.

41 http://65redroses.com/film/about-the-film/. Accessed July 4, 2015.

42 http://hellocoolworld.com/. Accessed July 4, 2015.

43 Franklin, Lindsey, "Understanding Our Impact," Oct 3, 2014. http://www.newmedia ventures.org/understanding-impact/. Accessed July 4, 2015.

44 http://www.gamesforchange.org/about/. Accessed July 4, 2015.

45 http://www.upworthy.com/about. Accessed July 4, 2015.

46 https://www.facebook.com/HalftheGame. Accessed July 4, 2015.

47 Tofel, Richard, ProPublica, *Non-Profit Journalism: Issues Around Impact*, 2013, p. 5.

48 http://www.motherjones.com/about. Accessed July 4, 2015.

49 http://en.wikipedia.org/wiki/The_Vancouver_Observer. Accessed July 4, 2015.

50 Author interview with Richard Tofel, Oct 22, 2014.

51 http://solutionsjournalism.org/. Accessed July 4, 2015.

52 http://www.npr.org/about-npr/178660742/public-radio-finances. Accessed July 4, 2015.

53 "Shad named new host of CBC's Q," Mar 10, 2015, http://www.cbc.ca/news/arts/shad-named-new-host-of-cbc-s-q-1.2989942. Accessed July 4, 2015.

54 Documentary Organization of Canada, *Growing the Pie: Alternative Financing & Canadian Documentary*, May 2014, p. 74.

55 Author email communications with Stephen Silha, July 1, 2015.

Index

253